Cavaliers and Cardinals

NINETEENTH-CENTURY FRENCH ANECDOTAL PAINTINGS

ERIC M. ZAFRAN

Taft Museum
Cincinnati

A catalogue published in conjunction with the traveling exhibition:
Taft Museum, Cincinnati, Ohio
June 25-August 16, 1992
Corcoran Gallery of Art, Washington, D.C.
September 19-November 15, 1992
Arnot Art Museum, Elmira, New York
November 21, 1992-January 17, 1993

exhibition and catalogue supported by
The National Endowment for the Arts and
The Florence J. Gould Foundation

2

Cover: *Jean-Léon Gérôme*
L'Eminence grise (The Gray Eminence), 1873
oil on canvas, 27 x 39 3/4 in.
Museum of Fine Arts, Boston
Bequest of Susan Cornelia Warren

© 1992 by Taft Museum. All rights reserved.
316 Pike Street
Cincinnati, Ohio 45202

Photo credits: Silverman Photography, nos. 55, 56; Tony Walsh, no. 15.
All photographic reproductions are copyrighted.
All rights reserved, 1992.

Library of Congress Catalog Card Number: 92-81383
ISBN: 0-915577-23-2

PRINTED IN THE UNITED STATES OF AMERICA

The Taft Museum is the first Fine Arts Fund institution and gratefully acknowledges its continuing support as
well as that of the City of Cincinnati and Ohio Arts Council. The Museum also receives awards from the
National Endowment for the Arts, National Endowment for the Humanities, and Institute of Museum Services,
all federal agencies.

Design: Linda Shepherd, Satogata/Vollmer Inc.
Electronic Output: Pagemakers Inc.
Printing: The Merten Company

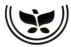

ACKNOWLEDGMENTS

This exhibition owes its genesis to a lively dinner conversation held in one of the best flamenco restaurants in Madrid. There Ruth K. Meyer, director of the Taft Museum, and I met as couriers for the Fortuny exhibition in 1989. Between *olés*, foot-stomping displays, and flaming entrées, I propounded one of my pet ideas—how wonderful it would be to organize an exhibition devoted to the brilliant French anecdotal painters of the nineteenth century. Little did I realize the idea would take root and come to fruition as a major event of the Taft's sixtieth-anniversary celebration. It is certainly a fitting tribute, since the Taft houses among its remarkably diverse holdings examples by two of the finest of these artists, Meissonier and Vibert. To Ruth Meyer, I thus again lift my glass and pronounce a heartfelt *gracias* for her unstinting support of this project and for allowing a guest curator the rare chance to freely pursue his vision.

For carrying out all the hard realities that such a vision entails, I owe a great debt of thanks to David Torbet Johnson, assistant director and registrar of the Taft Museum. He, with Lisa Davis Roberts, handled the myriad details of paperwork and coordination for the transportation of sixty-four works of art from thirty-seven locations with tremendous efficiency and diligence. The smooth production of the catalogue was made possible by Catherine O'Hara, who has proved to be an ideal editor, willing to listen to the author's suggestions and then make even better ones herself. It has been a pleasure to work with her. In addition at the Taft Museum, I wish to thank Angie Larimer, business manager, for all her helpful arrangements and Mark Allen, preparator, for creatively assisting in the installation at the Taft, which I was kindly asked to supervise.

At the other institutions that will present the exhibition, I also want to extend my thanks to their respective staffs, particularly David Levy, director, and William Bodine, Jr., assistant director for curatorial affairs, at the Corcoran Gallery of Art, and John D. O'Hern, director, and Rachael Sadinsky, curator, at the Arnot Art Museum.

This catalogue would not have seen the light of day if not for my most valued assistant, Regina Rudser, who, never losing her good humor, persevered uncomplainingly through various incoherent and indecipherable drafts, helping to produce one that finally made sense.

A number of individuals have helped with their expertise and skills. These include Eugene Abrams on musical matters, Robert Tomlinson on theater history and literary questions, and Roger Wieck on ecclesiastical garb. Assistance with translations was also provided by Laurence Royez and Clarina Notz. In addition, Ko Tokikuni, Efraín Barradas, and J. J. Schlegal all provided wise council and support.

For the research on this project, I used a number of institutions and wish to thank the helpful staffs at the following: The Frick Art Reference Library, New York; the Photography Archives of the National Gallery, Washington, D.C.; the Getty Art Research Library and Archives, Santa Monica; the Département de Documentation, Musée d'Orsay, Paris; the art departments of the Boston Public Library and the New York Public Library; and the library of M. Knoedler and Co., New York.

Many colleagues and friends in museums, universities, and galleries supplied information, assisted in locating paintings, and facilitated loans, and I would like to thank them all. The first both alphabetically and in terms of inspiration is Gerald M. Ackerman.

The others are Elizabeth E. Aston, Beverly Balger, Edward P. Bentley, Annette Blaugrund, Neil Blumstein, Robert Boardingham, Lillin B. Bodie, Jr., David S. Brooke, E. John Bullard, Georgina Callan, Leslie Cohen, David Daniels, Benjamin Dollar, James Draper, Everett Fahy, Trevor Fairbrother, Maddy Fiddel-Beaufort, Harriet Fowler, Marc Gerstein, Bonnie Grad, Jeff Harrison, Joan Hendrix, Constance Cain Hungerford, John Hunisack, Eugene Iglesias, Robert Isaacson, William R. Johnston, Evie T. Joselow, Robert Kashey, Brian P. Kennedy, Steven Kern, Joseph Ketner, Michael Komanecky, Edward W. Lipowicz, Mary Lublin, Dina G. Malgeri, J. Patrice Marandel, Melissa de Medeiros, Charles Millard, Peter Morrin, Troy Moss, Linda Muchliz, Helen Mules, Lawrence Nichols, Carol Osborne, Judith O'Toole, Karen Papineau, Joanne Paradise, Joseph J. Rishel, Betsy Rosasco, Donald Rosenthal, Alan Salz, Polly J. Sartori, Annette Schlagenhauff, Judy Schubb, Meyer Schweitzer, George Shackelford, Michael E. Shapiro, Herman Shickman, Robert Simon, Stephen B. Spiro, Brent Sverdloff, Edward Sullivan, Martha Thomas, Robert W. Torchia, Evan Turner, Robert C. Vose, Jr., Barry J. Ward, and Gabriel Weisberg.

Finally, I must express my deep gratitude to all the private lenders. Never have I met a group so enthusiastic about the area in which they collect and so willing to support their beliefs by generously loaning their beloved works. I hope they will feel their faith has been justified.

Eric M. Zafran
Boston
April 1992

PREFACE

In recognition of the sixtieth anniversary of the opening of the Taft Museum to the public on November 19, 1932, a sequence of exhibitions was planned to explore the basis of the formation of the permanent collections and to introduce them to new audiences. Besides touring shows and new installations in the museum galleries, equally grounded on new research, the collections of Charles Phelps and Anna Sinton Taft and of the Taft Museum are to be published within the coming months, following eight years of study by an international team of scholars.

Research on the history of the collection has proceeded simultaneously with study of specific works of art, and we are now able to consider the circumstances of the collection's formation. Following the death in 1900 of her father, David Sinton, Anna Sinton Taft was named sole heir to a millionaire's fortune. Two years later she and her husband, Charles Phelps Taft, who were nearing their thirtieth wedding anniversary, embarked on their first trip to Europe as a married couple. Following that trip, which included visits to many of the Continent's great museums and private collections, in April 1902 they began buying works of art, concentrating on Chinese porcelains and cabinet pictures, from New York City galleries.

They also engaged scholars to write catalogues of these collections. The first catalogue of the paintings was published late in 1902 and was compiled by Charles Fowles, who was then employed by the firm Arthur Tooth & Sons. That volume and the 1902 invoice from Tooth document the assembly of the collection. Among the works are the Meissonier oil *The Three Friends* and a Vibert watercolor *A Cardinal*, which have inspired this exhibition.

Despite an initial outlay of more than $150,000, the Tafts embarked cautiously on collecting paintings. As newcomers to this activity, they selected the kinds of small works that were easily integrated with the decor of their home. Thus, they began with established modern masters of the nineteenth-century French and British schools whose art represented the then-popular taste for scenes of pastoral life, landscape views, and anecdotal subjects.

From this early collection, the Tafts drew the confidence of taste that would lead them swiftly to the acquisition of larger and more significant works. Of the thirty paintings catalogued in the 1902 volume, only seven were still in the collection that the Tafts bequeathed to their museum in 1927. In addition to the Meissonier and Vibert, two Corots, two Daubignys, and a Fortuny remain among an inventory that includes works from the seventeenth century by the Dutchmen Rembrandt and Hals and from the eighteenth century by the Englishmen Reynolds and Gainsborough. Other nineteenth-century artists added include Turner, Millet, Ingres, and Sargent. Charles Fowles, in partnership with Stevenson Scott, was retained as adviser and agent for all these acquisitions until his tragic death on the *Lusitania* in 1915.

A chance meeting in Madrid led to the particular assembly of cavaliers and cardinals catalogued here. With a view to our approaching anniversary, I had been thinking about how to represent the Tafts' first collecting adventures in the context of revived curatorial interest in French academic art. Fortunately, I was able to share these musings with an acknowledged expert, Eric M. Zafran, who in 1982 had organized *French Salon Paintings from Southern Collections* for the High Museum in Atlanta. When we held that conversation in 1989, Dr. Zafran was curator of paintings at the Walters Art Gallery in Baltimore, a collection rich in nineteenth-century art. Now at home in his native city of Boston, where he is associate curator of European paintings at the Museum of Fine Arts, Dr. Zafran has brought his encyclopedic knowledge to the organization of this exhibition, as can be seen in his essay and catalogue entries. As guest curator, he has been responsible for searching out and selecting the excellent examples of anecdotal paintings that make up this exhibition, and he has also provided a useful survey of the first American collectors of these pictures. On behalf of the Taft Museum, I offer him our sincere thanks.

It is to the contemporary collectors of late-nineteenth-century French academic art that we are greatly indebted for their generosity in loaning works from their collections for this exhibition. Dr. Zafran and I thank them for their enthusiastic endorsement of our project. Their names are found among the museums and other public institutions listed as lenders to the exhibition. We also thank our colleagues at these institutions for endorsing our requests.

An initial award in 1991 from the Museums Program of the National Endowment for the Arts launched the planning for this exhibition and catalogue, while a second award from the Florence J. Gould Foundation, New York, made possible the execution of both. We thank John R. Young, president of the Gould Foundation, and our colleagues at the National Endowment for the Arts.

Ruth K. Meyer
Director

INTRODUCTION

ANECDOTAL SUBJECT MATTER

In 1874 when Jean-Léon Gérôme, who exhibited the *The Gray Eminence* (no. 9), won the medal of honor at the Salon rather than Camille Corot, the critic Philippe Burty condemned Gérôme's art in the following words: "It is beyond dispute that his interpretation of history is as puerile as it is inaccurate. It is not historical *genre*, but anecdotal *genre*—as weak in conception as the mythology that is danced and sung on the stage of Offenbach."[1] For Jules Claretie, however, who wrote a laudatory review of Gérôme's painting, it was "a good comedy of anecdotal history."[2] In 1878 Emile Zola, discussing other genre artists including Jean-Louis-Ernest Meissonier and Jehan-Georges Vibert, commented, "I know that all this genre painting is of no importance. It is the anecdotal side of art, an agreeable diversion for our bourgeoisie."[3] Clearly the term "anecdotal" had different connotations, depending on who was employing it.

The existence of anecdotal subject matter was not new: what was new and worthy of comment was its tremendous growth in popularity and its ascendancy at the annual Salons. The origins of this taste can be found earlier in the century in the works of the Troubadour School[4] and more importantly in the historical genre works of J.-A.-D. Ingres; his often repeated images of Francis I and the dying Leonardo, the doomed lovers Paolo and Francesca embracing, and especially Louis XIV entertaining Molière (see fig. 35) reduced history to charming storytelling.[5] Paul Delaroche effected a further development of anecdotal genre painting with his depictions of unusual incidents from the lives of historical personages, as for example in his most famous work, *Assassination of the Duc de Guise* (fig. 1), which drew enthusiastic crowds at the Salon of 1835.[6] To Charles Blanc, writing in 1878, a

clear line of development of this type of painting ran from Delaroche to his pupil Gérôme, whose success then convinced Meissonier to attempt it.[7]

At the 1868 Exposition Universelle in Paris, genre painting of all types and from all countries dominated. Reviewing the exhibition, Ernest Chesneau correctly observed that this sort of painting met the demand of the ever growing middle class for images of suitable size and subject matter to adorn their homes.[8] He went on to say that what pleases this public is

> uniquely the anecdote, gracious, amiable, pleasant; sometimes a historical anecdote, sometimes a scene of anecdotal customs taken from the elegant life of our times or the courtly life and cavaliers of previous centuries. The cleverness of the motif and the skill of execution are the only aspects the public and therefore the mass of artists care about. In three words, small size, small subject, small painting.[9]

In his last line Chesneau is repeating the usual lament of nineteenth-century writers on painting—that *la grande peinture*, heroic history and mythology painting, was declining and being replaced by the small scale in terms of both size and intellectual conception. In place of noble deeds performed by kings and heroes from the past, the public relished finely rendered figures shown in ordinary situations, preferably of a witty and charming sort.

A notion of the vast production of this type of popular art in the nineteenth century can be gleaned by examining the valuable compilation by Hook and Poltimore.[10] There divided into categories are all the favorite subjects, from sentimental dogs and cats to erotic harems. The present exhibition singles out only a few of these themes for closer examination—those associated with the major anecdotal artists. Some of their other subjects, especially Eastern, military, and

peasant ones have been treated in previous studies, but aside from the few Napoleonic images, these paintings have received little serious attention.

The primary focus here is on portrayals of cavaliers and gentlemen—usually readers, artists, and huntsmen of the sixteenth, seventeenth, and eighteenth centuries—and churchmen, primarily cardinals, with an occasional bishop and prelate. In addition there are Spanish subjects, including the bullfighter who assumes the role of a modern cavalier. The historical characters depicted in period recreations range from Richelieu and his trusted *éminence grise* to Louis XIV and from Molière to the Marechal de Saxe and Napoléon.

The popularity of these themes is related to contemporary social, political, and cultural trends of the era. Both Meissonier's and his followers' evocations of an

Fig. 1. *Paul Delaroche,* **Assassination of the Duc de Guise,** *The Wallace Collection, London.*

age of cavaliers and guardrooms mirror not only the growing taste for Dutch art[11] but also what Hook and

Poltimore refer to as "the development of the historical novel as a popular literary form." They characterize this movement as a "trivialisation of history,"[12] which is perhaps too severe, and one might prefer to call it a humanization; in either case, there was definitely a move in the arts toward making historical figures come alive through dramatic reenactments and exciting adventures. This trend was represented in England by Sir Walter Scott and in France by Alexandre Dumas. Their character types were given visual form in the works of Meissonier and a host of others, such as Paul-Alphonse Viry, Alexandre-Louis Leloir, and Ferdinand Roybet.

The nineteenth century in France also witnessed a great nostalgia for earlier epochs of French history. Memoirs from the seventeenth and eighteenth centuries were published,[13] and the Goncourts, among others, fostered a revival of interest in the rococo taste.[14] The supposedly charming world of François Boucher, Denis Diderot, and Jean-Honoré Fragonard was evoked in many of the intimate scenes that first brought fame to Meissonier.[15] Later in his career Meissonier, and then Gérôme, Vibert, and Edouard Detaille, took up subjects from the life of Napoléon. In this, too, they were part of a broad historical trend, a veritable cult of the emperor that had wide-ranging political ramifications for contemporary viewers.[16]

Equally an obsession was the fascination with Spain and things Spanish that runs throughout nineteenth-century French life and art.[17] During this time Spanish art was imported to Paris in great quantity.[18] This neighboring, yet still distant, land "of rich, warm colors, the home of vineyards and olive trees, where old legends mingled with the most lively and picturesque aspects of the modern world,"[19] beckoned to many French travelers. Théophile Gautier's influential travel journal *Tra Los Montes* first appeared in 1843; Prosper

Merimée, Victor Hugo, and other French writers used Spain as an evocative setting in their works, and the fictional figures Don Quixote, Figaro, and Carmen were widely known.[20] The painters Alfred Dehodencq, Henri Regnault, Gustave Doré, and Edouard Manet all went there, as did Vibert and Gérôme.[21] The most devoted of French artists was Jules Worms; his years of visits and depictions of Spanish subjects from 1863 onward culminated in a large volume of reminiscences in 1906.[22] Also during the mid- and late nineteenth century a flood of talented Spanish artists, including Marià Fortuny, Raimundo de Madrazo, and Eduardo Zamacoïs, moved to Paris, where they exhibited their vivid depictions of Spanish life.[23]

Of all the themes included in this exhibition, the most conspicuous, and perhaps most in need of explanation, is the satirical representation of the clergy. The anticlerical movement in France had been active since the time of the Revolution,[24] and became "an essential part of the Republican outlook" in the later nineteenth century.[25] Honoré Daumier was one of the first to give

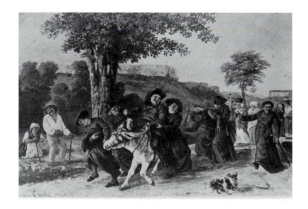

Fig. 2. *Gustave Courbet,* The Return from the Conference, *destroyed.*

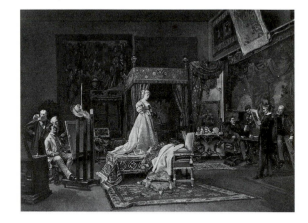

Fig. 3. *Ignacio Leon y Escosura,* The Artist's Studio *(after Strahan,* Etudes, *1882).*

vent to this sentiment in the visual arts. His early lithographs of the 1830s depict fat priests soliciting alms or highly caricatured churchmen gorging themselves, and in the 1850s several other prints viciously mocked the Capuchin monks.[26] A similar grotesque manifestation of anticlericalism was Gustave Courbet's rather coarse *The Return from the Conference* of 1863. This large depiction of drunken priests, parodying the entry of Christ into Jerusalem, was refused at the Salon, but Courbet showed it privately and in 1866 sent it to exhibitions in Boston and New York, where one critic described it as a scene of "utter and irredeemable vulgarity."[27] The original was later destroyed by a devout Catholic, who had acquired it for that purpose, but photographs (fig. 2) and preliminary studies are known.[28] By its size and volatile subject matter, Courbet's painting was clearly not meant for the polite walls of a cozy bourgeois home. Other artists would produce more palatable mocking images of the clergy, enjoying to the full the pleasures of life or showing

themselves to be as selfish and simpleminded as the rest of humanity.

Ferdinand Heilbuth was one of the first artists to make churchmen, at least for a period, his primary subject and prove there was a market for the theme. In 1855 he went to Rome, and there "his unique talent for treating the life and manner of the pontifical court was done with such intelligent discernment, subtle humor, and keen insight that Heilbuth entered at once upon a field of broadening renown. . . . He was surnamed 'the painter of cardinals,' so loyally did he render these cheery old gentlemen in red."[29] At the Salon of 1863 Heilbuth showed three examples of his cardinals and seminarians of Rome. Certainly Vibert, who was exhibiting at the Salon for the first time that year, must have noted these gently humorous works and seen the potential for even greater satire.

Vibert was to become the most famous painter of clerical satire but by no means the only one. Vincent Chevilliard, for example, who by chance painted one priest subject that was acquired by the Prince of Wales, thereafter became trapped as a specialist in this subject but with "less biting sarcasm" than Vibert.[30] Léo Herrmann, Henri-Adolphe Laissement, Emile Meyer (nos. 12, 13, 30), and a host of others were to follow in this line.[31]

THE ARTISTS

At the Exposition Universelle of 1878, the whole range of modern anecdotal genre artists, from Meissonier and Gérôme to Vibert and Worms were on prominent display. Paul Mantz grudgingly found that these genre painters, "aside from being very skilled, owe a great deal to the epigram, to literature, but one would hardly dare say to thought, since that word would be too grand, for these little masters."[32]

A fascinating painting by Meissonier's student, the Spanish artist Ignacio Leon y Escosura (fig. 3), brings together in unlikely fashion all these important "little masters" of genre and some others. By the grandeur of the setting, it conveys the tremendous material rewards (and not a little of the self satisfaction) that could be derived from success in this profession. Strahan, who reproduces it, explicates the scene:

> [Leon y Escosura] is seen at the left of the composition, diligently painting at his easel from his Marie de Médicis model. . . . As for the group of his friends assembled in the scene, they are [from left to right] Chaplin . . . [who] feeds Escosura's pet parrot with a familiarity that shows him a frequent guest. Corot . . . stoops to inspect the painting. Jules Worms and Vibert . . . are seen together, with a cup of tea between them for a bond of union. Gérôme, naturally grave and a little schoolmaster-like, but entirely kind and benevolent, inspects an engraving—(probably a Rubens, to complete the harmony with Marie de Médicis). . . . Meissonier is represented leaning on Gérôme's shoulder. . . . As they stand, the room full of visitors forms a little Walhalla for the immortals.[33]

If not fully concurring that all these artists are immortal, we can at least deem them worthy of consideration in the development of French nineteenth-century art and turn to an examination of their individual lives.

MEISSONIER

Writing in 1873, René Ménard observed, "Meissonier [then fifty-eight years old], is, perhaps, the most popular artist of our time. If he has a picture at the Salon, the crowd first ascertain where it is, and the

Fig. 4. *Honoré Daumier,* Before the Paintings of Meissonier, *lithograph.*

obstruction is such that it is not always easy to approach it."[34] Daumier satirized this situation in a lithograph of 1852 (fig. 4).[35] The painter attained this unparalleled position in part by deliberately limiting his range and the amount of his production he made available and then by creating (like other great nineteenth-century figures such as Verdi and Tolstoy) a flattering personal mythology. As Wolff wrote, Meissonier became "a spectator of his own apotheosis."[36] His myth was that of the penniless youth from Lyons, who with determination and hard work made himself into the greatest (or at least richest) artist of the century. His diligence and thoroughness were legendary. Wolff reported, "from morning till evening one of the greatest artists of our century bends over a task, which has continued for fifty years with the same conscientiousness, the same industry."[37] Stories abounded of his spending hours preparing a minor detail, of his stocking a whole

stable with horses to study their movement and then buying a field of rye to observe the effect of the horses trampling it down.[38] Henry James could rightly describe Meissonier as "the great archaeologist of the Napoleonic era."[39]

Meissonier's father, a dye merchant, moved his family from Lyons to Paris in 1818. Rejecting a career in

Fig. 5. *J.-L.-Ernest Meissonier,* **Two Soldiers,** *1849, Museum of Fine Arts, Boston, gift of the estate of Henry P. Kidder.*

business, Meissonier chose to pursue art. He studied briefly with the painter Léon Cogniet but later wrote that he learned little from him. Meissonier drew his inspiration and technique from his own study of seventeenth-century Flemish and Dutch painters—the so-called little masters. His technical abilities were greatly developed during the years he spent as a designer of wood engravings for book illustrations.

His first painting, *The Flemish Bourgeoisie* of 1834, met with surprising success. Alexandre Decamps praised it as "a little picture of remarkable finesse,"[40] and the Société des Amis des Arts acquired it for one hundred francs.[41]

Two years later Meissonier exhibited at the Salon *Chess Players: Flemish Subject* and *The Little Messenger.* These works showed both the continuing influence of the Dutch paintings in the Louvre and the delicate touch that supposedly led Eugène Delacroix to declare that Meissonier's works looked as if they had been "painted with a baby's eyelashes."[42]

Although he then produced some religious subjects, Meissonier concentrated on presenting at the Salon what was to become his limited repertoire of themes.

In 1840 the first *Reader* appeared. At the next Salon, which Muther writes was "the cradle of his fame," he showed another *Chess Game,* which the same author describes as "the most celebrated picture of the exhibition,"[43] and won a second-class medal. According to Bonnaffé, Meissonier's reputation was truly made at the Salon of 1842.[44] There appeared his first *Smoker* and musical subject, *The Bass Player.* In his Salon critique the enthusiastic Gautier made what was to become the standard comparison of Meissonier to the seventeenth-century Dutch masters: "In their small scale, we place these inestimable works without hesitation beside those of Metsu, Gerald Dou, and Mieris; perhaps even above them, because Meissonier

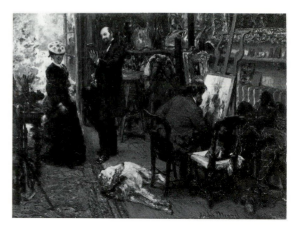

Fig. 6. *Adolphe Menzel,* **Meissonier's Studio,** *1868, The Fine Arts Museums of San Francisco, Jacob Stern Family Loan Collection.*

has the truth of drawing, the fineness of tone, and preciousness of touch joined with a quality that the Dutch hardly possess—style."[45] The poet-critic Baudelaire was one of the few (in 1845) to express reservations, noting, "On the whole M. Meissonier executes his little figures admirably. He is a Fleming, minus the fantasy, the charm, the color, the naïveté—and the pipe!"[46]

In 1843 Meissonier showed one work at the Salon, *A Painter in His Atelier,* the first in a long series treating this theme of a Dutch or French artist of the seventeenth or eighteenth century busily at work in his studio or presenting his creations to some admiring amateurs (nos. 18, 19).

Throughout the 1840s Meissonier continued to produce his small-scale, delicately textured, intimate genre scenes of soldiers, of gaming, of elegant gentlemen talking (no. 15), and of military figures in period dress (fig. 5). The production of these was interrupted only by the 1848 Revolution in Paris, which Meissonier observed firsthand and commemorated in one of his rare modern historical scenes, *Souvenir of the Civil War* (Paris, Musée d'Orsay), described by Mantz as Meissonier's *chef-d'oeuvre* and the only work in

which the painter "conveyed a dramatic sentiment that could engage the viewer's soul."[47]

From the 1850s date two famous historical scenes by Meissonier of a more violent nature, *The Bravi* of 1852 and *A Quarrel* of 1855. In the latter year, his works shown at the Exposition Universelle, according to Hungerford, "marked the apogee of Meissonier's rise as a genre painter."[48] He was awarded the Grand Medal of Honor, praised as the equal of Ingres, Delacroix, and Decamps, and most significantly for his international reputation, Napoléon III (at the request of Queen Victoria) purchased *A Quarrel* and presented

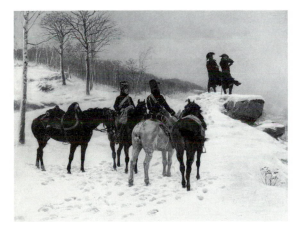

Fig. 7. *J.-L.-E. Meissonier,* Moreau and Dessholes before Hohenlinden, *National Gallery of Ireland.*

it to the visiting Prince Albert of England.[49] Meissonier's success allowed him to live in great luxury with an elegant home and studio in Paris and, from 1847, a suburban estate at Poissy.[50] There, he received his visitors, such as the German painter Adolphe Menzel, who had first come to Paris in 1855 and

became friendly with Meissonier, even painting in 1868 a lively view of the successful artist so hard at work in his atelier that he ignores his visitors (fig. 6).[51]

By the time of the 1857 Salon, at which Meissonier showed two earlier depictions of artists' studios (nos. 18, 19), several critics raised questions about the monotony of his subjects.[52] After nearly thirty years of steady production in a limited field, Meissonier was spurred by this criticism to move on to works of larger scale in the military and historical sphere. The first such work, a contemporary subject, was *The Emperor Napoléon III at the Battle of Solferino* (Musée d'Orsay), a battle he had actually witnessed in 1859. Meissonier substituted this painting for a genre subject to satisfy his official government commission, but it was not especially well received.[53] The painter did much better casting his imagination back in time and joining the Napoléon I revival. His first large-scale treatment of such subject matter, *1814, The Campaign of France* (see fig. 39), was shown with *Solferino* in the Salon of 1864. The painting *1814* was the first of what Meissonier, who seems gradually to have come to identify with the emperor,[54] envisioned as a Napoleonic cycle of works. It was followed by *Friedland, 1807*, originally commissioned by Sir Richard Wallace. The patron became impatient with the artist's slow progress, canceled his order in 1875, and, making the artist extremely angry, even asked for his money back. This actually did little harm to Meissonier's reputation, for he was able to sell the work to the American collector A. T. Stewart for the record sum of 380,000 francs ($60,000),[55] inspiring Henry James to call it "the dearest piece of goods I have ever had the honor of contemplating."[56] Of the other Napoleonic subjects that Meissonier planned, *The Morning of Castiglione* (location unknown) was left unfinished at his death, while *1810, Erfurt* and *1815, Bellerophon* remained only ideas.[57]

Meissonier's interest in the Napoleonic period resulted in a number of smaller works. Focusing on incidents involving Napoléon's generals and troops, they allowed the painter to use his skills as a miniaturist to much greater effect. Notable examples are the scene of General Desaix of 1867 (no. 25) and *Moreau and Dessholes before Hohenlinden* (fig. 7), a remarkable winter composition begun in 1875 with the two officers silhouetted in the distance as their orderlies and horses wait in the snowy foreground.[58] Meissonier continued producing such anecdotal genre works into the 1880s, a prime example being *The Guide* of 1883.[59]

During the 1860s and 1870s Meissonier further developed his single figure subjects—ever more elaborate eighteenth-century readers[60] and many cavaliers in seventeenth-century dress. The setting for the latter is often Meissonier's home at Poissy (no. 22), and in some cases Meissonier even served as his own model (no. 26). One small work of 1860, *The Priest's Wine* (Reims, Musée Saint-Denis), is unusual in his oeuvre of eighteenth-century scenes for introducing the figure of a priest dining with an elegant gentleman. From the 1860s also date many outdoor subjects of cavaliers arriving at a wayside inn (no. 24). The culmination of open-air subjects with elegant gentlemen was the large (at least for Meissonier) *Arrival at the Château* of 1883, painted for William H. Vanderbilt, in which the grand staircase recalls compositions by Gérôme.[61]

At the Exposition Universelle of 1867, which Mollett described as "the culminating incident of the Empire and the triumph of the career of Meissonier,"[62] the artist exhibited fourteen works, including *General Desaix* (no. 25), and was one of four French artists awarded the Grand Medal of Honor. As Blanc remarked, Meissonier had proven that in his genre he "had no equal, not in France, not anywhere."[63]

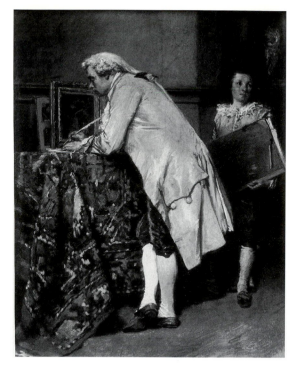

Fig. 8. *Victor-Joseph Chavet,* The Amateur, *Walters Art Gallery, Baltimore.*

However, not everyone agreed with these sentiments. Zola, in particular, raised his satiric voice at this time in some apt observations on both the artist and his admirers, calling the paintings little more than porcelain figurines that with their minuscule, realistic detail appeal to both the snobbish aesthetes and gross bourgeoisie who do not really like painting: "The works of this painter appeal to both little children and adults. That is why he is the master of masters, the artist universally admired and loved, the one who sells for the highest prices and who marches straight towards immortality."[64]

Zola could do little to halt Meissonier's march toward immortality. The painter, with his flowing white beard, increasingly took on the image of an Old

Testament patriarch (especially in his self-portraits).[65] Students, dealers, and collectors flocked to partake of his wisdom, and his observations were lovingly collected. Wealthy Americans in particular sought his works, and if they were fortunate (and rich enough), like William H. Vanderbilt, Leland Stanford, or Mrs. John W. Mackay, they could even convince the artist to paint one of his rare portraits.[66]

No longer finding it necessary to exhibit at the Salon, Meissonier showed his works in public only on special occasions, such as at the Galerie Georges Petit in 1884 to celebrate the fiftieth anniversary of his first Salon exhibition. In 1889 Meissonier was president of the Exposition Universelle, where nineteen of his works were displayed, and he received the Grand Cross of the Legion of Honor, becoming the first artist to achieve this distinction. The following year he helped found and became first president of a new group, the Société Nationale des Beaux-Arts.[67] In 1893 Meissonier was honored posthumously with another grand retrospective exhibition at Petit's gallery.

MEISSONIER'S FOLLOWERS

The tremendous success of Meissonier's seventeenth- and eighteenth-century scenes of cavaliers and gentlemen inspired a great many other artists, which Comte de Viel-Castel noted as a problematic development in a Salon review of 1852: "M. Meissonier is an artist of great talent. M. Plasson and M. Fauvilet, his imitators are refined and graceful, but they are founding a school which will be lost in a dry and minute *miniaturism* and will give birth to 'imperceptible painters.'"[68]

Other painters of similar subject matter, even if they had not worked or studied with Meissonier, were nev-

ertheless classified as his followers. This was the case, for example, with Victor-Joseph Chavet (1822-1906), who had trained with the decorative painter Pierre-Luc-Charles Cicéri before establishing himself in Paris. His first works shown at the 1846 Salon, *Young Man Reading* and *A Smoker*, clearly marked him as a Meissonier imitator although the master had refused to teach him.[69] In a typical example of his work from 1859, *The Amateur* (fig. 8),[70] a small panel of only 8 1/2 x 6 3/8 inches, one clearly sees his debt to Meissonier in both the subject matter and the attention to minute details of period dress.

Benjamin-Eugène Fichel also repeated subjects popularized by Meissonier, such as the painter in his studio (no. 6). A typical Salon showing of his in 1863, where he is listed as a student of Delaroche, included three works, all subjects associated with Meissonier—*The Arrival at the Inn, A Corner of a Library,* and *A Lively Gathering.* A critic observed that, while Fichel was the closest of all the followers to Meissonier, he was still an imitative talent, lacking the inspiration of the older artist.[71]

DETAILLE

Of all Meissonier's French students none achieved a renown equal to that of Edouard Detaille. Born into an art-loving family in Paris, he showed an early interest in both drawing and the military.[72] At the age of seventeen he was introduced to Meissonier, who took him on as a pupil rather than refer him to Alexandre Cabanel. The older artist, with his strict methods and dedication to detail, gave Detaille a firm grounding in "proper artistic methods." The student long remembered Meissonier's "marvelous lessons," which always ended with the advice, "Follow my example; reality,

always reality" (*la nature, toujours la nature*).[73] This influence was seen in Detaille's first Salon piece, *A Corner of Meissonier's Studio* of 1867. The following year he exhibited the first in his extensive production of military subjects, *The Band of Drummers*, which brought him some notice as a talented pupil of Meissonier. The next year he truly established himself with *Rest During Maneuvers, Camp at St. Maur, in 1868*, which was singled out for praise by such critics as Edmond About, Mantz, and Gautier and resulted in so many commissions that Meissonier encouraged him to establish his own studio.[74] On rare occasions Detaille painted nonmilitary historical anecdotes in the manner of Meissonier, such as *Les incroyables* and *A Corner of a Cafe under the Directorate*.[75] Late in his career he produced a great many Napoleonic scenes clearly indebted to his teacher (no. 5).[76]

GÉROME

At the age of sixteen, Jean-Léon Gérôme moved from his native Vesoul to Paris to study with Delaroche, the established master of historical subjects. Gérôme soon made his own reputation with *The Cock Fight* of 1846, a genre scene set in the ancient world.[77] Three years later *Michelangelo*,[78] his first example of a historical anecdote from more recent history, was, in the tradition of Ingres and Delaroche, dedicated to a famous artist. Not until 1861 did Gérôme paint another homage to an earlier artist, *Rembrandt*,[79] which in its scale and use of a seventeenth-century interior setting is somewhat reminiscent of works by Meissonier, while remaining quite different in mood and intensity.

Gérôme's first trip to Egypt resulted in a series of remarkable Eastern subjects that were exhibited in

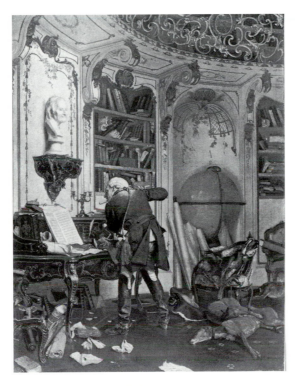

Fig. 9. *J.-L. Gérôme,* Rex Tibicen *(after Strahan,* Gérôme, *1881-83).*

1857. These and his recreations of the ancient world continued to be his main productions over the next few years with only a few scenes of Louis XI representing French history.[80] His first great anecdotal history subject, *Louis XIV and Molière* (no. 7), appeared in 1862.

Gérôme's interest in seventeenth-century subjects, especially the lost *Jean Bart*[81] of the same year, suggests the influence of Meissonier, who was a friendly colleague. Some of Gérôme's Eastern subjects, like *Arnauts Playing Chess* or *Bashi-Bazouk Singing*, are, as Ackerman has observed, Meissonier's motifs transformed into foreign dress.[82] Gérôme, again perhaps following Meissonier, also turned to Napoleonic subjects. Inspired by his Egyptian experience, he produced

a series of paintings in 1867-68 of the youthful Napoléon during his Egyptian campaign. These works show the general on foot, on camelback in the desert, on horseback overlooking Cairo, and most dramatically of all, contemplating the Sphinx in the work titled *Oedipus*.[83] The same years also witnessed the first of Gérôme's bullfighting subjects (no. 8), done before he visited Spain.

At the Salon of 1874 Gérôme showed three of his most elaborate historical anecdotes, each of which achieved renown and won for him a Medal of Honor. The first was the famous *The Gray Eminence* (no. 9). The other two have unfortunately disappeared from public view. *Rex Tibicen* (fig. 9)[84] had an elaborate composition: King Frederick the Great of Prussia practicing his flute in the Palace of Sans Souci. The multitalented king has apparently just returned from the hunt and launches into his music with gusto (if not true talent) under a wryly smiling bust of Voltaire. His pet greyhounds lounge in a rococo setting, rendered, says Claretie, "with such infinite artistry that one could not wish to have in their study a more fascinating painting."[85]

The third historical subject was another of his several depictions of Molière: *A Collaboration* (see fig. 37)[86] showed Molière listening to the aged playwright Corneille reading his part of the heroic tragicomedy *Psyché*, on which they collaborated. Unlike the amicable relationship that existed between La Fontaine and Molière (no. 10), there is a sense of tension in this collaboration, for Molière had previously mocked the older writer's tragedies in *La Critique*.[87] Here, according to Claretie, who was less enthusiastic about this painting, Gérôme had followed tradition in giving Corneille the head of a "*hidalgo chevaleresque*" (chivalrous nobleman).[88] Gonse did not care for either painting; he could not recognize King Frederick in the flute

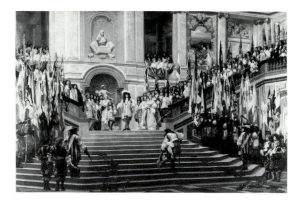

Fig. 10. *J.-L. Gérôme,* The Reception of the Grand Condé at Versailles *(after Strahan,* Vanderbilt, *1883).*

player *"enragé et grotesque,"* and as for *A Collaboration,* it was one of the painter's "least good works" with the writers given the "look of beef merchants making a deal."[89]

Undoubtedly the grandest of Gérôme's seventeenth-century subjects, *The Reception of the Grand Condé at Versailles* of 1878 (fig. 10) was probably painted specifically for William H. Vanderbilt.[90] Gérôme, in designing this subject, may have thought back to the Salon of 1863 where he showed *Louis XIV and Molière* (no. 7) and where Comte and Caraud presented the theme of the Grand Condé being received by the king after the Battle of Serf (1674). The exchange between the two—the Grand Condé apologizing for his slow pace in ascending because of his lameness and the king's *bon mot* of paying his cousin homage by saying that one so weighed down by honors could not be expected to climb quickly—is a pretty conceit, although in Gérôme's painting the protagonists are so far apart that they would have had to shout their words.[91] The colorful retinue lining the imposing staircase becomes the chief subject.

In the early 1880s Gérôme devised some unusual seventeenth-century anecdotal history themes. *The Duel over the Tulip* (fig. 11)[92] depicts an event from the

famous tulip mania of Holland with a cavalier defending his rare bloom against advancing soldiers. Claretie described it as a "pretty composition with flowerbeds of incomparable allure. . . . This is the historical Gérôme giving the *anecdote* the absolute value of a drama."[93] The next year saw the work *Wynant Focking,* in which Focking first tastes his invention, the liqueur curaçao.[94] In both, Gérôme seems to delight in the period costumes of ruffs and feathered hats.

In the 1890s Gérôme, who was then concentrating his artistic efforts primarily on sculpture, revived his earlier interest in Molière with two paintings—the lost *Boileau and Molière*[95] and *La Fontaine and Molière*

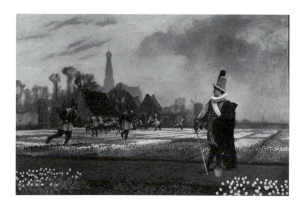

Fig. 11. *J.-L. Gérôme,* The Duel over the Tulip, *Walters Art Gallery, Baltimore.*

(no. 10). He showed his final French historical subject at the Salon of 1896, the highly original *Promenade of the Court in the Garden of Versailles* (fig. 12). Gérôme, who wrote that he had been inspired by the unusual light effects observed on a summer visit to Versailles,[96] presents a moonlit vision of King Louis XIV strolling alongside Madame de Maintenon's movable chair. Few

more romantic interpretations of French history were created in the nineteenth century.

BARGUE

Of the genre artists associated with Gérôme, none is more fascinating than the short-lived but technically brilliant painter Charles Bargue. His few surviving works show the influence of both the oriental subjects of Gérôme and the eighteenth-century themes of Meissonier.

Little concrete information exists about Bargue, since he did not have official artistic training or exhibit at the Salon. According to older sources, he was a student of Gérôme,[97] but Ackerman has found no record of this and notes that it is unlikely, since they were the same age.[98] Bargue did collaborate with Gérôme on a *Cours de dessin,* a self-study course of drawing relying on exquisite lithographs after sculpture and painting. The first volume was published in 1868, and the third and last was authored solely by Bargue in 1871. Although he probably did not travel to the East, he could cleverly imitate and even surpass Gérôme's Eastern subjects, as in his various jewel-like *Sentinels, Almahs,* and *Bashi-Bazouks.*[99] An affidavit dated 1888 and sold with one of Bargue's orientalist scenes was signed by Gérôme, attesting that he had seen it painted by Bargue and had even lent him some of the accessories.[100]

The various nineteenth-century sources all repeat the story of Bargue's tragic end. As Strahan tells it:

He could not secure the prices adequate to his highly-finished and painful style of work, and died young, of pure want. His health failing, last year, he applied for an advance to a dealer who had made vast profits by exploiting his pictures; his application being refused, he fell in a fit in front of the mer-

Fig. 12. *J.-L. Gérôme,* Promenade of the Court in the Garden of Versailles, *unlocated.*

chant's door, was removed to a charitable institution, and died there, while his masterpieces, few in number but wonderfully choice, were being snatched from each other by collectors at fanciful prices.[101]

Strahan was writing in the deluxe catalogue of the collection of William H. Vanderbilt, one of the chief "snatchers" who was able to bring to New York several of the painter's works, including his last and greatest accomplishment, *Playing Chess on the Terrace* (no. 3).

THE NEXT GENERATION

Commenting on the array of anecdotal genre painters, including Vibert, Worms, Delort, Berne-Bellecour, Leloir, and Fichel, who exhibited at the Salon of 1873, the hostile critic Castagnary wrote that "it was the lion Meissonier who has given birth to these lion cubs. So that today it is not only his works that degrade French taste, but also the generation of students formed in his image."[102] Jules Claretie was more sympathetic and invoked the comparison to Dutch art that had so frequently been made with Meissonier:

When one realizes that there are no longer at the Salon the great subjects which were formerly the glory of French art.

When one resigns oneself to admiring the talent, rather than awaiting the messiah called genius, one encounters in all the annual exhibitions a considerable number of works of interest and of a very particular charm. The dimensions are small, the talent is found in works no bigger than the span of two hands. There is such verve, such wittiness in these picturesque little paintings that one can not help applauding them. The Flemish after all, those that Louis XIV, enemy of intimate things, called *magots* have been great painters in small canvases, and one would be amiss to ask Teniers, Dou, Terborch, or Wouvermans to "make it large" as a minister of the Empire might wish to do.

I do not mean to say that we have a great many Gerard Dous among our modern painters, but there is more than one whose delicate touch and high finish create *chef-d'oeuvres* of small works.[103]

Unfortunately by this time the painter Zamacoïs had died, for he and Vibert were generally regarded as the outstanding artists of the younger generation of anecdotal genre specialists. Already by 1869 it could be stated that Vibert and Zamacoïs "are to the Parisian picture-buyers of to-day what Meissonier and Gérôme were yesterday—the novelty and the perfection of art."[104]

VIBERT

Both in *The Century Magazine* of 1895-96 and in his *Comédie en peinture* published after his death in 1902, Vibert left a detailed record of his life and production as an artist. He also wrote a useful text on the technique of painting. Of course he leaves much untold, but by consulting contemporary reviews and diaries, we can establish a fairly reliable picture of his activity throughout a long and prolific career.

Following Vibert's death in 1902, the American magazine *Brush and Pencil* published an extensive

appreciation of the painter by Frederick W. Morton. His opening paragraph offers a particularly clearheaded appraisal of the painter's accomplishments:

In the death of Jehan Georges Vibert, France has lost one of her most noted masters of genre painting. One is not to understand by this that Vibert was a great painter: he was not; he lacked the poetic insight, the soul, the "divine fire," that in art as in literature, must be the basis of real greatness. In plain terms, he was a minor artist, but he was one who had learned his profession thoroughly, and who, by his cleverness, won for himself popular applause.

He was a brilliant though hard colorist, but he had the faculty—perhaps it would be wrong to use a higher term—of producing pictures of a certain elegance and finish that captivated the many. He loved show, wit, humor, fine costumes, pretty faces, subjects that lent themselves to a fine display of technical ability. What is equally important in his career, he was a shrewd enough business man to read correctly his clientele, and to select a specialty that he knew would appeal to the tastes of those he wished to secure as patrons.[105]

There is truth in what Morton says, but there is also something more to Vibert's art, as is suggested by Stranahan's assessment:

His strongest title to admiration is his wonderful power of humorous characterization and satire for which he commands a pleased attention and enduring impression. But he combines an excellent technique with this faculty. He surrounds his characters with the most delicately painted accessories; oriental rugs lie in artistic harmony with wall hangings; and all forms of bric-a-brac are so related that they express the special delight of the artist in them; around these he gives well expressed space, light, shade, and perspective successfully treated, and crowns all with the faces, in which are depicted not only the emotions necessary to the moment, but a suggestion of the whole character.[106]

Compared to François Brunnery and other lesser artists, who later painted some of the same sorts of subjects, it is clear that Vibert, through the combination of his brilliant technique and true sense of humor, avoided kitsch and bad taste. The sheer beauty of his

Fig. 13. *J.-G. Vibert,* French Artists in a Spanish Posada, *1862, National Gallery of Victoria, Melbourne, purchased with the assistance of a Government Fund, 1864.*

coloristic effects and the inventiveness and range of his compositions endow his works with a freshness and vivacity that redeem them from the banal and still give instantaneous delight to the viewer.

Vibert was obviously a most engaging and charming man. His delight in entertaining is found not only in many of the paintings but also in his writing for the popular theater. He loved to dress up and appears in various guises in his paintings. At a costume ball given

by Goupil, Vibert dressed as a very convincing Napoléon I with an entourage, including Detaille as the duc de Reichstadt. When Vibert came face to face with his "descendant," Napoléon III, in the person of the painter Jundt, they proceeded to decorate everyone in sight, including the waiters, before ending the evening with a remarkable quadrille.[107]

The other area in which Vibert attempted to apply his light, entertaining touch was in his writing about his paintings. He had the luxury few artists enjoy of being able to look back after a long and successful career with an assemblage of excellent photographs of his work and freely invent stories to accompany them. This indulgence in *ekphrasis* is not always a success. His narratives can be precise and detailed or long-winded and roundabout by turn, but they never quite equal the brilliance of the finished paintings and watercolors themselves. In almost every case the painting is sufficient unto itself and can convey the meaning of the story to the viewer. Vibert, as Morton noted, was "a clever raconteur in paint."[108]

Vibert was born in Paris on September 30, 1840. He wrote that "according to the law of heredity [he] ought to have been an artist," because his maternal grandfather was "the celebrated French engraver Jazet." His paternal grandfather, Jean-Pierre Vibert, was also famous, a retired soldier who became a noted botanist, perfecting new species of roses, including one red rose named for his grandson, "the Georges Vibert," and "so it was," Vibert writes that he "was dedicated to red from the cradle."[109]

Vibert studied engraving with Jazet, but he soon realized that he wanted to be a painter and entered the studio of F.-J. Barrias, whom Vibert praised for the freedom he allowed his students, but who made them study drawing in black and white for three years before finally allowing them to work in color.[110]

Fig. 14. *J.-G. Vibert,* Narcissus Changed into a Flower, *Musée des Beaux-Arts, Bordeaux.*

Although on occasion called "a Meissonierist,"[111] Vibert did not study with that master. Rather, in April 1857, at the age of sixteen, he entered the Ecole des Beaux-Arts. There Vibert writes of himself, "He took at once the first place and kept it during the six years through which his study lasted."[112] Vibert here exaggerates a bit. He was indeed an active contestant in the various *concours* during his student years. In 1859, identified as a student of both Barrias and F.-E. Picot, he appears sixth on the list of the finalists in the figure competition for his *Jesus Appearing to the Apostles* and finished second out of eight in the landscape competition. The following year he did take a first place in the *concours de composition* for *Joseph Explaining the Dreams*. In 1861 Vibert's *Departure of Ulysses* was second of ten and his *Death of Priam* was awarded a third-class medal.[113]

About this time Vibert chose to continue his education by traveling abroad. Although he does not state when he first visited Spain, he clearly went more than once and, according to Jules Worms, had been there already by 1860.[114] In 1862 Vibert painted a small work, rather reminiscent of Decamps, titled *French Artists in a Spanish Posada* (fig. 13).[115] The pipe-smoking figure in profile to the right is certainly a youthful self-portrait.

His experience in Spain and solid academic training eventually produced results. In 1863 Vibert showed

his first works at the Salon, two genre pieces, *The Siesta* and *Repentance*, and a portrait. The next year when he won his first Salon medal, Vibert paired a mythological and a genre subject—*Narcissus Changed into a Flower* (fig. 14) and *Insouciance*. The former received a great deal of attention, which the reviewer for the *Gazette des beaux-arts* deplored, since he thought the work had little to do with Narcissus's transformation but was only an academic male nude and thus probably not suitable for public exhibition. Nevertheless, the journal repro-

Fig. 15. *J.-G. Vibert*, Roll Call After the Pillage, *Edward Wilson, Fund for Fine Arts, Chevy Chase, Md.*

duced it in a tastefully fig-leafed version.[116] Vibert had, in fact, cleverly derived the boy's pose of lazy eroticism from Cabanel's *Birth of Venus*, shown to great acclaim the previous year.[117] He continued in this double vein in 1865 with a notably crude painting, *Christian Martyrs in the Lion's Den*,[118] and *The Dead Sheep*.[119] *The Convent Choir*[120] painted the same year also had a sentimental religious air. In 1866 Vibert showed two paintings, another mythological theme in the style of Picot, *Daphnis and Chloé*,[121] and a Spanish subject, *The Entrance of the Toreros*, a collaboration

with Zamacoïs (see fig. 41), and two drawings. The Spanish subjects continued in 1867 with a watercolor of Don Quixote. That same year Vibert's *Narcissus*, already acquired by the Musée des Beaux-Arts of Bordeaux, was shown in the Exposition Universelle, evidencing his growing status and placing him in the company of both Meissonier and Gérôme.

According to Vibert's obituary in the *Chronique des arts*, he became well known at this time for his portraits, particularly of women, which displayed "a remarkable suppleness and elegance."[122] Not many of these are known today, and "it was the turn to genre from 1867 on that saw his rise in fame."[123] According to Montrosier,

> Not being able to bring the amateurs to his doors, he resolved to follow their tastes, and in 1867 he boarded the "genre" as bravely as he had the "grand style," and with much more tangible success. *The Roll-call after the Pillage* [fig. 15] was medaled, and Fortune herself lightened his doorways and penetrated into his atelier. All the world is familiar with this lucky picture through innumerable reproductions, —the long line of picturesque ruffians, muffled in all sorts of costumes, covered with broad hats or with morions, some carrying heavy arquebuses, others pikes, lances or halberds, and the captain on foot endeavoring to verify the number of his men of whom too many are in the inn or asleep on the highway. The scene, which passes in a charming village landscape, was so wittily written, so valiantly painted and in a scheme of color so subtle, that it pleased all the world; the amateurs of the incident, facetiously told, decided that M. J. G. Vibert had a future.[124]

A variant subject appeared at the Salon the next year: in *The Convent under Arms (Spain, 1811)* a motley assortment of priests are assembled to form a band of defense.[125] Also painted in 1868 was a subject that seems to combine some typical elements of Meissonier's

subject matter with Vibert's, *A Badly Kept Secret* (fig. 16), in which a wily cleric pumps a tipsy cavalier for information.[126]

The success of these ecclesiastical subjects is indicated by Vibert's 1869 exhibition of *Paying the Tithe*, showing two fat monks returning down a narrow street from their charity work.[127] Also exhibited was one of a number of detailed eighteenth-century genre subjects that Vibert was producing at this time, *Morning of the Wedding Day* (no. 32). The same year he painted one of his most elaborate works, *Waiting for the Diligence*, uniting both his clerical and Spanish themes.[128]

Vibert also turned his attention on occasion to religious themes. In 1869 he showed at the Salon *The Temptation* dated 1867, which shows a praying monk indifferent to the provocations of the delectable courtesans produced by the chief tempter.[129] This was a popular subject in France, since it allowed for the representation of appropriately seductive nudes.[130]

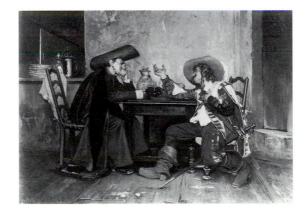

Fig. 16. *J.-G. Vibert*, A Badly Kept Secret *(after Goupil and Co., Galerie photographique), photograph courtesy of National Gallery of Art, Washington, D.C.*

Even more traditional was the *Assumption of the Virgin* painted for the chapel of Saint Denis in the church of Saint Bernard.[131]

Vibert had shown examples of his watercolors at the Salon as early as 1866, and, inspired by the example of Fortuny's watercolors, he and four other artists, all anecdotal genre masters—Leloir, Worms, Berne-Bellecour, and Zamacoïs—formed in 1868 a collective group known as the Cinq du Corps Législatif to pro-

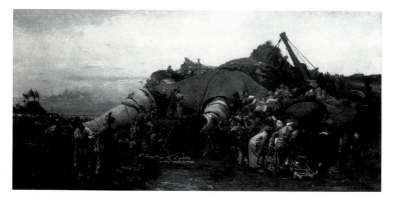

Fig. 17. *J.-G. Vibert,* Gulliver and the Lilliputians, *Canajoharie Library and Art Gallery, Canajoharie, N.Y.*

mote interest in watercolors. In 1878 they formalized their association as the Société d'Aquarellistes Français (Society of French Watercolorists) with Vibert as the first president. They held their first annual public exhibition in 1879 and gradually added a wide variety of other artists, such as James Tissot and Gustave Doré, to their exhibitions, which were held also in England and America.[132] Vibert devoted his full scientific abilities to the watercolor medium to achieve a more brilliant effect. The success of his method is proved by the remarkable freshness of the watercolors in the present exhibition (nos. 34, 35, 48, 49).

According to Morton, Vibert traveled extensively in the East, and some of his works "resemble Fromentin."[133] This last is hard to see, but Vibert must have left Europe at least once, for it is known that he, Detaille, Berne-Bellecour, and Leloir returned from an excursion to Algeria at the outbreak of the Franco-Prussian War.[134] Perhaps it was during the course of this trip that he found the subject of his curious large-scale *Egyptian Water-Carrier.*[135] Some of Vibert's other Eastern subjects, such as *The Pigeons of the Harem,* resemble works by Gérôme.[136]

In 1870, during the Siege of Paris, Vibert joined the "sharpshooters" and was wounded at Malmaison on October 21, for which he was awarded the Medal of the Legion of Honor.[137] After his recovery Vibert was most active as a comic playwright, and his staged productions included *La tribune mécanique* (Palais-Royale, May 1872), *Les carpeaux* (Variétés, 1874), *Les portraits* (1875), a one-act comedy *Le verglass* (Variétés, April 1876), and an operetta *Chanteuse par amour* (1877).[138] Vibert married a leading actress of the Comédie Française, Mme Maria Lloyd, and although he described her as a fierce defender of his reputation,[139] their relationship must not have been ideal as they divorced in 1887.[140] She, however, kept a good many of his paintings, which were included in the sale following her death in 1897.[141]

Vibert's artistic production also kept pace during the 1870s, and his *envois* to the Salons to some extent parallel Gérôme's of the 1860s, in that each year he tried to show a work of widely differing character, able to provoke interest for its novelty and through reproduction attain great renown. For example, in 1870 Vibert presented *Gulliver and the Lilliputians* (fig. 17), one of his "fantasy subjects" derived from Swift, which attracted great crowds and most commentators found quite humorous.[142] In 1873 Vibert showed both the

watercolor *The First Born* (no. 35) and the oil *The Departure of the Bridegrooms*, an amusing historical subject praised by Claretie as a "pretty scene of Spanish customs that the painter has bitten off and painted with a most agreeable talent."[143]

At the Salon of 1874 Vibert was represented by three works, *The Reprimand* (no. 36), which was acquired by Catharine Lorillard Wolfe of New York, *A Monk Gathering Radishes*, and an unusual portrait, *Coquelin in the Role of "Mascarille,"* thus showing off both his humorous and historical talents.[144] This same year Vibert produced a number of Spanish and monk subjects for American collectors, as documented by Samuel P. Avery.[145]

Vibert's Salon offering of 1875 was notable for *The Painter's Repose* and *The Grasshopper and the Ant* (fig. 18), the latter subject taken from La Fontaine but recast with a fat monk and a poor wandering minstrel.[146] These two insect-like figures meeting in a bleak winter landscape, which Vibert said was based on a childhood dream, is one of his most remarkable inventions and made even Zola smile.[147] Claretie suggested that the composition owed something to Zamacoïs,[148] but in fact it resembles Meissonier's especially poignant snow scene (fig. 7) painted the same year.

The major work Vibert showed the following year was *The Antechamber of the Bishop* (see fig. 44),[149] a richly humorous scene of diverse characters awaiting entry to the inner sanctum. Henry James characterized it as "very clever storytelling and a very pretty painting."[150] Zola commented in his equivocal way, "The painting is very nice, we can not disagree with that. Need we add, however, that it is not a question of art here, we are in the presence not of an artist but of a man of wit whose clever figures know how to please polite society."[151]

In this same year, Vibert, who had clearly become a well-established artist, was given a whole chapter in P. Veron's satiric publication *Les coulisses artistiques*. Veron credits Vibert with great skill and speed in establishing his reputation, as if he had "taken an express train," and in choosing the field—genre painting—that best accords with the temper of the times. Vibert, this author observes, never sought to rival the likes of Raphael, Veronese, or Rembrandt; if an equation is to be formulated on his art it is: "Vibert is to history painting (*grande peinture*) as Offenbach is to Meyerbeer."[152]

The Salon of 1877 saw the elaborate *The New Clerk*, which came immediately to America,[153] as well as *The Serenade* (no. 38). The critic Paul de Saint-Victor found these works "less vital, more rigid and photographic, lacking the freedom and freshness" of Vibert's earlier work.[154]

Vibert's fame, however, was now truly international, and he was visited by an itinerant American journalist, Anne Hampton Brewster, who was then living in Rome but spent several weeks visiting the studios of Paris.[155] Her widely reprinted article provides a wonderfully detailed account of the artist's character and home.

One of the most original artists that le Roux introduced me to is Vibert. . . . He is middle-sized, stout for age—for he seems only thirty-five—has a full, merry, happy, but very shrewd, sensible face; he loves work, and is . . . an indefatigable, untiring worker, but he loves also to take his play-hours. In the evening he goes to the theatre, and among his friends and himself removes his thoughts from his work and his studio.

And what a worker he is, not only in his studio, but all over his house! From the moment you enter the *grille* of his handsome residence in Rue de Boulogne, up to the studio, you see you are in an artist's house. There are fine Japanese majolica monsters on the portico; marble shelves full of

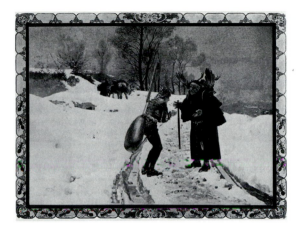

Fig. 18. *J.-G. Vibert,* **The Grasshopper and the Ant** *(after Vibert, 1902).*

flowers; the walls of the entrance-way are Pompeian; the walls of the staircase are covered with India-straw matting, and the outside of the stair-balustrade has a deep fringe of rattan; India plates of brass and India panelings are on the landing-places. His bedroom is Japanese, and he has painted the ceiling to imitate a great plaque of crackled porcelain; it is deliciously done. He has enclosed all his garden and made a sort of Japanese court and salon; there are skylights and gay friezes, and part of the ceiling he has decorated most skillfully with curious, grotesque, and gay-colored Japanese dragons and gilt diaperings. At the end of the court is to be a fountain of his own designing. I saw the photographs of it. There is a red marble base, and on the top of the whole is a bronze bust of La Fontaine, the French fabulist.[156]

Like many another painter of genre (one thinks of Greuze in the eighteenth century), Vibert harbored the desire to be accepted as a painter of serious historical subjects. Thus he presented at the 1878 Salon his monumental painting *The Apotheosis of Adolphe Thiers*. Miss Brewster had seen the picture in preparation in October 1877 and reported:

All Paris that is interested in art is talking of this picture, not only on account of its great cleverness but also because of its

curious history. The subject is now called the "Apotheosis of Thiers." When Vibert designed the picture he asked Detaille to help him paint it. The two men worked on it most faithfully; when it arrived at a certain point Detaille requested his master, Meissonier, to see it. Meissonier refused, and showed such displeasure that Detaille was obliged to give up all work upon it, as his master selfishly wished to keep the subject for himself. Vibert luckily, however, has not such feelings of delicacy toward Meissonier, and has resolved to finish the stupendous work alone and unaided.[157]

She goes on to characterize the work as "hardly an apotheosis, for the ideas and works of Thiers, rather than his person are deified in this noble design of Vibert's." Before a backdrop of the city of Paris, the famed statesman and former president of the Republic lies on a bier decorated with the Grand Cross of the Legion of Honor. At the foot of the bier stands an embodiment of France, a beautiful noblewoman weeping, and at its head is the figure of Glory; worked into the composition are references to the historical events in Thiers's life, including the destruction of the Bastille, the Commune, and the Siege of Paris.

This curious painting was not a critical success; Roger-Ballu described it as "a big painting, not a big work" and found "the sentiment faulty and lacking in taste." For him Thiers "resembles at first glance an Austrian general in a white uniform struck in the field of battle." He did, however, recognize Vibert's ability in the execution: "The flowers and all the details are treated with a skill and sureness of his marvelous hand . . . nevertheless one regrets that the conception had not been simpler."[158] In the end the work was purchased by the State for the Chamber of Deputies. Later sent to the Luxembourg Museum, it is now at Versailles. A slightly smaller grisaille version is at Harvard (fig. 19).[159]

18

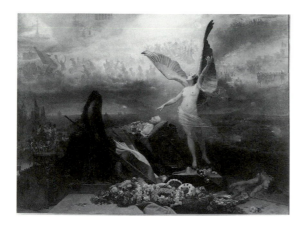

Fig. 19. *J.-G. Vibert,* The Apotheosis of Adolphe Thiers, *ca. 1877-78, The Fogg Art Museum, Harvard University, Cambridge, Mass., gift of Benjamin S. Bell.*

If *Thiers* was not a success, at least Vibert could take comfort in his strong representation at the 1878 Exposition Universelle, where six watercolors and seven oils, including *The Serenade* (no. 38), *The Departure of the Bridegrooms,* and *The Grasshopper and the Ant* (fig. 18), hung to acclaim in the same gallery as those of Gérôme. He was also awarded a third-class medal.[160]

Vibert's lucrative private commissions, especially from Americans, also continued during this time with a multifigured *Sacred Concert* that went to John Jacob Astor[161] and a famous pair of watercolors, *The Women's Bath* and *The Peeping Roofers,* purchased by William H. Vanderbilt.[162] Six of Vibert's watercolors, including these, were shown in 1880 at a New York exhibition of the Society of French Watercolorists.[163] The Cuban writer Jose Martí commented that "some of his cardinals look as if painted in blood."[164] The following year Vibert painted one of his most unusual subjects, *The*

Crucifix (fig. 20), for Samuel P. Avery, who described it as a "Jew in bric-a-brac shop selling Crucifixes to Cardinals . . . 25,000 f[rancs]."[165]

The painful experience of *The Apotheosis of Adolphe Thiers* may have turned Vibert's attention to more unusual contemporary genre scenes drawn from his own experience, for the next time he exhibited at the Salon, in 1881, the subjects were *Rehearsing Amateur Theatricals* and *The Night School* (fig. 21).[166] The mystery and difficulty of the artist's task is especially well captured in *The Night School,* a tour de force of visual effects, in which the bright reflections of two large suspended lamps, shining forth "like twin moons,"[167] turn night into day, so that the model in his Meissonier-like period costume can be studied by the intent students, ranging from children to seasoned professionals.

From 1883 date two pictures that were long in the Metropolitan Museum of Art until *The Startled Confessor,* which had been acquired by Catharine

Fig. 20. *J.-G. Vibert,* The Crucifix *(after Vibert, 1902).*

Fig. 21. *J.-G. Vibert,* The Night School, *The Cleveland Museum of Art, bequest of Noah L. Butkin, 80.292.*

Lorillard Wolfe, was deaccessioned.[168] The other is probably Vibert's largest and most serious clerical work, *The Missionary's Tale* (fig. 22).[169] A version of it was shown in Paris at the special Exposition Nationale that year,[170] and the subject became famous in its day as much for the high price of the large version when it was sold in America as for its content. Morton described it as "a scathing denunciation of the heads of the church who fatten in luxury, and reluctantly condescend on occasion to be bored with the recitals of the real workers for the Lord."[171] Cook pointed out, "Perhaps the deepest thrust in the picture is in a detail that at first does not strike the eye: the missionary can see, if his careless listeners have forgotten it, that over their heads hangs Ribera's powerful picture of the martyrdom of St. Bartholomew."[172] In *Remembrance of*

Things Past Proust had the conservative duc de Guermantes show his disdain for the more avant-garde, imaginary painter Elstir by praising Vibert's work: "I'd infinitely prefer to have the little study by M. Vibert . . . you can see the man's got wit to the tips of his fingers: that shabby scarecrow of a missionary standing in front of the sleek prelate who is making his dog do tricks, it's a perfect little poem of subtlety, and even profundity."[173]

The last Salon presentation by Vibert of the 1880s was *The Arrival* (fig. 23) in 1886. Based on descriptions in the reviews, it is the painting reproduced in Vibert's *Comédie en peinture* as *Moment critique (Critical Moment)* and now in The Haggin Museum.[174] Somewhat heavy-handed humor is displayed in this work in which Vibert himself is seen dressed as a cardinal who arrives at a convent courtyard and, because of his girth, has difficulty dismounting from his mule.

In 1889 Vibert's thirteen watercolors (including *A Scandal*, no. 49) displayed at the Exposition Universelle gained him an appointment as an Officer in the Legion of Honor for his advancement of this field of art.[175] In the 1890s, aside from one humorous ecclesiastical subject, *Le cordon bleu* of 1891,[176] most of the themes Vibert exhibited at the Salon were taken from the seventeenth- and eighteenth-century theater, namely Molière and the *commedia dell'arte: The Hypochondriac* of 1890,[177] and *Pulchinelle's Despair*[178] and *The Sick Doctor* (no. 47), both of 1892.

In 1899 Vibert's final presentation at the Salon was *The Eagle and the Fox* (see fig. 45).[179] This was the first anecdotal subject with famous historical figures that he exhibited and one of a number of Napoleonic paintings he produced in the last years of his career. In 1895 he had been a juror, along with Detaille and Gérôme, to choose a poster design announcing a new

history of Napoléon[180] and may have been inspired to paint his own inventive scenes of the emperor's private life (no. 58).

The 1899 Salon was not, however, the artist's last public showing in Paris, for he had a well-deserved curtain call at the Exposition Universelle of 1900. Eleven

Fig. 22. *J.-G. Vibert,* **The Missionary's Tale,** *The Metropolitan Museum of Art, bequest of Collis P. Huntington, 1900 (25.110.140).*

works, both watercolors and oils, were shown.[181] Since so many of his major works were by then in America, the most impressive of these was probably *The Sick Doctor* (no. 47), which would likewise soon cross the ocean.

Reviewing Vibert's career, it is clear that his range of clerical subjects was enormous. As a contemporary cartoon would have it (fig. 24),[182] Vibert spent his time surrounded by a veritable menagerie of entertaining clergymen who ignore the serious religious art on the walls to drink, chat, and guffaw at Vibert's painting on the lectern-easel. How seriously then are Vibert's gibes at the church to be taken? According to Morton,

Fig. 23. *J.-G. Vibert,* **The Arrival** *or* **His Eminence Returns,** *Haggin Collection, The Haggin Museum, Stockton, Calif.*

Vibert was too well informed, too much alive to the absorbing interests of the day, to keep aloof from the Kulturkampf, which for years has been more or less rife in France against the church as an organization, and which only recently has resulted in riots . . . and not a few of his paintings are little less than pictorial polemics against church and clergy.[183]

However, the pictures themselves rarely seem polemical. Vibert went to great length in the *Comédie en peinture* to convince the reader that he was knowledgeable about the church and its hierarchy, which is further confirmed by the fifty-two lots of ecclesiastical garments sold as part of his estate. The point of many of the paintings and what provides their humor is that the religious duties of the clergymen never seem

onerous. Instead they are usually shown pursuing their favorite hobbies—painting, sculpture, playing instruments, cooking, astronomy, and butterfly collecting. Sometimes these rascally monks and cardinals are engaged in questionable or secretive activities. The most notable example is probably *The Committee on Moral Books* (fig. 25),[184] in which the characters have the illicit pleasure of reading the condemned literature before destroying it. In many cases the lavish furnishings of the cardinals' chambers seem to have most intrigued the painter. A number of his scenes, such as

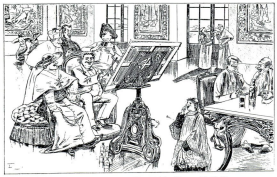

M. VIBERT, le peintre des milieux où la gaîté et la peinture sont inaltérables.

Fig. 24. *Anonymous,* "Mr. Vibert, the painter of places where gaiety and painting are constant" *(after* Revue illustré, *in the documentation of the Musée d'Orsay, Paris).*

The Cardinal's Friendly Chat (fig. 26), are set at Fontainebleau, in this case in the Turkish boudoir of Marie Antoinette.[185]

Disturbances in these elegant settings are rare but provide wonderfully comic moments when they occur. These can consist of the confrontation between a cardinal and a lobster[186] or in *The Abolition of Slavery* (fig. 27)[187] a grand cockatoo asserting its independence by

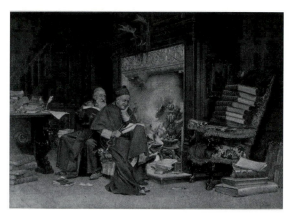

Fig. 25. *J.-G. Vibert,* The Committee on Moral Books *(after Strahan,* Vanderbilt, *1883).*

purposely breaking a large Chinese vase much to the astonished horror of the cardinal. In another case a pet monkey escapes, causing a frantic chase by a posse of priests.[188]

As Morton has written, Vibert,

owing to his keen satires on the princes of the church, has been likened to the novelist Ferdinand Fabre, and the comparison is not without aptness, for each in his respective medium discloses the same relish for a sly thrust at the priesthood, and the same delight in gibbeting the men of holy orders who are more worldly than spiritual.[189]

However, having plowed through novels by this once-esteemed writer, I can say that while both men treat ecclesiastical themes, especially the churchmen's lust for power, Fabre's books contain little of Vibert's humor or wit.[190]

Henry James noted in 1876 that Vibert is "a painter who is greatly relished in America, where many of his pictures are owned."[191] Indeed the diaries of Lucas and Avery, and the number of Vibert's works mentioned in Strahan and sold throughout the late nineteenth and early twentieth centuries in America, make it abundantly clear that he was immensely popular.[192] Henry

Gibson had *The Roll Call* (fig. 15), John Duff *The Schism* (no. 37), William Walters and then Peter Scheman *Gulliver* (fig. 17), William H. Vanderbilt *The Peeping Roofers* and *The Committee on Moral Books* (fig. 25), Charles Crocker *The Convent under Arms*, G. I. Seney and then Jay Gould *The Night School* (fig. 21), John Sellers *The Trial of Pierrot* (no. 41), John T. Martin *Abstinence*, and Jordan L. Mott *The Painter's Repose.* By far the most famous case was *The Missionary's Tale* (fig. 22) of 1883 that was acquired by Mary Jane Morgan from Knoedler's and then sold at her auction in 1886 to Collis P. Huntington for the staggering price of $25,500.[193] This work became that collector's favorite painting, and he bequeathed it to the Metropolitan Museum of Art. According to S. N. Behrman, Huntington thought it a

religious scene . . . an allegory of his life. . . . The cardinals look at the old missionary with that kind of expression, saying what a fool you are that you should go out and suffer for the human race when we have such a good time at home. I lose the picture in the story when I look at it. I sometimes sit half an hour looking at that picture.[194]

With such devoted collectors, Vibert did not have to exhibit at every Salon, and his representation there became more infrequent in the later part of the nineteenth century. The few works he did send, and others such as *He Doesn't Come* (no. 39), recorded by Avery and Lucas, are helpful in providing fixed dates, for Vibert's technique during this period remained virtually unchanged, and the dating of his works from the 1870s onward is difficult.

What is not difficult to ascertain is the painter's commercial acumen. Avery and Lucas provide numerous references to Vibert's prices for oils and watercolors, including those done after his Salon works.[195]

The Goncourts' *Journal* is even more specific, reporting that Vibert

> kept sketches of all his compositions past and future. When a dealer or collector arrived at his house he showed these to them. Having requested a painting, they then saw Vibert go to a drawer, pull out a stamp (*timbre*) with a reduction made in the darkroom and paste it into his big account book and write next to it the amount agreed upon. This Vibert is a man who knows how to make a painting pay off to a degree never before dreamed of. From one painting he finds a way to sell the drawing, the oil sketch, the watercolor, and sometimes two or three replicas of different dimensions.[196]

This fascinating account raises questions about Vibert's working methods. He obviously had little patience for the new impressionist style of painting. In the text accompanying his painting *The Joys of Art*, he refers satirically to this school of painting and obliquely

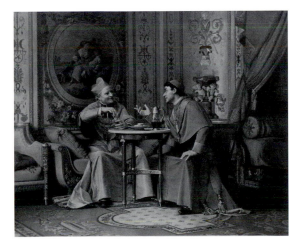

Fig. 26. *J.-G. Vibert,* **The Cardinal's Friendly Chat,** *New Orleans Museum of Art, gift of Mr. and Mrs. Chapman II. Hyams.*

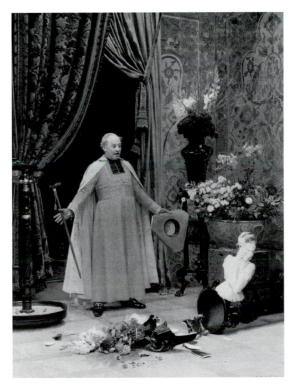

Fig. 27. *J.-G. Vibert,* **The Abolition of Slavery,** *Collection of the Haussner family, Baltimore.*

to Monet:

> Now, Monseigneur belongs to the very latest school, the *eclatistes*, who paint only with intense colors and without hardly any of the tones. Ah yes; I have heard of them. It appears that the head of that school is suffering from an attack of ophthalmia contracted through looking at his own pictures. I understand how your delicate sense of shading must be offended by this new style; still, there are perhaps some good points in it.[197]

For his own part Vibert preferred realistic images with a fastidious devotion to detail that was often described as photographic. In the *Comédie en peinture* he reproduced a photograph of himself at work in his

studio with a model dressed as a bishop seated before him (fig. 28), which is perhaps a bit too neat to really reflect his working method. In fact, this photograph is something of a joke, for, according to Veron, the playful Vibert, having been solicited to provide his American devotees with an image of himself, donned false whiskers and presented a bearded countenance unknown in France.[198] This carefully posed photo-

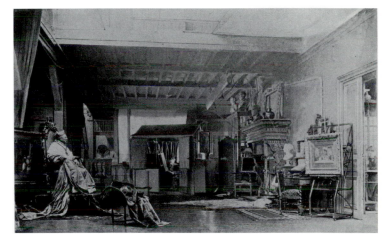

Fig. 28. *Vibert in his studio, photograph (after Vibert, 1902).*

graph and the description of the *timbre* made in the darkroom suggest the importance of photography to Vibert. It seems likely that to create the multiple versions of his work that the Goncourts mention, Vibert, as did other nineteenth-century painters, may have followed a method of treating his gessoed panels with a photosensitive gel and projecting a lantern slide on this surface, which, when developed, provided a basis for the actual painting.[199] As his writings on the art of

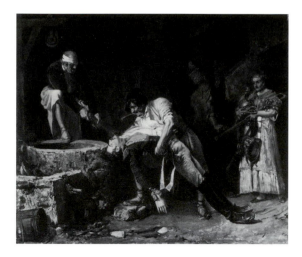

Fig. 29. *E. Zamacoïs,* Spain 1812—The French Occupation, *Walters Art Gallery, Baltimore.*

painting make clear, Vibert was thoroughly scientific in his approach. His involvement with photography is evidenced by the large amount of photographic equipment auctioned in his estate sale.[200]

ZAMACOIS

Eduardo Zamacoïs was born in Bilbao in 1847, and his first art training was at the Escuela de Bellas Artes de San Fernando in Madrid. He went to Paris in 1861 and there, along with the other Spanish painters Luis Ruipérez and Ignacio Leon y Escosura, became a pupil of Meissonier, as is evident in his smaller period paintings. He also attended some of Gabriel-Charles Gleyre's classes and made his debut at the Paris Salon in 1863 with *The Enlisting of Cervantes* and *Diderot and d'Alembert*, two works of historical genre, one Spanish and one French. The following year he exhibited *Conscripts in Spain* and in 1866 *The Entrance of the Toreros* (see fig. 41), a work painted in collaboration with Vibert, as well as *The First Sword*.[201] Zamacoïs quickly established himself as a talented painter of unusual genre scenes and fanciful historical recreations.

The detailed realism and minuteness of touch that he had learned from Meissonier is evident in his 1866 painting *Spain 1812—The French Occupation* (fig. 29), which is most likely the work he exhibited that year in Madrid.[202] Quite original, however, is the passion, even brutality, of the subject. Two irregular Spanish fighters, watched by an old woman, dispose of the corpse of a French cuirassier down a well.

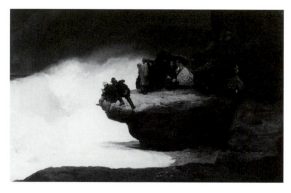

Fig. 30. *J.-G. Vibert,* The Coast at Etretat, *The Snite Museum of Art, University of Notre Dame, on extended loan from Mrs. Noah L. Butkin.*

In 1867, according to Mantz in his Salon review, Zamacoïs achieved the success worthy of an independent student of Meissonier.[203] The works he showed were *Indirect Contribution* and *Fools of the Seventeenth Century*. This success was followed in 1868 by *The Favorite of the King* (see fig. 47), the most famous of his many scenes of dwarfs and jesters (see no. 65). Its subject was described in the *Gazette des beaux-arts* as "not only witty but also truly laughable, notable for the brilliant balance of costumes, poses, and expression."[204] The prestigious journal even gave it the honor of an engraved reproduction.[205]

In 1868 Zamacoïs traveled to Rome and resided in

the studio of his illustrious compatriot, Marià Fortuny, whose works he helped introduce to France and to the great American patron of Spanish artists, William Hood Stewart.[206] While in Rome, Zamacoïs painted *The Refectory of the Trinitarians* shown in Paris at the Salon of 1869.[207]

Writing at this time, Eugene Benson gives some idea of the high regard in which Zamacoïs's work was held by his contemporaries:

> Zamacoïs, with a manner almost as perfect as Meissonier's, is a satirist; he is a man of wit, whose means of expression is comparable to a jeweled and dazzling weapon—so much so that, to express his rich and intense color, his polished style, he has been said to embroider his coarse canvas with pearls, diamonds, and emeralds. I should suggest the form and substance of his works as a painter, by saying that he has done what Browning did as a poet when he wrote the "Soliloquy of the Spanish Cloister," what Victor Hugo has done in portraying dwarfs and hunchbacks; but with this difference, that what is *en grand* and awful in Hugo is small, elaborated, and amusing in Zamacoïs.[208]

During these same years the close friendship between Zamacoïs and Vibert flourished. They collaborated on at least two paintings,[209] and the Spanish artist met his wife at Vibert's studio.[210] In 1867 Vibert painted an unusual scene of tourists at the rocky coast of Etretat (fig. 30). According to Sheldon, Vibert and Zamacoïs are the two intrepid men on the edge of the precipice.[211] In addition it appears that in the few years remaining before Zamacoïs's death, they coordinated their entries at the Salon. Thus, in 1869 when Vibert showed his scene of a Spanish monk riding on a donkey, *Paying the Tithe*, Zamacoïs presented his *Return to the Convent* (fig. 31).[212] At the following Salon they both aroused a good deal of attention for their fanciful themes, Vibert for his *Gulliver* (fig. 17) and Zamacoïs for *The Education of a Prince* (fig. 32).

The unfriendly critic Duret paired them as having chosen grotesque subjects rendered in garish colors, producing "*un ragout épicé* [a spicy stew] that draws the public like a mirror does swallows and a red cape the bulls."[213] As Sheldon explicated it, *The Education of a Prince* shows "a party of Cardinals, generals, diplomats in a grand *Salon* watching with intense interest the antics of a royal baby, who amuses himself by killing little wooden soldiers; each spectator smiles loyally in his own peculiar way."[214]

To avoid the Franco-Prussian War, Zamacoïs returned to Madrid. Described as "small and nervous" with "bushy hair and flashing eyes,"[215] Zamacoïs's intense nature was well captured by his friend Fortuny in an etching of 1869.[216] In a note of November 25, 1870, to the artist Martin Rico, Fortuny wrote from

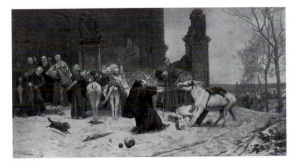

Fig. 31. *E. Zamacoïs,* The Return to the Convent *(after Strahan, Treasures, 1879-80).*

Granada: "I am delighted to learn that you feel inclined to come here. . . . We can paint courtyards and gypsies when we please. Don't trouble yourself about Zamacoïs. He will not come, and if he did come he would not stay two weeks in Granada. You know his nature. This quiet and want of bustle would not suit him."[217] Sadly, the restless Zamacoïs was not to travel

at all, for he died suddenly at the age of twenty-nine on January 12, 1871, in Madrid.[218]

In 1878 his work was included posthumously in the Exposition Universelle, and Charles Blanc praised Zamacoïs as "a charming and witty painter, dead before his time, who did not give into the errors of Fortunyism or imitate Meissonier when he painted the clever and well made *The Favorite of the King*."[219]

As Zamacoïs's son reported, most of his father's works had gone to America,[220] where collectors were enthusiastic about his unusual, even bizarre, subjects—none more so than William H. Stewart.[221] Of major oils by Zamacoïs, *The Rival Confessors* of 1869, which sold for $6,500 at the John T. Johnston sale, was in the John Jacob Astor collection; *The Return to the Convent* (fig. 31) was in the R. L. Cutting collection; *The Education of a Prince* (fig. 32) belonged to Robert Lenox Kennedy; Stebbins had *Indirect Contributions*; T. R. Butler *Court Jesters Playing Bowls* (no. 64); Vanderbilt *The Favorite of the King* (see fig. 47); and Mrs. S. D. Warren of Boston *Court Jesters at Cards*. Not everyone in America was taken with Zamacoïs's unusual subjects, and under the heading "Revolting Art," a reviewer for *The New York Times* wrote in 1876: "The recent Spanish paintings of hump-backed dwarfs and cripples with deformed faces, their deformities made more hideous by gorgeous costumes, are sins against art."[222] The usually critical Henry James, however, was more receptive to Zamacoïs's work:

This young Spanish painter, who died a year ago, had created a brilliant specialty of his own by his mediaeval dwarfs and court-fools, his monks and gallants and other historico-romantic figures. What he might have lived to accomplish further, it is hard to say; it is possible that a certain precocious firmness and hard perfection had indicated the limit of his development. But as he stands, Zamacoïs is a very pretty figure of a master. He is the model of the painters of letters and culture.[223]

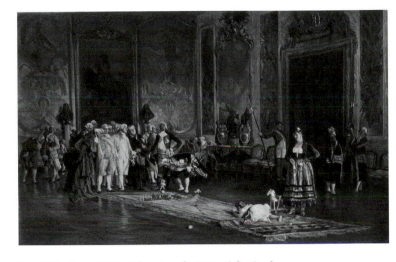

Fig. 32. *E. Zamacoïs,* The Education of a Prince *(after Strahan, Treasures, 1879-80).*

THE COLLECTING OF FRENCH ANECDOTAL GENRE PAINTINGS IN AMERICA

In her detailed recreation of old New York society, *The Age of Innocence*, Edith Wharton described the drawing room of the wealthy Welland family as "a wilderness of purple satin and malachite" in which was found "a small painting representing two cardinals carousing, in an octagonal ebony frame set with medallions of onyx."[224] Such precious anecdotal works had indeed come to be synonymous with the old-fashioned collecting taste of the rich American merchant princes. There had been collectors of painting in America from the beginning of the nineteenth century,[225] but only in the post-Civil War period did the acquisition of

contemporary European paintings of this sort flourish on a grand scale. The heyday of this pursuit was reached in the late 1870s and early 1880s. A. Saule wrote in 1878,

> How thoroughly *genre* pictures are appreciated by the art-buying public of the United States is pretty well shown by the preponderance of works of that class in every public exhibition or sale of private galleries. Indeed, French and other painters of such pictures have, for several years found a mine of wealth in the pockets of rich and cultivated Americans; and not a little of the comfort as well as reputation of such artists as Meissonier, Gérôme, Bouguereau, Cabanel, Zamacoïs, Vely, and a host of others . . . has been due to the purses of their admirers on this side of the Atlantic.[226]

The record of this appreciation was captured by a one-time student of Gérôme, Earl Shinn (writing under the pseudonym Edward Strahan), who produced both the remarkable three-volume compendium *The Art Treasures of America* and the equally grand deluxe catalogue of the William H. Vanderbilt collection. As Strahan noted in his introduction to the former, "For the art of the old masters we have to go to the Vatican and the Louvre" but for great modern art "America will be the judgement-hall, for its Vaticans and Louvres are here." He continues to explain that his work

> is issued as the first attempt to inventory in encyclopedic form the whole treasury of a country in works of art—the enumeration being kept, however, within the grade of certain obvious criteria of merit and value. . . . The opinions expressed have been, however, personal and sincere, and at a transparent depth between the lines will be perceived a very fixed conviction.[227]

This conviction seems to have been that every work of the traditional Salon and academic type, and an occasional Barbizon example, was to be lauded in the most lavish manner and no mention whatsoever was to be made of impressionism. Strahan's work is thus on the one hand a monument to conservative, and often extremely bad, taste; on the other it provides a remarkable overview of a major aspect of the art collecting in America during this period.

John Oldcastle wrote in 1887, "If good Americans go to Paris when they die, rich ones go before their death, and with the rest goes the great picture-buyer." He adds, "the New York Croesus finds his way to Paris rather than London in search of pictures."[228] It was indeed primarily to France that American collectors looked for inspiration and validation of their collecting taste. This led, as the editor of *The North American Review* wrote in 1877, to a situation in which, "Painters were urged to turn out bad imitations and superficial reproductions of foreign and especially of French Schools. Purchasers longed to see their walls hung with subjects which could recall to them the Reignaults [*sic*], the Meissoniers and Gérômes of transatlantic fame."[229] How and when did these purchasers discover the anecdotal genre? In 1855 the periodical *The Crayon* carried a report on the Paris Exposition of Fine Arts stating, "Genre painting is also progressing. The one who marches at the head of the numerous army is, perhaps, Meissonier, who displays so much intelligence and exquisite skill in his infinitely small picture."[230] Praise of Meissonier's talents, his role as the founder of "the Infinitesimal School," and the story of Queen Victoria admiring one of his works and being presented with it by Emperor Napoléon III continued to appear in this periodical throughout the 1850s.[231] In an issue of 1860, Meissonier was among the French artists singled out for a biographical study, which concluded with the information that his best works in the United States were "in the collection of

Messrs. August Belmont and John Wolfe."[232] Mr. Belmont's famous Meissonier was *A Chess Game* showing "two men seated upon magnificently upholstered chairs; at their left a table bearing a decanter of wine and glasses; a beautiful dog stretched out asleep on the highly polished floor" (which seems identical to fig. 38).[233] Mr. Wolfe had *The Smoker*, perhaps the same "man in a cabaret" described as "painted in almost miniature size . . . but with extraordinary delicacy and breadth of execution."[234] *The Smoker* from his collection was sold in December 1863.[235]

One of the earliest books published on art and collecting in America was *The Art-Idea* of 1864 by James Jackson Jarves, who noted that "private galleries in New York are becoming as common as private stables." For him,

24

Meissonier is the painter of the *Salons.* Fashion is his stimulus. His vigorous design, tasteful composition, exquisite finish, minuteness without littleness, manual skill, his force and spirit, despite the inferiority of his motives and want of sympathy for noble work almost elevate him to the level of a great master. Indeed in so far as doing what he attempts superlatively well, he is one.[236]

Meissonier was, therefore, early established as a paragon, that only the wealthiest could afford, but many other artists of a similar type, often even more humorous or edifying, were available at dealers[237] and at auctions to be snatched up in a frenzy of buying and selling. As some early collectors experienced financial difficulties and had to sell their collections, as John Taylor Johnston, who had acquired one of his Meissoniers (no. 23) in Paris in 1868, did in 1876,[238] others (in this case Darius O. Mills) were able to acquire these works at ever increasing prices.

At the time of Strahan's publication almost all the major collectors in America possessed some examples of anecdotal genre. The wealthiest of these was the New York dry goods and real estate entrepreneur A. T. Stewart.[239] Stewart had become so famous for his purchase of Meissonier's *1807, Friedland* that a character in William D. Howell's novel *The Rise of Silas Laphan* (1884) remarks, "Why, they tell me that A. T. Stewart gave one of those French fellows sixty thousand dollars for a little seven-by-nine picture the other day." In addition his collection included Gérôme's *A Collaboration* (see fig. 37) and works by Zamacoïs and Fichel.[240]

William H. Vanderbilt, who only began acquiring seriously in 1878, quickly formed a collection described as "the most celebrated of all."[241] In his palatial home at 640 Fifth Avenue, he had perhaps the most notable group of Meissoniers and Bargues in

America, as well as works by Gérôme, Vibert, and Zamacoïs, whose famous *The Favorite of the King* (see fig. 47) can be easily seen on one of his crowded gallery walls (fig. 33).[242]

A collection more notable for the quality than the quantity of its works was that of James H. Stebbins of New York. His pair of outstanding Gérômes (nos. 7, 9) as well as a tiny Meissonier (no. 24) are included here, but he also had unusual examples by Detaille, Zamacoïs, and Vibert.[243] Some other collectors in New York at this time were John Jacob Astor, R. L. Kennedy, William Rockefeller, John T. Martin, Jay Gould, and Collis P. Huntington, who spent $26,300 each on Meissonier's *The Lost Game* and Gérôme's *Louis XIV and Molière* (nos. 21, 7) when they were auctioned at the Stebbins sale.[244] George I. Seney of Brooklyn owned Vibert's *The Grasshopper and the Ant* (fig. 18), Delort's *Richelieu and Father Joseph* (no. 4), and a *Falconer* by Viry.[245] Outside New York some of the many collectors who had prime examples of anecdotal art were John Duff of Boston, W. P. Wilstach and Henry Gibson of Philadelphia, H. Probasco of Cincinnati, and Charles Crocker of San Francisco.

Several women also formed major collections in the late nineteenth century. The most remarkable was probably that of Mary Jane Morgan. Following the death in 1878 of her much older husband, who had created a steamship empire, she indulged a profligate passion for paintings. With little fanfare she amassed from the New York dealers a hoard of about 250 paintings valued at close to four million dollars. This collection was only discovered by her astonished stepchildren after her own sudden death in 1885; the whole group was sold the following year in a celebrated auction, of which one of the star pieces was Vibert's *The Missionary's Tale* (fig. 22).[246]

A better known, but less adventurous, collection was created by another New Yorker, Catharine Lorillard Wolfe. Following the death of her parents, who each had independent fortunes, Miss Wolfe was thought in 1872 to be the richest unmarried woman in the world. Her life was devoted to charity and collecting, and she was the only woman to contribute to the Metropolitan Museum of Art's first fund drive. Traveling to Paris in 1872, she visited artists and their dealers so that she returned with fashionable examples by Leloir, Meissonier, Vibert (nos. 14, 27, 35), and others. Advised by her cousin John Wolfe, she also added works purchased at auction, such as the important Meissonier, *The Two Van de Veldes* (no. 19). Her collection, which a French writer described in 1908 as "displaying a taste that was quite touching but quite incoherent,"[247] was bequeathed in 1887 to the Metropolitan Museum of Art along with an endowment. Her will designated that a separate gallery be established for the paintings and watercolors (a condition long ago abandoned) but unfortunately not that the works be held permanently by the museum.[248]

Women collectors of note outside New York were Mrs. S. D. Warren of Boston, whose great Gérôme (no. 9) went to that city's museum and who also assembled works by Bargue, Zamacoïs, and artists of the Barbizon School.[249] On the West Coast Alice Scott was the proud owner of Vibert's *Duet of Love*.[250]

Of these many collections, only a handful have survived. The pendulum of fashionable collecting turned away from the anecdotal artists, and already in the late 1880s many of these great collections—Stebbins (1889), Stewart (1887), Seney (1885), and others—were being dispersed. Even some collections that remained intact, such as that of Mr. Corcoran in Washington, D.C., Miss Wolfe's bequest to the Metropolitan Museum of Art, and Henry C. Gibson's

of 1896 to the Pennsylvania Academy of the Fine Arts, have been depleted by deaccessioning, some of it in quite recent times.

Fortunately, several other period collections do still exist. Without a doubt the grandest is that of William T. Walters (1819-1894) of Baltimore, housed in the memorial museum built by his son and successor, Henry.[251] A dedicated collector from 1857, Walters was also an adept businessman who realized the potential of selling important art to his peers. He seems to have imported many works purely for resale, as, for example, Vibert's *Gulliver* (fig. 17), which appears only briefly in his collection. Other works he did pursue and hoard. Gruelle records that Walters, during one of his trips to Europe (probably in 1867), visited Zamacoïs's studio and was eager to purchase the dramatic painting *Spain 1812* (fig. 29). The artist would not part with it, "declaring it his best effort, and refusing to sell it as long as he lived. He added, however, that should his wife ever wish to dispose of it after his death, Mr. Walters should have the refusal of it." Four years after the death of Zamacoïs "the coveted picture" was thus obtained.[252] Likewise Meissonier's *1814* (no. 20) seems to have been a work that Walters pursued and finally landed in 1886. Henry Walters, while broadening the collection, also continued to add works complementing his father's taste for the little anecdotal masters, as with the purchase of Meissonier's *End of the Game of Cards* at the W. H. Stewart sale in 1898.[253]

Matthais H. Arnot of Elmira, New York, a philanthropic banker, pursued both old masters and contemporary works that appealed to him and built a special picture gallery in the mid-1890s to house his more than seventy paintings. The first acquisition having been made abroad in 1869, the collection grew slowly as he came to concentrate on buying works consecrated at the sales of other distinguished collectors. This meant he sometimes had to compete with his New York City rivals in the great public auctions of the day. His tussle at the Mary Jane Morgan sale of 1886 with Collis P. Huntington over Vibert's *The Cardinal's Menu* (no. 43) was considered major news.[254] In 1910 Arnot bequeathed not only his collection but the gallery and an endowment as well to his hometown, so that the collection is housed in an authentic nineteenth-century setting recently restored to its original Victorian splendor.[255]

In Cincinnati at the beginning of this century Mr. and Mrs. Charles Phelps Taft were forming a collection of European paintings. In a compilation of these made in 1902 by the firm Arthur Tooth and Sons, the anecdotal paintings then present included Meissonier's *The Three Friends* (no. 15), Léo Herrmann's *Checkmated*, and Vibert's *A Morning Gossip*. These last two were shortly thereafter sold, as the Tafts redirected their collection to more serious old-master paintings.[256] Fortunately the Meissonier and a Vibert watercolor of a cardinal have remained in the museum and served as the inspiration for the present exhibition.

In the late nineteenth and early twentieth centuries, other couples in America forming collections that are still fairly intact were Charles and Martha Parsons of St. Louis,[257] Jonas and Susan Clark of Worcester, Massachusetts,[258] Sara and Chapman Hyams of New Orleans,[259] and Mary and Robert Stuart of New York City.[260] Among individual works that found permanent homes in this period and are available for inclusion in the present exhibition are Vibert's *If I Were Pope* (no. 46), acquired in 1894 by the Union League of Philadelphia, and the same artist's *The Wonderful Sauce* (no. 45), bequeathed in 1899 by Elisabeth H. Gates to the then Albright Art Gallery in Buffalo.

The fall from grace of the anecdotal genre painters, as well as other representatives of academic and Salon painting, may be seen to culminate in the sale of the once-acclaimed William H. Vanderbilt collection in New York in 1945.[261] Both a Bargue and Meissonier (nos. 2, 18) passed into temporary obscurity, as did Vibert's *Committee on Moral Books* (fig. 25), which sold for a mere $2,700. The grand Gérôme, *The Reception of the Grand Condé at Versailles* (fig. 10), brought only $5,100.[262]

A few collectors, primarily outside New York—such as Louis Terah Haggin,[263] Robert Sterling Clark,[264] Charles H. Martin,[265] Andrew J. Sordoni,[266] and Mr. and Mrs. W. H. Haussner[267]—did remain dedicated to this sort of painting in the mid-twentieth century. It is only in recent years, as evident in this exhibition's list of lenders, that private collectors and public institutions are once again proudly accumulating on a wide scale these comic cardinals and colorful cavaliers.

NOTES

1. Philippe Burty, "Prizes at the Salon," *The Academy* (June 13, 1874), p. 674.

2. Claretie, 1876, p. 211; Jules Claretie was the pseudonym of Jules Arsène Arnaud; see Sloane, 1951, p. 219.

3. Zola, 1959, p. 217.

4. See Marie-Claude Chaudonneret, *La Peinture Troubadour*, Paris, 1980.

5. See Marjorie B. Cohn in *Ingres: In Pursuit of Perfection*, exh. cat., J. B. Speed Art Museum, Louisville, 1983, p. 16.

6. See Norman D. Ziff, *Paul Delaroche, A Study in Nineteenth-Century French History Painting*, New York, 1977, pp. 23-27, 30-31, 86-87, 146-51, and Sloane, 1951, pp. 118-19. The Salon version of *Duc de Guise* is in the Musée Condé, Chantilly; a small watercolor study is in The Wallace Collection, London. See *Wallace*, 1968, p. 89.

7. Blanc, 1878, p. 235.

8. Chesneau, 1868, p. 242.

9. Ibid., p. 244.

10. Hook and Poltimore, 1986.

11. See Ten Doesschate Chu, 1974; Haskell, 1976, pp. 146-50; and H. van der Tuin, *Les vieux peintres des pays-bas et le critique artistique*, Paris, 1948. Symptomatic of this taste was Théophile Gautier's, "Un tour en Belgique et en Hollande," *Caprices et zigzags*, Paris, 1884.

12. Hook and Poltimore, 1986, p. 142.

13. For example, Le Duc de Noailles, *Histoire de Madame de Maintenon et des principaux événements du règne de Louis XIV*, Paris, 1849, 4 vols; and F. Barrière, ed., *Mémoires inédites de Louis-Henri de Loménie*, Paris, 1828.

14. For this revival of eighteenth-century taste, see Seymour B. Simches, *Le romanticism et le goût esthétique de XVIIIe siècle*, Paris, 1964. Also Haskell, 1976, pp. 111-12, 133.

15. The connection between eighteenth-century masters and Meissonier was made by Théophile Gautier, "Meissonier," *GBA* (May 1862), p. 424.

16. For the literature on Napoléon that inspired Meissonier, see Hungerford, 1980, p. 101. Studies of the cult of Napoléon include Maurice Descotes, *La légende de Napoléon et les ecrivains français au XIXe siècle*, Paris, 1967; Jean Lucas-Dubreton, *Le culte de Napoléon, 1815-1848*, Paris, 1959; Jean Tulard, *Le mythe de Napoléon*, Paris, 1971; and *La légende Napoleonienne, 1796-1900*, exh. cat., Bibliothèque Nationale, Paris, 1969. For background, see also Michael Marrianan, *Painting Politics for Louis-Philippe*, New Haven, 1988, pp. 146, 174-77.

17. See Ernest Martinenche, *L'Espagne et le romanticism français*, Paris, 1922.

18. See Paul Guinard, "Zurbarán et la 'decouverte' de la peinture espagnole en France . . . ," in *Hommage à Ernest Martinenche*, Paris, 1939; Haskell, 1976, pp. 161-65; and Paul Guinard and Robert Mesuret, "Le goût de la peinture espagnole en France," in *Trésors de la peinture espagnole*, exh. cat., Palais du Louvre, Musée des Arts Décoratifs, Paris, 1963, pp. 13-26.

19. Montrosier, "Jules Worms," in *Figures contemporaines tirées de l'album Mariani*, Paris, 1902, VII, n.p.

20. See Léon-François Hoffman, *Romantique Espagne, l'image de l'Espagne en France entre 1800 et 1850*, Paris, 1961; and Ilse Hempel Lipschutz, *Spanish Painting and the French Romantics*, Cambridge, Mass., 1972, esp. pp. 141-46.

21. See Paul Guinard, "Romantiques françaises en Espagne," *Art de France*, II (1962), pp. 179-206, and *Manet and Spain*, exh. cat., Museum of Art, University of Michigan, Ann Arbor, 1969.

22. Worms, 1906; for his characteristic works, see Cook, 1888, II, p. 195, and Strahan, *Treasures*, III, 1880, p. 38.

23. See Gonzáles and Martí, 1989.

24. See Alec Mellor, *Histoire de l'anticléricalisme française*, Paris, 1966; J. Salwyn Schapiro, *Anticlericalism*, Princeton, 1967; John McManners, *Church and State in France, 1870-1914*, London, 1972; and Jean-Marie Mayeur and Madeleine Reberioux, *The Third Republic from Its Origins to the Great War, 1871-1914*, Cambridge, England, and New York, 1987, pp. 104, 108-9.

25. John A. Scott, *Republican Ideas and the Liberal Tradition in France, 1870-1914*, New York, 1966, p. 141; Adrien Dansette, *Religious History of Modern France*, New York, 1961, I, pp. 309-16; and Elizabeth Kashey, "Religious Art in the Nineteenth Century," *Christian Imagery in French Nineteenth-Century Art, 1789-1906*, exh. cat., Shepherd Gallery, New York, 1980, pp. 27-28.

26. Delteil, *Daumier*, I, 1925, nos. 20, 21, and VI, 1926, nos. 2088, 2089.

27. See *Courbet und Deutschland*, exh. cat., Kunsthalle, Hamburg, 1978, pp. 170-71, 271-73; Brooklyn, 1988, pp. 68-69; Sloane, 1951, p. 158; and Meyer Schapiro, "Courbet and Popular Imagery," *Journal of the Warburg and Courtauld Institutes*, IV (1941), p. 168.

28. Robert Fernier, *La vie et l'oeuvre de Gustave Courbet*, Paris, I, 1977, pp. 196-97, nos. 338-40; Henri Zerner has pointed out to me that Courbet's *La mort de Jeannot à Orléans* (Fernier, II, 1978, no. 609) also contains a caricature of a priest.

29. Wesley Reid Davis in *Catalogue Deluxe of the Modern Masterpieces Gathered by the Late Connoisseur William H. Stewart*, New York, 1898, n.p., and Charles Yriate in the sale catalogue of the Heilbuth atelier sale, Galerie Georges Petit, Paris, May 19-21, 1890, pp. 8-15.

30. See Stranahan, 1897, pp. 350-51, and "Glimpses of Parisian Art," *Scribner's Monthly* (Dec. 1880), pp. 174-75.

31. Hook and Poltimore, 1986, pp. 100-113.

32. Mantz, 1879, p. 48.

33. Strahan, *Etudes*, 1882, p. 64. The painting is probably *The Studio* that Samuel P. Avery bought from Leon y Escosura for 2,500 francs on Aug. 18, 1875; see Avery, Diarics, 1979, p. 333.

34. Quoted in Clement and Hutton, 1879, II, pp. 107-8.

35. Delteil, *Daumier*, VII, 1926, no. 2294, *Devant les tableaux de Meissonier*.

36. Wolff, 1886, p. 55

37. Ibid., p. 51.

38. Ibid., p. 54; Van Dyck, 1896, p. 94; Burty, 1882, p. 286.

39. James, 1958, p. 38.

40. Alexandre Decamps, *Le musée, revue du Salon de 1834*, Paris, 1834, p. 98.

41. Burty, 1882, p. 274; Van Dyck, 1896, pp. 96-97; *Wallace*, 1968, pp. 198-99.

42. Quoted in Stranahan, 1897, p. 340.

43. Muther, 1907, p. 373.

44. Edmond Bonnaffé, "Un dossier de documents inédits pour servir à la biographie de Meissonier," *GBA* (Aug. 1891), p. 128.

45. Quoted in Bonnaffé, 1891, p. 128.

46. See Jonathan Mayne, trans. and ed., *Art in Paris, 1845-1862, Salons and other Exhibitions Reviewed by Charles Baudelaire*, Ithaca, 1965, p. 23.

47. Mantz, "Salon de 1865," *GBA* (July 1865), p. 12. The painting is discussed in depth by Hungerford, 1979, pp. 277-78, 282-88.

48. Hungerford, 1980, p. 90; for *The Bravi*, now in The Wallace Collection, see Gréard, 1897, p. 305.

49. Gautier, 1856, pp. 65-72.

50. See John Milner, *The Studios of Paris*, New Haven, 1988, pp. 174-75, and Sheldon, 1882, p. 109.

51. For Menzel's painting, see *Adolph Menzel*, Nationalgalerie, Berlin, 1980, pp. 36-37.

52. Hungerford, 1980, p. 91.

53. Ibid., pp. 89-90.

54. Ibid., p. 100; also see Goncourt, 1956, XII, p. 112, and Burty, 1892, p. 17.

55. Meissonier's angry letters to Sir Richard Wallace of Aug. 1879 are preserved in The Wallace Collection, London. The painting is now in the Metropolitan Museum of Art. See Sterling and Salinger, 1966, pp. 152-54, and Donald Mallett, *The Greatest Collector*, London, 1979, pp. 160-62.

56. James, 1958, p. 33.

57. Gréard, 1897, pp. 44-45, 226.

58. Avery, *Diaries*, 1979, p. 340; Calais, 1989, pp. 112-13, no. 36.

59. Sold at Sotheby's, New York, Feb. 24, 1987, no. 45; see Gréard, 1897, opp. p. 192.

60. See Calais, 1989, pp. 108-9, no. 34.

61. According to Towner, 1970, p. 31, this "dazzling throng of society folk from the court of Louis XIII" cost Vanderbilt $40,000.

62. Mollett, 1882, p. 65.

63. Blanc, 1876, p. 421.

64. Zola, 1959, pp. 108-10.

65. See the images in Gréard, 1897, frontispiece and opp. p. 224 and pp. 324, 351, 362; also Tarbell, 1895, p. 114.

66. For Vanderbilt's portrait, see Strahan, *Vanderbilt*, 1883, III, p. 49. The reference to Mrs. Mackay paying $10,000 for her portrait is in Sheldon, 1882, p. 114. On Stanford's portrait, see Carol M. Osborne, "Stanford Family Portraits . . . ," *The Stanford Museum*, X-XI (1980-82), pp. 3-6; and idem, *Museum Builders in the West*, exh. cat., Stanford University Museum of Art, 1986, p. 44, fig. 56.

67. Hungerford, 1989, pp. 71ff.

68. Quoted in Mollett, 1882, p. 29.

69. Burty, 1892, p. 21.

70. Johnston, 1982, p. 113, no. 120.

71. Gueullette, 1863, pp. 18-19, 23.

72. Marius Vachon, "Edouard Detaille," *GBA* (Nov. 1897), p. 430; Sheldon, 1882, p. 21; and Armand Dayot, "Edouard Detaille, Painter of Soldiers," *The Century Magazine* (Oct. 1898), p. 809.

73. Quoted in Los Angeles, 1974, n.p.

74. See Vachon, 1897, p. 430.

75. Strahan, *Treasures*, II, 1880, ill. p. 35; Humbert, 1979, p. 90.

76. Dayot, 1898, p. 889, related that Detaille's interest in Napoleonic subjects owes its origins to a family story that Napoléon, riding through Boulogne in 1805, nearly trampled the artist's father.

77. Ackerman, 1986, p. 186, no. 14; see also Atlanta, 1983, p. 104, no. 32.

78. Ackerman, 1986, pp. 34, 188, no. 20.

79. Ibid., pp. 208-9, no. 124.

80. Ackerman, 1986, pp. 208-9, nos. 121-23.

81. Ibid., no. 140.

82. Ibid., p. 52.

83. Ibid., pp. 76-77, 220-23, nos. 171-76. For an appreciation of *Oedipus*, see that by Gérôme's American student Will Low in Van Dyck, 1896, p. 37.

84. Ackerman, 1986, p. 234, no. 238.

85. Claretie, 1876, p. 211-12.

86. Ackerman, 1986, pp. 96, 234, no. 232.

87. D. B. Wyndham Lewis, *Molière: The Comic Mask*, London, 1959, p. 148.

88. Claretie, 1876, p. 212.

89. Gonse, 1874, p. 38.

90. Ackerman, 1986, pp. 108, 127, 242, no. 265; Hering, 1892, p. 239. An oil study for the composition is in the Springfield Museum, Mass. (Ackerman, 1986, p. 242, no. 265B).

91. Chesneau, 1864, pp. 226-27, commented on the problematic nature of this subject for a painting.

92. Ackerman, 1986, pp. 117, 124, 250, no. 311.

93. Claretie, 1884, p. 60.

94. Ackerman, 1986, pp. 117-18, 125, 250, no. 311.

95. Ibid., p. 268, no. 393.

96. Ibid., pp. 145-46, 278-79, no. 438.

97. See Stranahan, 1897, p. 319.

98. Ackerman, 1986, p. 102, and *The Other Nineteenth Century*, exh. cat., National Gallery of Canada, Ottawa, 1978, p. 40.

99. *A Sentinel* of 1876 sold at Christie's, New York, Oct. 24, 1990, no. 3; one of 1877 is in the Museum of Fine Arts, Boston. Other such works are in the Malden Public Library, Malden, Mass.; two sketches in the Tannenbaum collection, Toronto; a New York private collection; and another sold at Sotheby's, New York, Oct. 23, 1990, no. 39.

100. See sale catalogue, Parke-Bernet, New York, Oct. 16, 1941, p. 29, no. 70.

101. Strahan, *Vanderbilt*, 1883, I, p. 12.

102. Castagnary, 1892, II, p. 87.

103. Claretie, 1876, p. 173.

104. Eugene Benson quoted in Clement and Hutton, 1879, II, p. 368.

105. Morton, 1902, p. 321.

106. Stranahan, 1897, p. 348.

107. Veron, 1876, pp. 256-57. The story is also told by Zamacoïs, 1948, p. 30.

108. Morton, 1902, p. 325.

109. Vibert, 1895-96, p. 79.

110. Ibid., p. 80.

111. Muther, 1907, p. 376.

112. Vibert, 1895-96, p. 80.

113. Philippe Grunchec, *Les concours d'esquisses peintes, 1816-1863*, exh. cat., Ecole Nationale Supérieure des Beaux-Arts, Paris, 1986, I, p. 131, II, pp. 71-77, 99-101.

114. Worms, 1906, p. 55.

115. In the National Gallery of Victoria, Melbourne; see *Illustrated Catalogue of the National Gallery*, Melbourne, 1905, p. 23, no. 42, ill.

116. Léon Lagrange, "Le Salon de 1864," *GBA* (June 1864), pp. 512-13, ill.

117. See Mantz, "Salon de 1863," *GBA* (June 1863), pp. 483-85.

118. Vibert, 1902, II, p. 236.

119. This must be the picture that James, 1872, p. 247, describes as having been shown at the Doll and Richards Gallery in Boston.

120. Vibert, 1902, II, p. 235; sold at Christie's, New York, May 24, 1989, no. 41.

121. For a discussion of this work see Atlanta, 1983, p. 164, no. 64.

122. *La chronique des arts et de la curiosité*, no. 27 (Aug. 1902), p. 22.

123. Ibid.

124. Montrosier, 1881, p. 122 (trans. in Strahan, *Etudes*, 1882, p. 26). Vibert, 1895-96, p. 722-25. Idem, 1902, II, p. 146. Formerly in Henry Gibson's collection, Philadelphia; see Montgomery, ed., 1889, p. 119; and

then in the Pennsylvania Academy of the Fine Arts from which it was sold. It is now in the collection of Edward Wilson, Chevy Chase, Md.

125. Vibert, 1895-96, pp. 551-53; idem., 1902, II, p. 17.

126. Vibert, 1902, I, p. 159.

127. Ibid., p. 128.

128. Ibid., p. 91. Formerly owned by Edward Matthews and then J. H. Stebbins; see Sheldon, 1882, p. 120.

129. Vibert, 1902, I, p. 135; Montrosier, 1881, p. 122; sold at Parke-Bernet, New York, Jan. 14, 1961, no. 234.

130. A once well-known *Temptation of Saint Anthony* by A.-L. Leloir is described in Cook, 1888, II, p. 160.

131. Clement and Hutton, 1879, II, p. 323.

132. Eugène Montrosier, "Georges Vibert," *Society of French Aquarellists*, Paris, 1883, II, pp. 207-24.

133. Morton, 1902, p. 329.

134. Los Angeles, 1974, n.p.

135. Sold at Sotheby's, New York, May 14, 1976, no. 252, and now in the Forbes collection, New York.

136. Reproduced in Vibert, 1902, I, p. 234; it recalls the similar eunuch guardians by Gérôme of 1883 (Ackerman, 1986, pp. 252-53, nos. 319, 320).

137. Vibert, 1895-96, p. 81.

138. See Veron, 1876, pp. 256-57.

139. Vibert, 1895-96, p. 80.

140. The divorce sale was held at Hôtel Drouot, Paris, Apr. 21-23, 1887.

141. The sale was held at Hôtel Drouot, Paris, June 1-5, 1897, and included five of Vibert's paintings and several watercolors.

142. See Vibert, 1902, I, pp. 223-24; J. Goujon, *Salon de 1870, propos en l'air*, Paris, 1870, pp. 118-19; René Ménard, "Le Salon de 1870," *GBA* (1870), p. 45; and a watercolor version mentioned by Castagnary, 1892, I, p. 423. Edward W. Lipowicz, *Catalogue of the Permanent Collection of the Canajoharie Library and Art Gallery*, Canajoharie, N.Y., 1969, no. 16; Lucas (*Diary*, 1979, II, p. 345) wrote to Walters about it on Aug. 15, 1871.

143. Claretie, 1876, p. 174. Castagnary, 1892, II, p. 86, was not as charitable. See Vibert, 1902, II, p. 74.

144. Claretie, 1876, pp. 253-54. See Vibert, 1902, I, p. 24.

145. Avery, *Diaries*, 1979, pp. 231-32.

146. Sometimes translated *The Cricket and the Ant*. See Cook, 1888, II, p. 195. Vibert, 1895-96, pp. 260-61; idem, 1902, I, pp. 237-39; according to the photo files of the Frick Art Reference Library, the painting was in the collection of T. B. Martin of Omaha in 1945.

147. Zola, 1959, p. 162.

148. Claretie, 1876, p. 333.

149. Vibert, 1902, II, pp. 102-11.

150. James, 1958, p. 153.

151. Zola, 1959, p. 186.

152. Veron, 1876, pp. 253-56.

153. The painting (Vibert, 1902, I, p. 190) was imported to New York by William Schaus, as reported in *The New York Times*, Sept. 15, 1877, p. 5; it belonged to Theron R. Butler, according to Sheldon, 1882, p. 120.

154. Paul de Saint-Victor, "Un Salon composite," *L'Artiste* (July 1877), p. 26.

155. See Estelle Fisher, *A Gentle Journalist Abroad, The Papers of Anne Hampton Brewster*, Philadelphia, 1947.

156. Quoted in Clement and Hutton, 1879, II, p. 323.

157. Ibid.

158. Roger-Ballu, "Le Salon de 1878," *GBA* (July 1878), pp. 68-69. For Paul de Saint-Victor in *L'Artiste* (July 1878), it was, "as if a vaudevillian had delivered the funeral orations. . . . If the intentions of the painter were not certain, one would take this cardboard apotheosis for a disguised parody." To Castagnary, 1892, II, p. 325, who traditionally criticized Vibert's genre works, this was a work for which the painter was to be praised for his courage, but he did wonder about the political implications of the composition. Even Bryan, 1921, V, p. 296, referred to this painting as "perhaps the worst work he ever painted."

159. Bowron, 1990, p. 132, fig. 325.

160. *Catalogue officiel*, Paris, 1878, pp. 63-64, nos. 826-32. See Blanc, 1878, p. 245, and J. B. F. W., 1878, p. 182. *The Grasshopper and the Ant* received special mention at this time in Edward Strahan's *The Chefs-d'Oeuvre d'Art of the International Exposition, 1878*, Philadelphia, 1878, pp. 128-30.

161. See Strahan, *Treasures*, II, 1880, p. 7.

162. The pair of watercolors, Vibert, 1902, II, pp. 42-43, had been shown in the second exhibition of the Society of French Watercolorists in Paris, 1880, nos. 1, 2. They were purchased for Vanderbilt by Lucas on Mar. 1, 1880. See Lucas, *Diary*, 1979, II, p. 491.

163. "The French Water-Color Exhibition," *The Art Amateur* (May 1880), p. 14.

164. Jose Martí, "The French Watercolorists," *The Hour*, New York, June 12, 1880, rep. in *Obras completas*, Havana, XV, 1975, pp. 307-10.

165. Avery, *Diaries*, 1979, p. 605. Vibert, 1902, II, p. 187.

166. Vibert, 1902, II, pp. 32, 46. These works were praised by Daniel Bernard, "La peinture de genre," *L'Exposition des beaux-arts (Salon de 1881)*, Paris, 1881, pp. 9-10. J. Buisson in *GBA* (July 1881), p. 70, however, was not impressed: "Au Salon de 1881 les petits cadres sont moins nombreux et la peinture minuscule faiblit. M. Vibert se meurt; la Muse n'en pleurera pas" (At the Salon of 1881 little frames are less numerous and minuscule painting grows weak. Vibert is dying; the muse will not cry for him).

167. Vibert, 1895-96, p. 556; see also Zakon, 1978, pp. 37, 62, 65, no. 20.

168. Vibert, 1902, I, p. 86. Sterling and Salinger, 1966, pp. 196-97; *The Startled Confessor* was sold at Sotheby's, New York, May 28, 1981, no. 91, and was last in Armand Hammer's collection; see *Architectural Digest* (Aug. 1985), ill. p. 85.

169. Vibert, 1895-96, pp. 82-83; idem, 1902, I, p. 102. Sterling and Salinger, 1966, p. 197. This work had gone to Knoedler's, New York, and was sold at Chickering Hall, Apr. 14, 1893, and purchased by R. M. Streeter; see *The New York Times*, Apr. 15, 1893, p. 7.

170. According to Paul Le Fort, "L'Exposition nationale de 1883," *GBA* (Nov. 1883), p. 400. Since he writes that "several small canvases had been gathered of which the subjects always assured a crowd," it seems likely that it was a smaller version of *The Missionary's Tale* that was exhibited.

171. Morton, 1902, p. 328.

172. Cook, 1888, II, pp. 194-95.

173. Proust, 1981, II, p. 520.

174. Vibert, 1902, I, pp. 203-4. Sanders, 1991, pp. 152-53. See J. Noulens, *Artistes français et étrangers au Salon de 1886*, Paris, 1887, pp. 299-300.

175. The Society of French Watercolorists' works were shown at Champs-de-Mars in a *pavillon spécial* near the Palais des Beaux-Arts. See *Exposition Universelle Internationale de 1889, catalogue générale officiel*, Lille, 1889, pp. 311, 321.

176. Vibert, 1902, II, pp. 169-72. The work was sold from the Knoedler estate at Chickering Hall, New York, Apr. 14, 1893, no. 385; see *New York Tribune*, Apr. 15, 1893, p. 7.

177. Possibly the work illustrated in Vibert, 1902, I, p. 40, and last seen at Cider House Galleries; see *Apollo* (Mar. 1976), p. 11.

178. Vibert, 1902, I, pp. 228-29.

179. *Salon*, Paris, 1899, no. 1956. See Sanders, 1991, pp. 156-57.

180. See Delteil, *H. de Toulouse-Lautrec*, XI, pt. 2, 1920, under no. 358.

181. See *Catalogue général officiel, Exposition Universelle de 1900*, Paris, 1900, pp. 126-27, nos. 1869-80. Also listed in *Catalogue officiel illustré de l'Exposition Décennale des beaux-arts, 1889-1900*, Paris, 1900, p. 264.

182. In the documentation of the Musée d'Orsay, Paris.

183. Morton, 1902, p. 325.

184. First in the collection of Governor Latham of California and then W. H. Vanderbilt. See Strahan, *Treasures*, III, 1880, p. 111, ill. p. 109; Vibert, 1902, II, pp. 176-78.

185. See *Peintures françaises du Museum of Art de la Nouvelle Orléans*, exh. cat., Musée des Beaux Arts, Orléans, 1984, p. 51, no. 17. Fontainebleau also provided the setting of Vibert's *Coronation of the King of Rome* (no. 58), and *The Eagle and the Fox* (fig. 45), *The Red Portfolio*, and *The Astronomer*, all at The Haggin Museum. See Sanders, 1991, pp. 154, 156.

186. Vibert, 1902, I, p. 160.

187. Ibid., pp. 170-72.

188. Ibid., p. 154.

189. Morton, 1902, p. 325.

190. On Fabre and his writing, see Edmund Gosse, *French Profiles*, New York, 1905, pp. 153-75; Algar Thorold, *Six Masters in Disillusion*, London, 1909, pp. 68-79; and Ray Preston Bowen, *The Novels of Ferdinand Fabre*, Boston, 1918.

191. James, 1958, p. 153.

192. *The Art Journal* (1875), p. 89, reported, "of all the pictures, finished or unfinished, which now adorn [Vibert's] *atelier*, there is not one that has not been bespoken, or that has not already been purchased for the United States." J. B. F. W., 1878, gives a thorough list of works by Vibert then with American collectors and dealers.

193. Norton, 1984, p. 25.

194. S. N. Behrman, *Duveen*, Boston and Toronto, 1972, pp. 145-46.

195. Lucas, *Diary*, 1979, II, pp. 407-8, 412, 487, 491.

196. Goncourt, 1956, XI, p. 9. Vibert also promoted prints after his compositions, as J. B. F. W., 1878, p. 185, reports a series of ten etchings published that year by the artist in Paris.

197. Vibert, 1895-96, p. 941.

198. Veron, 1876, p. 260.

199. I am grateful to Robert Kashey for the explanation of this process. He has noted it in works attributed to Detaille, Meissonier, Grützner, and others, where an assistant usually did the actual painting. In the case of Vibert, whose pictures, "when not at his best . . . are decidedly flat and hard" (Morton, 1902, p. 323), this could account for the occasional poorer quality of some works.

200. In the sale of "Objets d'art et curiosités," from Vibert's home held at Hôtel Drouot, Paris, Dec. 1-2, 1902, nos. 460-501 are photographic apparatuses.

201. González and Martí, 1989, p. 250.

202. Ibid.

203. Mantz, "Salon de 1867," *GBA* (June 1867), p. 532.

204. J. Grangedor, "Salon de 1868," *GBA* (July 1868), pp. 19-20. See also Sheldon, 1882, p. 117; Blanc, 1878, p. 328; and Strahan, *Vanderbilt*, 1883, IV, p. 65.

205. *GBA* (Sept. 1868), opp. p. 268.

206. See *Fortuny*, 1989, p. 41, and William R. Johnston, "W. H. Stewart, the American Patron of Mariano Fortuny," *GBA* (Mar. 1971), pp. 183-88.

207. Formerly in the National Museum of American Art, Washington, D.C.; see Atlanta, 1983, pp. 172-73, no. 70, and González and Martí, 1989, p. 250.

208. Quoted in Clement and Hutton, 1879, II, p. 369.

209. In addition to *The Entrance of the Toreros* (fig. 41), there was one titled *Les deux ennemis*, sold, Hôtel Drouot, Paris, Apr. 21-28, 1887, no. 75, described as having the figure painted by Zamacoïs and a parrot by Vibert.

210. Zamacoïs, 1948, p. 29.

211. Sheldon, 1882, p. 118, and Vibert, 1902, II, pp. 29-30.

212. The works are linked by Mantz in his Salon review, *GBA* (July 1869), p. 10; Théophile Gautier, *Tableaux à la plume*, Paris, 1880, p. 314; *Merveilles de . . . Salon de 1869*, pp. 280-81; and Paul Casimir Perier, *Propos d'art à l'occasion du Salon de 1869*, Paris, 1869, p. 208. For Zamacoïs's painting, see Strahan, *Treasures*, II, 1880, pp. 33-34; last sold, Christie's, New York, Oct. 25, 1989, no. 181.

213. T. Duret, *Critique d'avant-garde*, Paris, 1883, pp. 17-18. The success of Zamacoïs's painting was also noted by Castagnary, 1892, I, pp. 422-23. Henri Delaborde, "Salon de 1870," *Revue des deux mondes, 1864-74*, p. 707, praised their wit.

214. Sheldon, 1882, p. 118. The work was also praised by René Ménard, "Salon de 1870," *GBA* (July 1870), pp. 49-50; last sold, Christie's, New York, May 24, 1989, no. 143.

215. Sheldon, 1882, p. 115.

216. See Fortuny, 1989, p. 219. no. 139.

217. In *Catalogue De Luxe of the Modern Masterpieces of the W. H. Stewart Collection*, American Art Association, New York, 1898, n.p.

218. Sheldon, 1892, p. 115, says the cause of death was "pulmonary consumption"; the Stewart catalogue said "angina pectoris." A chill caught at the reception ceremony of Amadéo I led to a gangrenous condition, according to González and Martí, 1989, p. 251.

219. Blanc, 1878, p. 328.

220. Zamacoïs, 1948, p. 29.

221. The Stewart collection sale of Feb. 3-4, 1898, included Zamacoïs's *Checkmated*, no. 101.

222. *The New York Times*, July 5, 1876, p. 6.

223. James, 1872, p. 246.

224. Orginally published in 1920. In Scribner's 1970 classic paperback this quote occurs on p. 281.

225. See Lilian B. Miller, *Patrons and Patriotism*, Chicago, 1966, and Constable, 1964.

226. A. Saule, "Genre Pictures," *The Aldine*, IX, no. 1 (1878), p. 22.

227. Strahan, *Treasures*, I, 1879, pp. v-vi.

228. John Oldcastle, "An American Millionaire's Gallery," *The Art Journal* (1887), p. 153.

229. "The Progress of Painting in America," *The North American Review*, CXXIV (May 1877), p. 459.

230. Paul Mantz, "Correspondence," *The Crayon*, II, no. 23 (Dec. 5, 1855), p. 358.

231. See *The Crayon* (Apr. 25, 1855), p. 261; (Sept. 26, 1855), p. 198; (Oct. 10, 1855), p. 234; (Oct. 1857), pp. 311-12.

232. "Artist Biography," *The Crayon*, VII, pt. 6 (June 1860), p. 167.

233. Belmont's *Chess Game* was exhibited in 1858. See *The Crayon*, V (Jan. 1858), p. 23, and (Feb. 1858), p. 59. A full description of the work was given in Fuller-Walker, "Our Fine Art Collectors: The Belmont Gallery," *The Aldine*, IX, no. 8 (1879), p. 259. Seen and admired by Durand-Gréville, 1887, p. 75; Strahan, *Treasures*, I, 1879, pp. 107-8, 118; Cook, 1888, I, p. 68, ill.; see also Fink, 1978, pp. 92, 94; and Eugene Benson, "Galleries of Belmont and Blodgett," *Putnam's Magazine*, V (May 1870), pp. 534-37.

234. "Our Private Collections," *The Crayon*, III, pt. 1 (Jan. 1856), p. 27.

235. Strahan, *Treasures*, I, 1879, p. 53, and Fink, 1978, p. 94.

236. James Jackson Jarves, *The Art-Idea*, ed., Benjamin Rowland, Jr., Cambridge, Mass., 1960, p. 146.

237. On the earliest dealers in New York, see Fink, 1978, pp. 87-89.

238. On the famous Johnston collection sale, Dec. 19-22, 1876, after an exhibition at the National Academy of Design, see Alan Nevins and M. H. Thomas, eds., *The Diary of George Templeton Strong: Post War Years, 1865-1875*, New York, 1952, IV, p. 417; Eugene Benson, "Gallery of John Taylor Johnston," *Putnam's Magazine*, VI (July 1870), pp. 81-87; "The Sale of the Johnston Gallery," *The Aldine*, VIII, no. 10 (1877), p. 312; Tomkins, 1970, pp. 34-35; and Madeleine Fidell-Beaufort and Jeanne K. Welcher, "Some Views of Art Buying in New York in the 1870s and 1880s," *Oxford Art Journal*, V, no. 1 (1982), pp. 48-50.

239. On A. T. Stewart and his home, see Oldcastle, 1887, pp. 153-56, and Walter Rowlands, "Art Sales in America," *Art Journal* (1887), p. 294. Jay E. Canter, "A Monument of Trade: A. T. Stewart and the Rise of the Millionaire's Mansion in New York," *Winterthur Portfolio*, X (1975), pp. 165-97, and Towner, 1970, pp. 69-80, 109-12.

240. Strahan, *Treasures*, I, 1879, pp. 24, 37, 38, 52, and Young, 1960, pp. 73-74.

241. Durand-Gréville, 1887, p. 251; Patterson, 1989, p. 96.

242. W. H. Vanderbilt died in 1883, and the collection was inherited by George W. Vanderbilt and then by Cornelius Vanderbilt. According to a note inserted in the Parke-Bernet sale catalogue of Apr. 18-19, 1945, it had been displayed at the Metropolitan Museum of Art in a special gallery from about 1902 until 1920.

243. Strahan, *Treasures*, I, 1879, p. 106.

244. See Towner, 1970, p. 122.

245. See Strahan, *Treasures*, III, 1880, pp. 124, 126.

246. See Towner, 1970, pp. 80-114.

247. Léonce Bénédite, "Les collections d'art aux Etats-Unis," *La revue de l'art*, XXIII (Mar. 1908), p. 166.

248. See Tomkins, 1970, pp. 71-72.

249. Sale, Mendelssohn Hall, New York, Jan. 8-9, 1903.

250. See "Famous Paintings Owned on the West Coast," *Overland Monthly*, XXII (1893), pp. 239-41. The painting appears in Vibert, 1902, II, p. 98, in the section titled "Amoroso."

251. See Denys Sutton, "Connoisseur's Haven," *Apollo* (Dec. 1966), pp. 2-13; Johnston, 1982, pp. 13-25.

252. Gruelle, 1895, p. 89.

253. Johnston, 1982, pp. 24, 113.

254. See *The New York Times*, Mar. 5, 1886.

255. Information on the Arnot collection is from Rachael Sadinsky, "Introduction," in Arnot, 1989.

256. See Brockwell, 1920, pp. x-xi.

257. See Washington University, St. Louis, *Charles Parsons: Collector of Paintings*, 1977.

258. A catalogue on the Clark collection by Bonnie L. Grad is forthcoming.

259. See Prescott N. Dunbar, *The New Orleans Museum of Art: The First Seventy-Five Years*, New Orleans, 1990, pp. 35-37.

260. Lenox Library, *Catalogue of the Paintings in the Robert L. Stuart Collection, The Gift of his Widow Mrs. Mary Stuart*, New York, 1894.

261. Parke-Bernet, New York, Apr. 18-19, 1945.

262. Norton, 1984, p. 142.

263. On the history of the Haggin collection and museum see Sanders, 1991, and Mary Louise Andonov, *A Catalogue of the Nineteenth Century French Paintings in The Haggin Collection . . .*, MA thesis, University of California, Riverside, June 1975.

264. Constable, 1964, pp. 81-82.

265. See Omaha, 1990.

266. See Wilkes-Barre, 1975 and 1977, and E. Willard Miller, *Pennsylvania: Keystone to Progress*, 1986, pp. 422-23.

267. Information on the Haussner collection is given on the Haussner's Restaurant menu, "Masterpieces in Art and Dining," Baltimore, 1992.

LIST OF LENDERS

The Ackland Art Museum, The University of North Carolina at Chapel Hill

Albright-Knox Art Gallery, Buffalo, New York

Arnot Art Museum, Elmira, New York

The Brooklyn Museum, New York

Mrs. Jesse Brownback

Mrs. Noah L. Butkin

Sterling and Francine Clark Art Institute, Williamstown, Massachusetts

The Cleveland Museum of Art, Ohio

The Corcoran Gallery of Art, Washington, D.C.

The Currier Gallery of Art, Manchester, New Hampshire

Dallas Museum of Art, Texas

The Detroit Institute of Arts, Michigan

Hugh V. Gittinger, Jr., Washington, D.C.

Mrs. Harry Glass

J. E. Kampe, Washington, D.C.

Dr. and Mrs. Howard R. Knoll, Anaheim, California

Malden Public Library, Malden, Massachusetts

The Metropolitan Museum of Art, New York

Museum of Fine Arts, Boston

New Orleans Museum of Art, Louisiana

The New-York Historical Society, New York

Philadelphia Museum of Art, Pennsylvania

Private collections

Mr. and Mrs. Don Purdy

Bill and Cindy Ross

Fred and Sherry Ross

The Saint Louis Art Museum, Missouri

Sandorval & Co., Inc., New York

Sordoni family collection

Taft Museum, Cincinnati

Joey and Toby Tannenbaum, Toronto

The Union League of Philadelphia, Pennsylvania

The Walters Art Gallery, Baltimore, Maryland

Washington University Gallery of Art, St. Louis, Missouri

The Mr. and Mrs. James Wenneker collection

Edward Wilson, Fund for Fine Arts, Chevy Chase, Maryland

CHARLES BARGUE
CA. 1825-1883

1. *A Footman Sleeping,* 1871
 Oil on panel, 13 3/4 x 10 1/4 in. (34.9 x 26 cm)
 Signed and dated lower right: *C. BARGVE 71*
 The Metropolitan Museum of Art, New York,
 bequest of Stephen Whitney Phoenix, 1881

Provenance: Stephen W. Phoenix, New York, 1881.

Exhibition: *Paintings and Prints . . . Knoedler, One Hundred Years,* Knoedler Gallery, New York, 1946, no. 5.

Literature: Hoeber, 1900, p. 82, ill. p. 85; Sterling and Salinger, 1966, pp. 175-76.

While recalling elements from paintings by Meissonier and Gérôme, Bargue's little gem of a panel reveals his own inventive genius within the genre of costume period pieces. The elegantly liveried footman has dozed off awaiting the return of his master or a guest. Shockingly, one of his white gloves has fallen to the floor. Perhaps the household keeps irregular hours, as suggested by the unsightly clutter of books on the chair. Its wealth, however, is made clear not only in the footman's finery but also in the crested Renaissance bench and Rubensian detail of the tapestry behind him.

2. *The Artist and His Model*, 1878
Oil on panel, 10 3/4 x 7 3/4 in. (27.3 x 19.7 cm)
Signed and dated lower right: *BARGVE 78*
Mrs. Noah L. Butkin

Provenance: Goupil and Co., Paris and New York; William
H. Vanderbilt, New York; George W. Vanderbilt; Brigadier
General Cornelius Vanderbilt; Mrs. Cornelius Vanderbilt;
sale, Parke-Bernet, New York, Apr. 18-19, 1945, no. 39;
Robert Lehman, New York; Herbert Roman, Inc., New York,
1979; Shepherd Gallery, New York.

Exhibition: On loan to the Metropolitan Museum of Art,
New York, 1902-20.

Literature: Strahan, *Treasures*, III, 1880, p. 108; *Vanderbilt*,
1882, p. 44, no. 113; Strahan, *Vanderbilt*, 1883, p. 12;
Vanderbilt, 1884, p. 32, no. 55; Stranahan, 1897, p. 321;
Apollo (Jan. 1979), p. 57 (adv.); Avery, *Diaries*, 1979, p. lx;
Patterson, 1989, p. 105.

The subject of the artist at his easel, with or without
a model, was one Bargue treated a number of times in
both drawings (fig. 34) and paintings.[1] Meissonier had
popularized the theme in similarly scaled panels (see
no. 18) but never with the voluptuous richness of
Bargue. The presence of the semiclad model looking at
the drawing, presumably of herself, adds a piquant
touch that would have shocked the older master. But
he certainly would have applauded the mastery of
detail. The plumed cockatoo and the parrot further
contribute to the slightly decadent atmosphere.[2] The
studio is filled with all the accouterments of a
successful artist—rich draperies, paintings in the
manner of Anthony van Dyck and Jacob van Ruisdael,
and a French Renaissance-style cabinet, on top of

which are a majolica vase and a plaster cast of Cupid,
usually attributed to Pierre Puget.[3]

The painter himself is clearly intended by his dress
and the decidedly Boucher-like oval composition of the
allegorical nude on his easel to be of the eighteenth
century. Certainly, his back view, with elegantly coiffed
hair and a wonderful expanse of apricot-colored silk
frock coat, is the highlight of the painting. Both this
element and the cockatoo reappear in Bargue's
masterpiece of 1883—*Playing Chess on the Terrace* (see
no. 3).

1. Another much sketchier version of the subject with the figures facing
in the opposite direction is in the National Museum of Wales, Cardiff.
See John Ingamells, *The Davis Collection of French Art*, National
Museum of Wales, Cardiff, 1967, p. 25. It, two related oil studies, and
a drawing were all owned by Alexander Young and sold in his sale at
Christie's, London, July 1, 1910, nos. 137, 138, 139, 252. Preparatory
drawings for the Cardiff painting include one exhibited in *The Non-
Dissenters*, Shepherd Gallery, New York, 1968, no. 169, and 1975, no.
4, now in the Butkin collection, Cleveland (fig. 34). Another
reproduced in Graham Reynolds, *Nineteenth-Century Drawings, 1850-
1900*, London, 1949, no. 24, is now in the Fitzwilliam Museum,
Cambridge. Bargue's oil studies of the painter working alone at his
easel include one sold at Christie's, New York, May 25, 1984, no. 76,
now in a private collection, and another exhibited at Shepherd Gallery,
New York, 1979, no. 2, now also in the Butkin collection.
2. Such birds, especially in artists' studios and collectors' cabinets, are a
frequent detail in nineteenth-century paintings by, among others,
Marià Fortuny and Raimundo de Madrazo, and figure often with
women, as in works by Gustave Courbet, Edouard Manet, and
Alexandre-Louis Leloir. See the examples in the Stewart sale, New
York, Feb. 3-4, 1898, nos. 26, 119.
3. This sculpture was to become one of Paul Cézanne's favorite motifs.
See Richard W. Murphy, *The World of Cézanne, 1839-1906*, New
York, 1968, pp. 132-33.

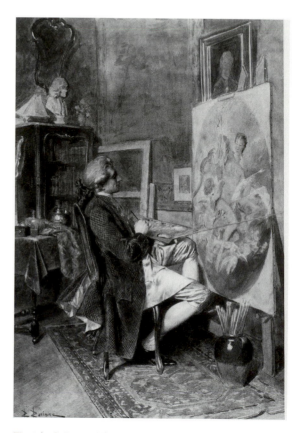

Fig. 34. *C. Bargue,* **The Artist's Studio,** *drawing,
Mrs. Noah L. Butkin.*

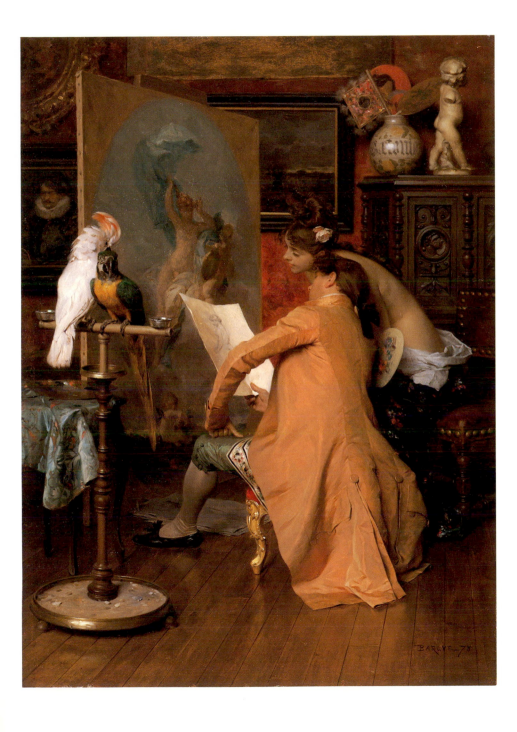

CHARLES BARGUE
CA. 1825-1883

3. *Playing Chess on the Terrace*, 1883
Oil on panel, 11 1/4 x 17 1/4 in. (28.6 x
43.8 cm)
Signed lower left: *C. BARGVE*
Sordoni family collection

Provenance: William H. Vanderbilt, New York;[1] George W.
Vanderbilt; Brigadier General Cornelius Vanderbilt; Mrs.
Cornelius Vanderbilt; sale, Parke-Bernet, New York, Apr. 18-
19, 1945, no. 133.

Exhibitions: On loan to the Metropolitan Museum of Art,
New York, 1902-20; *Charles Bargue*, Fearon Gallery, New
York, 1926.

Literature: Strahan, *Vanderbilt*, 1883, p. 12; *Vanderbilt*,
1884, p. 18, no. 26; Stranahan, 1897, p. 321; *The [New York]
Sun*, Dec. 5, 1915, ill.; *New York Post*, Mar. 6, 1926.

Once again Bargue takes an idea or theme, namely
the chess game in period dress, from Meissonier but
treats it in a novel way—moving it outdoors. He
produces an original composition with the serpentine
balustrade of the terrace providing a horizontal
division, separating the humans and animals from the
mysterious thicket of trees. The large fallen leaves on
the ground provide an autumnal touch, which is
enhanced by the somewhat wistful, even melancholy,
air of the figures and the coolness of the light filtering
through the trees. Every action seems suspended—the
chess player's hand poised to make a move, the spaniel
anxiously watching the enraged cockatoo, and the
figure looking over the balcony. Similar elements, such
as the cockatoo and the man looking over the balcony,
are found in the works of Vibert, who possibly found
inspiration in Bargue's example. Although a more
vigorous colorist, neither Vibert nor, in fact, any other
artist of this genre could invest this type of subject with

the poignancy Bargue achieved.

This work was described in the 1884 Vanderbilt
catalogue as Bargue's "last and most important work."
Strahan rightly writes, "It is the most elaborate
composition of the artist and represents a toil almost
incredible."

1. George Lucas records buying a Bargue from Goupil on July 17,
1882, for the high price of 65,000 francs. Lucas, *Diary*, 1979, II, p.
546. In his diary Samuel P. Avery, who acted as an agent for William
H. Vanderbilt, notes on Sept. 11, 1882, "Wrote W.H.V. of buying
Bargue. Will draw 75,000." Since Mr. Vanderbilt already owned *The
Artist and His Model* (see no. 2), it is most likely, given the high
amount mentioned, that it was this terrace scene that was changing
hands. See Avery, *Diaries*, 1979, p. 710.

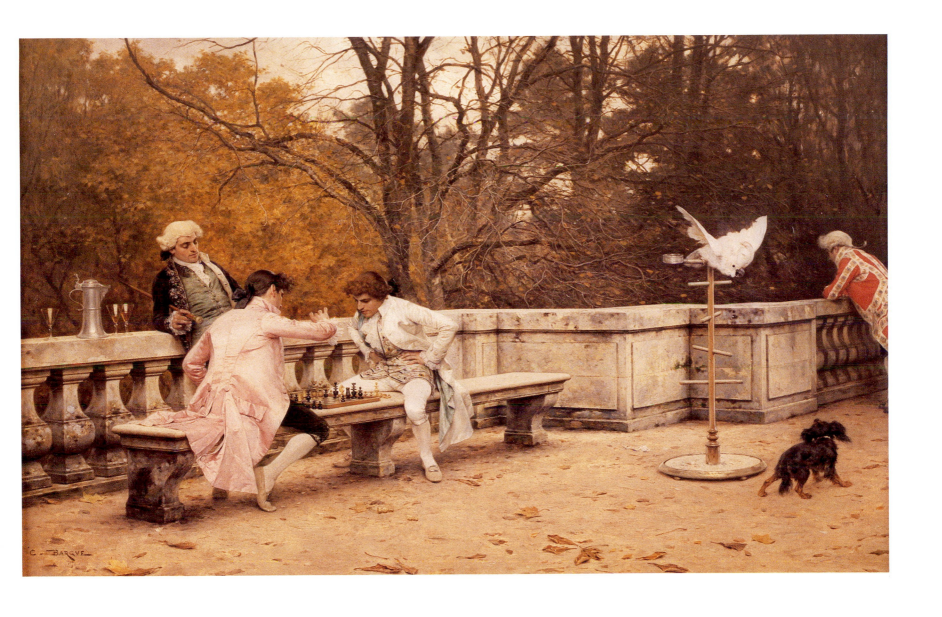

CHARLES-EDOUARD DELORT
1841-1895

4. *The Cardinal's Leisure (Richelieu and Father Joseph)*
Oil on canvas, 31 x 24 in. (78.7 x 61 cm)
Signed lower right: *C DeLort*
The Detroit Institute of Arts, gift of Mrs. Helen
L. DeRoy

Provenance: George I. Seney, New York; sale, American Art
Galleries, New York, Mar. 31-Apr. 2, 1885, no. 87; Mrs. Helen
L. DeRoy, Detroit.

Exhibition: Detroit, 1979, no. 19.

Literature: Strahan, *Treasures*, III, 1880, p. 126; Bénézit, 1976,
III, p. 476.

Delort was born in Nîmes. After first pursuing a
military career, he followed the advice of Gérôme, a
family friend, and entered the studio of Gabriel-Charles
Gleyre in 1859. He also studied the old masters,
particularly those of eighteenth-century France. In 1862
Delort accompanied Gérôme to Egypt, and the exotic
sites he viewed there were to become a mainstay of both
his oils and watercolors. He often returned to the Near
East, especially to Algeria, where he died.

Following his return from Egypt, Delort entered the
Ecole des Beaux-Arts in 1864, where his teachers were
both Gleyre and Gérôme. That same year he had his
first work exhibited at the Salon. In addition to his
Eastern subjects, sometimes of an erotic nature,[1] Delort
was primarily a painter and illustrator of historical genre
scenes, especially those set in seventeenth- and
eighteenth-century France. He won a medal for *The
Embarkation of Manon Lescaut.* A dedicated and
productive artist, he learned to paint with his left hand
after suffering paralysis of his right.

Delort's historical genre scenes often involve clerical
figures,[2] as is the case with this work now titled *The*

Cardinal's Leisure but more accurately called *Richelieu
and Father Joseph* at the time of its sale in 1885. The
scene shows Richelieu, the prime minister for Louis
XIII, planning a naval campaign with his adviser, the
famous *éminence grise*, Father Joseph. A mother cat
and her kittens have temporarily distracted the
cardinal, who pushes back his imposing chair to
observe their cavorting on a plan of a fortified city
under naval siege.

It has been suggested that this work, like Gérôme's
Eminence grise (see no. 9) was inspired by Edward
Bulwer-Lytton's drama *Richelieu*,[3] but no such scene
exists in the play. Delort, in fact, may have been
inspired to do a variation on his teacher's famous
composition. The inclusion of the large tapestry with
the cardinal's coat of arms is certainly a visual allusion
to it. Delort, however, seems purposely to create a
different type of figure for Père Joseph. Instead of the
smooth shaven, slightly sanctimonious character seen
in Gérôme's painting, we have here a full-bearded,
serious friar who does not allow even the delightful
tableau of kittens at play to interrupt his concentration.

1. See for example *A Voluptuous Smoke* of 1867, sold at Sotheby's,
London, Mar. 25, 1981, no. 82.
2. A tantalizing entry in Lucas, *Diary*, 1979, II, p. 549, records the
delivery of "a Cardinal picture" by Delort. In Avery, *Diaries*, 1979,
pp. 250, 531, 559, works by Delort include an "Innkeeper and
Cardinals," a "Cardinal looking out of window," "Cardinal entering
doors," and "Priests arriving at courtyard of Inn."
3. Both in the Seney sale catalogue and in Detroit, 1979.

JEAN-BAPTISTE-EDOUARD DETAILLE
1841-1912

5. *Napoléon I and His Staff, 1813*, 1900
Watercolor, 19 1/2 x 27 3/4 in. (49.5 x 70.5 cm)
Signed and dated lower right: *EDOUARD
DETAILLE / 1900*
New Orleans Museum of Art, gift of Mr. and
Mrs. Chapman H. Hyams

Provenance: Mr. and Mrs. Chapman H. Hyams, New
Orleans.

Exhibition: Lexington, 1973, no. 29.

Literature: *Hyams*, 1964, no. 35.

Detaille concentrated mainly on contemporary
military events and, with the exception of *Napoléon in
Egypt* shown at the Salon of 1878,[1] seems to have done
very little Napoleonic imagery before the early 1890s[2]
when a great number appear.[3] It may be that following
Meissonier's death in 1891, Detaille felt free to tackle
one of his mentor's chief subjects, or perhaps he simply
inherited the demand for such works. In this example,
by indicating the date in the title, Detaille sought to
antedate what is probably the most famous Napoleonic
image by Meissonier, *1814, The Campaign of France*
(see fig. 39), the composition of which he is clearly
emulating. As in Meissonier's oil painting, the
emperor, on a noble white horse, precedes his marshals.
Instead of being shown on flat, snow-covered ground,
they emerge from a wood. The mood is more jubilant
than in Meissonier's *1814*, for the campaign of 1813
waged in Germany was, at least at the beginning, quite
successful. Detaille, in depicting the emperor, follows
the prototype of the Walters version (see no. 20)
showing him with his coat open and hands at his sides.
Meissonier, in his large *1814*, went to great lengths to
individualize each officer, noting for example that first

behind Napoléon came Marshal Ney, clearly indicated,
since he never put his arms through the sleeves of his
coat.[4] The figure in the analogous position in
Detaille's watercolor does not do this and seems a
much younger man, although the marshal directly
behind him does look a bit like General Comte de
Flahaut, Napoléon's orderly, the third to the left in
Meissonier's painting.

This watercolor reuses motifs that Detaille had also
employed for a large oil of 1894, *La victoire est à nous!
(Victory is Ours!)*, which depicts Napoléon at the head
of his officers riding through the ranks of the soldiers
on the eve of the Battle of Jena, October 14, 1806.[5] In
the watercolor, with its animating touches of gouache,
Detaille, although working already in the twentieth
century, is able to summon up a lively vision of France's
glory in the early nineteenth.

1. This work was sold from the Dreyfus collection at Galerie Georges
Petit, Paris, May 29, 1889, no. 26, and probably again from the La
Bigne collection, Galerie Georges Petit, Paris, June 2-7, 1902.
2. A watercolor of Napoléon I and his generals at the Battle of
Austerlitz dated 1873 is listed in the *Catalogue of the Paintings in the
Robert L. Stuart Collection at the Lenox Library*, New York, 1894,
no. 61.
3. A number of Napoleonic images by Detaille were in the La Bigne
collection sale, nos. 12, 17, 45. *Bonaparte at Fréjus*, a watercolor of
1894, was sold at the same location on Mar. 3, 1919, no. 53. Of
larger paintings, *Vive l'empereur (Long Live the Emperor)* of 1891 is in
the Art Gallery of New South Wales, Sydney, and *La revue de 1812
(The Review of 1812)* of 1910 is in the Musée de l'Armée, Paris. See
Humbert, 1979, pls. 26, 27.
4. See Gréard, 1897, pp. 255-56.
5. Humbert, 1979, pl. 29. A study in pen, ink, watercolor, pencil, and
gouache of Napoléon riding in a similar manner but at an earlier
moment in his career was executed by Detaille in 1891. See
Nineteenth-Century French Drawings, Hazlitt, Gooden, and Fox, New
York and London, 1991, no. 20.

BENJAMIN-EUGENE FICHEL
1826-1895

6. *Studio of a Painter*, 1869
 Oil on panel, 8 3/4 x 6 1/8 in. (22.2 x 15.6 cm)
 Signed and dated lower left: *E. FICHEL / 1869*
 The Brooklyn Museum, bequest of the estate of
 William H. Herriman

Entering the Ecole des Beaux-Arts in 1841, Fichel
was a student of both Paul Delaroche and Martin
Drolling. These masters' taste for large-scale narrative
works found expression in the young artist's vast early
work *The Discovery of the Circulation of Blood* that was
placed in the Ecole de Médecine. Although he painted
many insightful portraits, Fichel achieved his greatest
renown as a painter of intimate genre scenes in the
Dutch manner. As one Salon critic aptly observed,
there were many "victims" of Meissonier,[1] but of these
another critic found Fichel was the one "who by his
delicate and fine touch and the irreproachable
correctness of his line came the closest to Meissonier."[2]
Although, in fact, his touch was not as minute as
Meissonier's, his more broadly conceived
representations of artists, cardplayers, diners, and
elegant toilettes have a vivacity and a liveliness of
character often lacking in the work of the older painter.
Fichel first exhibited at the Salon in 1849 and
continued to show his works until late into the century,
achieving what was described as "an envied place
among the genre painters of the French school of the
nineteenth century."[3] He was made a Knight of the
Legion of Honor in 1870 and lived in great splendor at
23 rue de la Chaussée-d'Antin surrounded by the many
period props that he employed for his paintings.[4]
 Scenes set in the studio of an eighteenth-century
painter were a frequent subject for Fichel.[5] He paid
particular attention to the subject the artist was
depicting and usually included, as here, another figure
observing the creative activity. In this case a portrait of

a military gentleman is in preparation. By presenting
the painter and the observer from the back, Fichel
establishes a mood of intense concentration, and one
has the sense of having gained private entry to the
closed, self-contained world of an earlier era. This
mood is enhanced by Fichel's usual care for the
setting—antique chairs, elaborate wood paneling,
doors with paintings above, and the tapestry of a
secular subject that he used as a backdrop on at least
one other occasion.[6]

1. *Causeries à deux sur le Salon de 1857*, Paris, 1857, p. 165.
2. Gueullette, 1863, p. 23. Ferdinand de Lasteyrie, *La peinture à l'Exposition Universelle*, Paris, 1863, p. 150, also found in Fichel "one of Meissonier's most distinguished imitators."
3. In *Exposition de tableaux des petits maîtres de l'Ecole de 1830*, exh. cat., Galerie Georges Petit, Paris, 1913.
4. See Veron, 1876, pp. 183, 189.
5. See examples sold at Christie's, New York, May 28, 1982, no. 136, and Oct. 25, 1984, no. 28; *Amateurs chez un peintre (Collectors Visiting a Painter)* is at the Museum of Grenoble.
6. In *Chess Game in the Palace* of 1871 sold at the Dorotheum, Vienna, Sept. 18-21, 1979, no. 40.

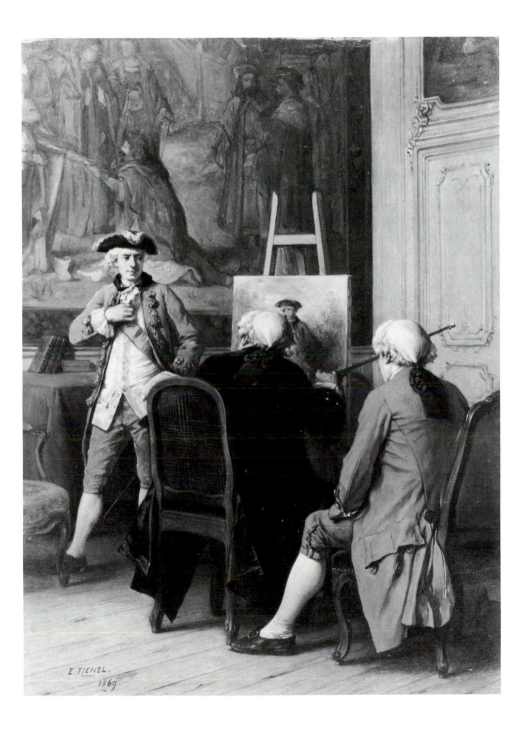

JEAN-LÉON GÉROME
1824-1904

7. *Louis XIV and Molière*, 1862
Oil on panel, 18 x 31 in. (42 x 75 cm)
Signed upper left: *J. L. GEROME*
Malden Public Library, Malden, Mass.

Provenance: Goupil and Co., Paris; Edward Matthews, Paris, 1867; Gambart, London, 1868; Khalil-Bey, Paris; sale, Hôtel Drouot, Paris, Jan. 16-18, 1868, no. 32; James H. Stebbins, New York, 1868-89; sale, American Art Galleries at Chickering Hall, New York, Feb. 12, 1899, no. 68; Collis P. Huntington, New York; P. A. Valentine, New York, 1923; William Randolph Hearst, 1923-39; sale, Parke-Bernet, New York, Jan. 5, 1939, no. 14; J. Schmittzer and Sons, New York, 1940; Vose Galleries, Boston, 1940; sold to the Malden Public Library, Dec. 14, 1940.

Exhibitions: *Salon*, Paris, 1863, no. 769; *Exposition Universelle*, Paris, 1867, no. 294; *Loan Exhibition*, Society of Decorative Arts, National Academy of Arts, New York, 1878; Dayton, 1972-73, no. 13.

Literature: Théophile Gautier in *Moniteur universel*, June 11, 1863; Paul Mantz, "Salon de 1863," *GBA*, XIV (1863), pp. 494-95; Gueullette, 1863, pp. 24-25; C. de Sault, *Essais de critique d'art, Salon de 1863*, Paris, 1864, pp. 63-64; Chesneau, 1864, pp. 166-67, 227; Arthur Stevens, *Le Salon de 1863*, Paris, 1866, pp. 11-12, 53-55; Théophile Gautier, "Collection de S. Exc. Khalil-Bey" in *Collection des tableaux . . . de Khalil-Bey*, Paris, 1867, pp. 17-18; Mantz, 1867, p. 325; Strahan, *Treasures*, I, 1879, p. 99; Montrosier, 1881, I, p. 18; Strahan, *Gérôme*, 1881; Durand-Gréville, 1887, p. 73; *The Studio* (Nov. 1888), p. 192; Hering, 1892, p. 106; Charles F. Horne, *Great Men and Famous Women*, II, 1894, ill. opp. p. 198; Van Dyke, 1896, p. 36; Stranahan, 1897, pp. 318-19; Keim, 1912, p. 62; *Twenty Paintings: Malden Public Library*, Malden, Mass., 1949; Robert Rosenblum, "Ingres Inc.," in *The Academy: Art News Annual*, XXXIII (1967), pp. 70-71; Towner, 1970, p. 122; Meyer, 1973, p. 32; Philadelphia, 1978, p. 321; Vesoul, 1981, ill. p. 19; Ackerman, 1986, pp. 67-68, 72, 212-13, 338, no. 138; Mainardi, 1987, p. 169; Weinberg, 1991, pp. 84-85, pl. 86.

The subject is derived from an anecdote told in the *Mémoires* of Mme de Campan, which were published in 1822. She relates that King Louis XIV, to honor the young Molière and to admonish the snobbishness of his courtiers, invited the dramatist to join him alone at his table one morning for his *petit levé* (breakfast). He then summoned his courtiers, and as the Salon *livret* describes the scene: "Alors le roi, se tournant vers les familiers de sa cour: 'Vous me voyez, leur dit-il, occupé de faire manger Molière, que mes officiers ne trouvent pas d'assez bonne compagnie pour eux!'" (You see me, Messieurs, eating with Molière, whom my footmen do not consider good enough company for themselves!)

Painted in 1862 and exhibited at the Salon the following year, this work marked a departure for Gérôme, as he turned from the Neo-Grec, Eastern, and ancient scenes that had so far made his reputation to those of French history. Indeed, as Gautier observed in 1867, the scene is treated with the severity and style of a history painting but in reduced dimensions. Ackerman has suggested that both the artist's training with Delaroche, a painter of anecdotal historical incidents, and the encouragement of his friend Meissonier, who specialized in the cavalier genre, may have led to this departure.[1]

The subject had been established as one suitable for painters by Jean-Auguste-Dominique Ingres.[2] This master, whom Gérôme revered and whose works inspired some of Gérôme's, had executed his first version of it in 1857 and gave it to the Théâtre Français, where Gérôme probably saw it when installing his portrait of the famous actress Rachel. Ingres did a second version in 1859 (fig. 35), which was sold for the substantial sum of 25,000 francs in 1861.

Also shown at the Salon of 1863 was a painting of the same subject by J.-E. Leman,[3] and critics naturally contrasted the two. De Sault, for example, preferred Leman's treatment of Louis but credited Gérôme for the better general effect. She, like Paul Mantz and Arthur Stevens, had a negative reaction to Gérôme's depiction of Molière, which they felt slighted his greatness. Mantz believed Gérôme was interesting when he painted something he had actually seen and hoped "this historical curiosity would be his last error." Stevens, who described Gérôme's talent as "cold and geometric" and his subjects as "witty anecdotes," went so far as to say how much better the work would have been if Meissonier had painted it. Chesneau also thought the subject presented insurmountable difficulties for Gérôme and declared, "The orient is better suited to his talents." At the opposite extreme was Charles Gueullette, who referred to the "three jewels" that Gérôme exhibited at the Salon and praised this work for its finish and its wealth of details, "which when viewed with a glass offer prodigies of perfection."

Comparing Gérôme's painting to that of Ingres, one notes that the younger artist reversed the placement of

Fig. 35. *J.-A.-D. Ingres,* **Louis XIV and Molière,** *private collection, photograph courtesy of Wildenstein & Co.*

the two main figures, moved the royal bed closer to the center, removed the rather awkward gates separating the king from his courtiers, and added to their number at the far left the haughty cardinal, identified by Ackerman as Mazarin but by Strahan as Archbishop de Retz, with his biretta crushed in his anxious hands.

In Gérôme's rendering the subject has both more grandeur and more bite. As Ackerman has tellingly observed, the composition "forces the reading from left to right. The line of disdain leads from the indignant Cardinal . . . past Louis' condescending gesture to the humble but honest figure of the young Molière," who, according to the Stebbins sale catalogue, sits "listening with a face full of satire and satisfaction at the humiliation of his arrogant enemies." The disconcerted courtiers, nobles, and clergy were the very targets of Molière's barbed satire, as Gautier justly observed. These bowing figures with their hats doffed will reappear in Gérôme's *L'Eminence grise* (see no. 9) and *The Reception of the Grand Condé at Versailles* (fig. 10). The brilliance of the jewel-like coloring and the highly polished surface, different from the more atmospheric effect he had generally employed, are further signs of Gérôme's debt to Ingres.

Both an oil sketch and a replica by Gérôme are known. The oil sketch (Ackerman, no. 138B) was sold at Christie's, London, June 15, 1982, no. 451, and was last at Colnaghi's, New York. The replica (Ackerman, no. 139) was sold, like the original, to Gambert of London and recently reappeared (in sales at Sotheby's, London, June 21, 1988, no. 24, and New York, Oct. 24, 1989, no. 94). It has an English provenance that enables us to establish the American line of the Malden painting from the Stebbins collection onward. The greater brightness of this version also allows us to observe a few more of the details, most notably the large painting on the wall behind the king. Louis

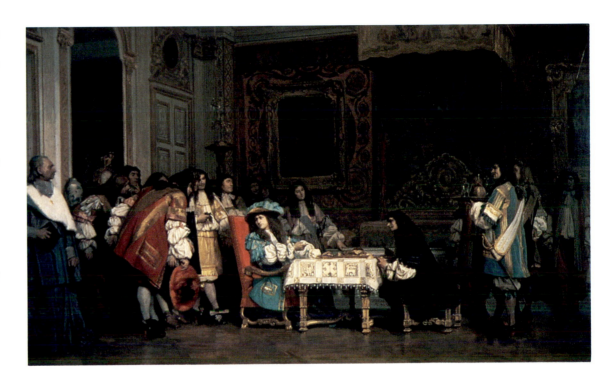

XIV's bed was actually flanked by two paintings, *King David with His Harp* by Domenichino and a youthful *Saint John the Baptist* attributed to Raphael.[4] Gérôme seems to combine the two subjects by showing a young figure holding a harp in a landscape.

The subject of Louis XIV and Molière was repeated in a painting by J.-H. Vetter shown at the Salon of 1864 and then along with Gérôme's in the Exposition Universelle of 1867.[5] The fame of Gérôme's version was such that Zola could disdainfully mention it as one of the artist's works sure to be found in reproduction in every provincial drawing room.[6]

1. Ackerman, 1986, p. 67.
2. Georges Wildenstein, *Ingres*, 1954, pp. 183, 222, 225, cat. nos. 281, 293, nos. 118, 119; Patricia Condon et al., *Ingres*, Lexington, 1983, p. 103.
3. Now in the Museum of Arras.
4. See Gérald van der Kemp, *Versailles*, New York, 1981, p. 82.
5. No. 609 in the Exposition Universelle, now in the Sénat, Paris. See Paris, 1974, no. 231.
6. In his review of the 1867 Exposition Universelle: see Zola, 1959, p. 112.

JEAN-LÉON GÉROME
1824-1904

8. *The Picador*, ca. 1866-70
Oil on canvas, 11 x 9 1/2 in. (28 x 24 cm)
Inscribed and signed lower left: *à Mr. Knoedler /
J.L. Gérôme*
Mrs. Noah L. Butkin, on extended loan to the
Snite Museum of Art, University of Notre Dame

Provenance: From the artist; to Mr. Knoedler; Earl Spring,
Fort Worth; sale, Sotheby Parke-Bernet, New York, Jan. 16,
1975, no. 86.

Literature: Ackerman, 1986, p. 222, no. 177B.

Gérôme did not visit Spain until 1872, but even
earlier he had produced several scenes of bullfighting.
The subject gave him an opportunity to depict a
modern arena with masses of people in the stands and
blood on the sand comparable to his more famous
recreations of ancient gladiatorial contests. The
impetus to paint scenes of the bullfight in the mid-
1860s probably came from the example of Manet, who
had been to Madrid in 1864 and did a series of
bullfight scenes, most notably one now at the Art
Institute of Chicago.[1]
As Ackerman has written,

Gérôme evidently saw these loosely drawn compositions in
Manet's studio, for he painted two canvases of the same scene
. . . the preliminary torturing of the bull by the picador. In
his versions, Gérôme used all the precision and accuracy of
the Academic Realist style, as if to show Manet what he
should have done by correcting his "errors" in perspective and
foreshortening.[2]

This oil sketch was probably preparatory for one of
the now lost paintings of the same subject.[3] If inspired
by Manet's *Bullfight*, it nevertheless manages to capture
an unusual slice of reality in Gérôme's typical manner.

The bull is not present, but its furious power is evident
in the felled horse and the picador who painfully makes
his way toward the exit gate. Another picador defiantly
stands his ground, seeming to await a renewed attack.
This sculptural group of horse and rider recalls the
forceful images of Napoléon on his horse that Gérôme
was painting about the same time. The prostrate horse
is a motif that also occurs in one of Gérôme's most
moving desert pictures, *The Arab and His Steed* of
1872.[4] The bloody goring of horses was one of the
aspects of the bullfight that Théophile Gautier
described in detail in his reminiscences of Spain, which
Gérôme undoubtedly would have known.[5]
For Gérôme's admirer Strahan the now lost large
version was a great success:

Certainly, to our taste, this quiet and sombre corner of the
arena that Gérôme gives is more effective than those
melodramatic and ambitious canvases of certain French and
German painters, filled with rearing and plunging beasts, and
tumbled corpses, and all the fury of the combat.[6]

However, for another American critic writing in 1872
when the lost work was in the Gibson collection in
Philadelphia, it was not so pleasing, but rather

one of his cynical and cruel pictures—one of his most
depressing examples of "showing-up" some distant country
where we hoped there was some romance left and proving by
a piece of literal transcription how vile and mean is the
actuality. It is a Spanish arena with excruciating, almost
perpendicular seats, a prosaic audience, a villainous picador
without a shade of gallantry, an ugly gray horse lame in the
near foreleg . . . a sorrel lies dead on the sand decorated with
obscure reddish blots. This [is a] revolting portrayal of the
ugliness and prose of the bull fight.[7]

1. See Gerald Ackerman, "Gérôme and Manet," *GBA*, LXX (1961),
pp. 171-72; also Ackerman, 1986, nos. 178-79, 338.
2. In the sale catalogue entry for *L'Entrée du taureau (Entry of the Bull)*
sold at Christie's, London, Nov. 24, 1989, p. 162, no. 130.
3. Shown in the Salon of 1870 and last recorded in the T. R. Butler
sale, Mendelssohn Hall, New York, Jan. 7, 1910. See Ackerman,
1986, p. 222, no. 177, ill.
4. Ackerman, 1986, no. 220.
5. See Gautier, 1853, pp. 66-68. He observes, "of all animals there are
certainly none whose dead bodies are so melancholy to look at as that
of a horse."
6. Strahan, *Gérôme*, 1881, n.p.
7. E. S., "Mr. Henry C. Gibson's Gallery," *Private Art Collections of
Philadelphia*, May 1872, p. 575.

à mͨ Knoedler
J. L. Gérôme

JEAN-LÉON GÉROME
1824-1904

9. *L'Eminence grise (The Gray Eminence)*, 1873
Oil on canvas, 27 x 39 3/4 in. (68.5 x 101 cm)
Signed lower right: *J.L. GEROME*
Museum of Fine Arts, Boston, bequest of Susan
Cornelia Warren

Shown only in Cincinnati and Washington, D.C.

Provenance: Goupil and Co., Paris, 1873; sold to James H.
Stebbins, New York, 1873-89; sale, American Art Galleries at
Chickering Hall, New York, Feb. 12, 1889, no. 76; H. B.
Mason, Boston; Mrs. Samuel Dennis Warren, Boston; sale,
Associated American Artists, New York, Jan. 8-9, 1903, no.
55; purchased by Avery for the Museum of Fine Arts.[1]

Exhibitions: *Salon*, Paris, 1874, no. 798; *Exposition
Universelle*, Paris, 1878, no. 357; *World's Columbian
Exhibition*, Chicago, 1893, no. 2924; *Painters of the French
School*, Guildhall, London, 1898, no. 38; *Loan Exhibition*, St.
Botolph Club, Boston, Jan. 1901, no. 13; *Paintings in the
Collection of the Late Mrs. S. D. Warren*, Museum of Fine Arts,
Boston, 1902, no. 54; *Literature and Poetry in Painting since
1850*, Wadsworth Atheneum, Hartford, Conn., 1933, no. 29;
French Painting, Carnegie Institute, Pittsburgh, 1936, no. 24;
Fiftieth-Anniversary Exhibition, Portland Art Museum,
Portland, Oreg., 1942-43, no. 28; Detroit, 1954, no. 25;
Clothes Make the Man, Denver Art Museum, 1956; *Artists of
the Paris Salon*, Cummer Art Gallery, Jacksonville, Fla., 1964,
no. 19; *Triumph of Realism*, Brooklyn Museum, 1967-68, no.
8; Dayton, 1972-73, no. 25; *From Neoclassicism to
Impressionism: French Paintings from the Museum of Fine Arts,
Boston*, Municipal Art Museum, Kyoto; Hokkaido Museum
of Modern Art, Sapporo; and Sogo Museum of Art,
Yokohama, 1989, no. 47; *French and American Impressionism:
Crosscurrents*, Museum of Fine Arts, Boston, 1992.

Literature: Gonse, 1874, pp. 34-36; *Figaro*, May 6, 1874;
Ernest Duvergier de Hauranne, "Le Salon de 1874," *Revue des
deux mondes*, June 1, 1874, pp. 672-73; *Journal des débats*,
June 7, 1874; Paturot, 1874, pp. 28, 198-99; "Among the
Studios of Paris," *Art Journal*, 1875, p. 89; Claretie, 1876, pp.

210-11; S. G. W. Benjamin, *Contemporary Art in Europe*,
1877, ill. p. 98; "Contemporary Art in France," *Harper's New
Monthly Magazine* (Mar. 1877), ill. p. 483; Blanc, 1878, pp.
235-36, 328; M. Beigerat, *Les chefs d'oeuvre d'art à
l'Exposition Universelle*, Paris, 1878, p. 94; Zola, 1959, p. 207;
Strahan, *Treasures*, I, 1879, pp. 99-100; Mantz, 1879, p. 48;
Clement and Hutton, I, 1879, p. 290; *Magazine of Art*, III
(1879-80), p. 458, ill. p. 456; Montrosier, 1881, I, p. 18, ill.;
Strahan, *Gérôme*, 1881, pp. 195-96, ill. p. 194; *Art Amateur*,
V, no. 2. (July 1881), p. 30; Claretie, 1884, II, pp. 75-76;
Durand-Gréville, 1887, p. 73; *The Studio* (Nov. 1888), p.
192; *Art Amateur*, XX, no. 2 (Jan. 1889), no. 26; *The
Collector*, no. 18 (Sept. 1, 1890), p. 150; Hering, 1892, p.
216, ill. opp. p. 144; Van Dyck, 1896, p. 36; Stranahan,
1897, p. 316; Brownell, 1901, p. 101; *Museum of Fine Arts
Bulletin*, Mar. 1903, p. 4; *Magazine of Art*, II (1904), p. 208;
Emporium, XIX (1904), p. 165; Moreau-Vauthier, 1906, p.
149; Keim, 1912, p. 62; R. H. Ives Gammell, *Twilight of
Painting*, New York, 1946, pl. 11; Ackerman, 1967, pp. 102-
3; Boime, 1971, p. 3; Meyer, 1973, p. 32; Murphy, 1979, pp.
xl, xlvi; Rosenblum, 1984, pp. 355-56, pl. 56; Ackerman,
1986, pp. 86, 96, 234-35, no. 233; Theodore Stebbins and
Peter Sutton, *Masterpiece Paintings from the Museum of Fine
Arts, Boston*, 1986, p. 68, ill.

Fig. 36. *J.-L. Gérôme,* **Figure in Clerical Robes on a Staircase,**
study for L'Eminence grise, *1873-74, Museum of Fine Arts,
Boston, Francis Welch Fund.*

The focus of attention in this composition and the
source of this work's title is the Capuchin friar, François
LeClerc du Trembly (1577-1638). Known as Père
Joseph or the Gray Cardinal, he was Cardinal
Richelieu's secretary and confidant and thus considered
the power behind the throne, since Richelieu in effect
ruled France when Louis XIII was a child.

It has been suggested that the source of inspiration
for the painting was Bulwer-Lytton's 1838 drama
Richelieu,[2] which was apparently produced in Paris in
the late 1860s.[3] This play may indeed have put the
historical figures in the artist's mind, but no scene in
the play is equivalent to the much more powerful
tableau Gérôme's own genius devised. The Salon guide
of May 1874 quotes only an unidentified source: "And

when the courtiers bowed to him, he seemed to be
reading his breviary and not to see them."[4] By this
time, its first public presentation, the painting, which
according to Claretie, "truly makes a profound
impression," was already famous through reproduction
in prints and photographs.[5] The work's status as one of
the painter's masterpieces was confirmed when it was
shown at the Exposition Universelle of 1878. Despite
the carping of Zola, who dismissed it as "an historical
anecdote,"[6] the work drew much attention. Blanc, for
example, stated that Zamacoïs's *Le favori du roi (The
Favorite of the King)* (see fig. 47), in which a jester
descends a staircase, inspired Gérôme's composition
and also remarked that *L'Eminence grise* was admired by
visitors from all countries, especially those who know a

little of history.[7] In her enormous 1892 monograph on the painter, Fanny Hering quotes the London *Atheneaum* as commenting, "The characterization is perfect, the figures are triumphs of design, and the picture is, as a whole, the best of Gérôme's late productions." In 1901 a reactionary writer, such as Brownell, continued to revere Gérôme's work, using it as a stick with which to castigate Manet, but by 1984 Robert Rosenblum could write:

> Here Gérôme gives us a snapshot of this baroque world of pomp and intrigue, an effect of the instantaneous and the fragmentary that beneath the historical trappings, is not alien to the vision of Manet and Degas. . . . To be sure, Gérôme's reconstruction of seventeenth-century France is painted with the precision of a jeweler, in minuscule and invisible brushstrokes that oppose the rapid, dashing facture of a Manet; but both achieve, on different levels, the illusion of an immediately seized truth about the empirical world.

As with the earlier *Louis XVI and Molière* (see no. 7), the historical subject shows the noble and clerical courtiers at their most obsequious, bowing deeply to or looking askance at the self-absorbed, barefooted gray friar, who descends the staircase reading his breviary. All eyes are fixed on the monk, isolated on the right side of the composition[8] and framed by the enormous tapestry bearing the arms of Cardinal Richelieu, from whom he derives his unspoken power. The staircase vista, used to tremendous theatrical effect by Gérôme, is his recreation of one at the Château Richelieu that was destroyed during the Revolution.[9]

Although a rather small painting, this is one on which Gérôme spent a great deal of effort. He made both preparatory drawings (fig. 36) and several oil sketches.[10] The result is a work that, like his ancient gladiatorial scene *Police Verso*, gives, as Ackerman has written, "definite pictorial form or iconography to a popular expression." Echoes of Gérôme's staircase

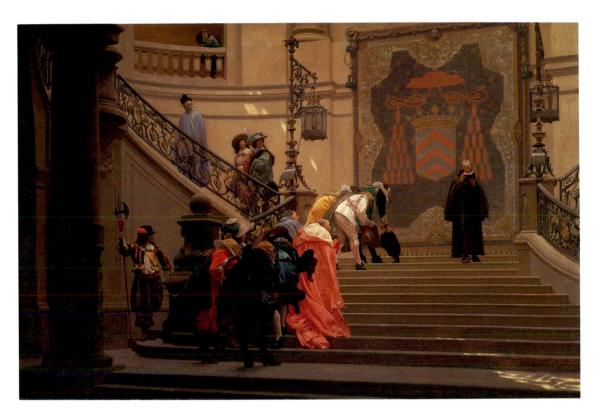

composition can be found in a wide range of later works.[11]

L'Eminence grise and *Louis XVI and Molière* (see no. 7) were once together in the Stebbins collection in New York and are now located not far from each other—the former in the Museum of Fine Arts, Boston, and the latter in the public library of the suburb of Malden.

1. Susan Cornelia (Mrs. Samuel Dennis) Warren, who owned the painting, bequeathed at her death a monetary legacy to the Museum of Fine Arts to be used to purchase pictures from the sale of her collection. Thus the painting was auctioned in New York but came back to Boston. See Martin Green, *The Mount Vernon Street Warrens*, New York, 1989, p. 164.
2. See J. Lethière, *Le théâtre anglais en France au dix-neuvième siècle*, Paris, 1924, p. 302.
3. This notion first appears in the text accompanying a photogravure of the painting, which, however, also reproduces an interior scene in the cardinal's room with Richelieu and Père Joseph that is apparently more closely based on two scenes in the play. Information from the files of the Museum of Fine Arts, Boston.

4. *Explication des ouvrages . . . exposés au Palais des Champs-Elysées, le 1er Mai 1874*, Paris, 1874, p. 115.
5. Claretie, 1876, p. 210.
6. In his review of the 1878 Exposition Universelle for *Le Messager de l'Europe*, see Zola, 1959, p. 207.
7. Blanc, 1878, p. 235.
8. Claretie, 1876, p. 211, made the telling observation that the placement of the chief figure off to the right reminded him of Delaroche's famous composition *La mort de duc de Guise (Assassination of the Duc de Guise)* (see fig. 1). Gonse, 1874, p. 36, observed that it looked like the staircase in the Comédie Française.
9. This according to Ackerman, 1986, although Blanc described it as the grand staircase of the Palais-Royale, which Horace Vernet and others had already used for its picturesque effect. A painting by Gérôme of a single musketeer of the cardinal standing at the foot of the staircase was sold at Sotheby's, New York, Feb. 11, 1981, no. 37.
10. Over fifty pencil sketches exist according to Hering, 1892, p. 216. See those reproduced in Gonse, 1874, pp. 33, 35, and Strahan, *Treasures*, I, 1879, p. 98; an oil sketch is in a private collection, New York.
11. *A Cardinal Descending a Staircase*, formerly attributed to Leutze but now called German School, at the Fogg Art Museum. See Lexington, 1973, no. 53, and Bowron, 1990, no. 445. Also a modest painting by Middelton Jameson recently offered at Christie's, New York, Oct. 16, 1991, no. 255, seems to hark back to this Gérôme.

JEAN-LÉON GÉROME
1824-1904

10. *La Fontaine and Molière*, ca. 1890
Oil on canvas, 11 1/16 x 7 15/16 in. (28.1 x
20.2 cm)
Signed at right on table edge: *J.L. GEROME*
The Ackland Art Museum, The University of
North Carolina at Chapel Hill, Ackland Fund

Provenance: Goupil and Co., Paris; Stoppenbach and
Delestre, London; Brandt Dayton, New York, 1984.

Literature: Ackerman, 1986, pp. 142, 270, no. 394.

Gérôme first depicted Molière in the painting of the
playwright with King Louis XIV (see no. 7). He then
reappeared in the work known as *A Collaboration*,
which showed the two great dramatists Molière and
Corneille (fig. 37).[1] Finally about 1890 Gérôme
painted two more modest works, varying this theme of
two literary figures: one was *Molière and Boileau* (now
lost), and the other is this depiction of Molière with the
famous poet, satirist, and fabulist La Fontaine.
Although the two writers were good friends,[2] there is
no known collaboration between them. The older
man, La Fontaine, admired the younger's work. After
the successful production of Molière's *Les fâcheux (The
Troublemakers)*, La Fontaine penned his famous verses
proclaiming his support:

> C'est un ouvrage de Molière.
> Cet écrivain, par sa manière,
> Charme à présent toute la cour.
> De la façon que son nom court,
> Il doit être par delà Rome:
> J'en suis ravi, car c'est mon homme.[3]

On Molière's untimely death, La Fontaine
composed the dramatist's best-known epitaph:

> Sous ce tombeau gisent Plaute et Térence,
> Et cependant le seul Molière y gît.
> Leurs trois talents ne formoient qu'un esprit,
> Dont le bel art réjouissoit la France.
> Ils sont partis! et j'ai peu d'espérance
> De les revoir. Malgré tous nos efforts,
> Pour un long temps, selon toute apparence,
> Térence et Plaute et Molière sont morts.[4]

In the painting the standing La Fontaine seems to
have been seized with inspiration to recite some verses
to Molière, who pauses with his pen poised to write.
This intimate scene of two famous men, one standing
and one seated in a book-lined chamber, may derive
from a very similar composition depicting Diderot and
d'Alembert by Zamacoïs exhibited at the Salon of
1863.[5]

1. Shown in the Salon of 1874. Sheldon, 1882, p. 88, mistakenly
identified it as *Molière and Scarron*. See Ackerman, 1986, p. 234,
no. 232.
2. See H. C. Chatfield-Taylor, *Molière: A Biography*, New York, 1906,
pp. 301-2, 306, 315-17.
3. See Arthur Tilley, *Molière*, Cambridge, 1921, p. 19.
4. Quoted in John Palmer, *Molière*, New York, 1930, pp. 484-85.
5. Salon, no. 1907; Clement and Hutton, 1879, II, p. 368. The
painting was last seen in a private collection, Fresno, Calif.

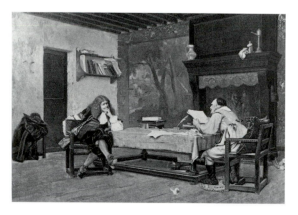

Fig. 37. *J.-L. Gérôme,* A Collaboration *(after Strahan,* Treasures,
1879-80).

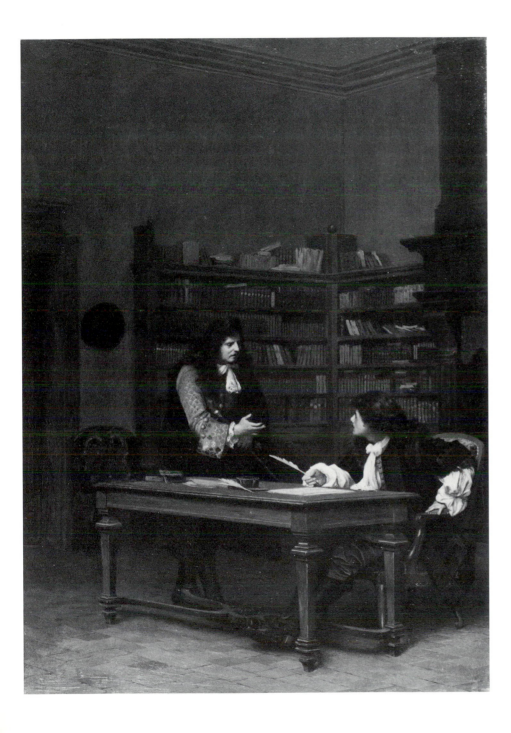

LUCIEN-ALPHONSE GROS
1845-1913

11. *Halt of the Cavaliers*, 1868-69
 Oil on canvas, 22 x 18 1/4 in. (55.9 x 46.4 cm)
 Signed and dated lower left: *Lucien Gros 1868-69*
 Arnot Art Museum, Elmira, N.Y., bequest of
 Matthias H. Arnot, 1910

Provenance: Samuel P. Avery; Hinman Barrett Hurlbut,
Cleveland; acquired 1883 by Matthias H. Arnot, Elmira, N.Y.

Exhibitions: *Salon*, Paris, 1869, no. 1111; Arnot, 1989, no.
11; Tulsa, 1989-90, no. 14.

Literature: *Merveilles de . . . Salon de 1869*, p. 302; *Arnot*,
1936, no. 11; *Arnot*, 1973, p. 108.

Gros was born in Wesserling, France. He studied
with Meissonier and made his Salon debut in 1865,
winning medals in 1867 and 1876. This example
shown at the Salon of 1869 owes a direct debt to a
number of Meissonier paintings, the most notable of
which are perhaps *The Roadside Inn* (Wallace
Collection), in which cavaliers are set against a tree-
filled landscape with dappled light effects,[1] and *The
Rider's Rest* (Hamburg, Kunsthalle) that shows a
seventeenth-century cavalier seated on the ground,
leaning against a tree as his horse grazes in the
distance.[2] The anonymous reviewer of the 1869 Salon
noted Meissonier's influence on one school of
landscape painting and of Gros's effort could only say it
is *"un tableau habile voilà tout"* (a competent painting,
that is all).

It was most likely the Arnot painting that was
purchased by the American art dealer Samuel Avery on
June 26, 1875, when he records in his diary, "To Poissy
with Lucas called on Gros, bought picture of landscape
with horses and two soldiers under trees 17 x 21—for
2000."[3] Avery in turn sold it to the Cleveland

businessman, Hinman Barrett Hurlbut, from whom
Mr. Arnot had acquired it by 1883.[4]

1. *Wallace*, 1968, p. 197, no. P328.
2. Kraft and Schüman, 1969, p. 210, no. 1292.
3. Avery, *Diaries*, 1979, p. 297.
4. See Arnot, 1989, pp. 30-31.

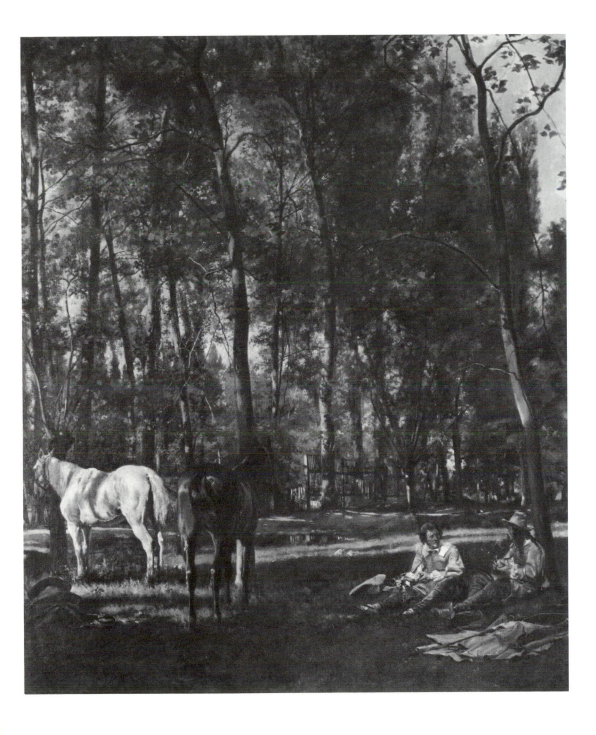

LÉO HERRMANN
1853-?

12. *The Cardinal*
 Oil on canvas, 9 x 7 in. (22.9 x 17.8 cm)
 Signed lower right: *Leo Herrmann*
 Washington University Gallery of Art, St. Louis,
 bequest of Charles Parsons, 1923

Provenance: Charles Parsons, St. Louis.

Exhibitions: *Charles Parsons: Portrait of a St. Louis Collector*,
Washington University, St. Louis, Dec. 1976-Jan. 1977; *The
Centennial Exhibition*, Washington University, St. Louis,
May-Oct., 1981; *Life and Land*, Washington University, St.
Louis, Nov. 1983-Apr. 1984.

Literature: Gallery of Art, Washington University, *Charles
Parsons Collection of Paintings*, St. Louis, 1977, p. 47.

Essentially self taught, the Parisian-born Herrmann
(whose names are sometimes reversed)[1] was a satiric
artist. Exhibiting at the Salon for the first time in
1875, Herrmann occasionally painted dandies[2] or
soldiers, but most of his subjects in both oil and
watercolor are ecclesiastical ones, such as *The Good
Story*—a scene of two monks at a table—shown at the
Salon of 1876.[3] Some, such as a cleric feeding a swan[4]
or a cardinal painting,[5] seem directly inspired by
Vibert, but in the present small example he goes that
master one better, creating a delicate but funny
composition. This cardinal in his scarlet robe and scull
cap is at his leisure in the garden and sips a red drink
(wine?) through an exquisitely long straw. The sense of
exaggeration, in which the imbibing parodies the
reception of the Eucharistic wine, is remarkable. A
comparable watercolor of a cardinal in profile taking
tea but set in an interior is in the Brooklyn Museum.[6]
This type of subject matter must have been frequent in

the artist's oeuvre, for one titled *L'Heure du porto (Time
for Port)* was sold in 1920[7] and another called *After
Lent* was in the Astor collection.[8]

1. See Montrosier, 1881, I, pp. 125-27.
2. See one sold at Sotheby's, London, Mar. 19, 1986, no. 96.
3. See Viardot, 1882, II, ill., n.p.
4. This work sold at Christie's, New York, May 28, 1982, no. 12,
clearly resembles Vibert's *Le vilain gourmand* (see no. 54).
5. Sold Sotheby's, London, May 15, 1968, no. 76.
6. Bequest of Mrs. Caroline H. Polhemus, acc. no. 06.72.
7. Sale, Hôtel Drouot, Paris, Nov. 26, 1920, no. 18.
8. Listed in Strahan, *Treasures*, II, 1880, p. 78.

HENRI-ADOLPHE LAISSEMENT
1844-1921

13. *A Good Hand*
 Oil on panel, 21 x 25 1/2 in. (53.3 x 64.8 cm)
 Signed lower right: *H. Laissement*
 Bill and Cindy Ross

Provenance: Sale, Sotheby's, New York, Oct. 19, 1984, no. 223.

Born in Paris and a student of Cabanel's, Laissement first exhibited at the Salon in 1879. He specialized in detailed recreations of elegant eighteenth-century scenes[1] as well as ecclesiastical subjects.[2] On occasion he painted portrait groups, of which the most notable is *Une lecture au comité en 1886 (A Reading to the Committee in 1886)*, depicting Alexandre Dumas the Younger reading to distinguished members of the Comédie Française.[3]

The present example, combining the familiar motif of card playing—often found in the period pieces of Meissonier and his followers—with the churchmen, is an unusual creation. Like Vibert, the artist presents the self-indulgent clergy living in luxurious interiors, but by having one cleric face directly out to share his winning hand with us, he draws us into the scene in a manner quite different from the distant, objective format Vibert usually maintained.

The painter makes a point of distinguishing the rank of the two players. The one about to discard a card is a bishop or archbishop, indicated by his purple cassock, stockings, and mozzetta, his patent leather shoes, and his pectoral cross. His rival, all in red, is a cardinal. Thus, not only does he have the higher rank, but his smile indicates he also has the better hand. It seems to be a run of diamonds and several aces. The tapestry behind them depicts the Ovidian myth of Vertumnus and Pomona, a scene of deception, perhaps befitting the trickery of the game.

1. For example those exhibited at the Salons of 1894 and 1895. See also those sold at Christie's, London, June 22, 1990, no. 44, and Sotheby's New York, Oct. 28, 1986, no. 57.
2. Typical examples sold at Christie's, London, May 30, 1986, no. 57, and Oct. 4, 1991, no. 51, and at Sotheby's, New York, Feb. 29, 1984, no. 83, and Oct. 28, 1986, no. 90.
3. See *La Comédie-Française, 1680-1980*, exh. cat., Bibliothèque Nationale, Paris, 1980, no. 720.

ALEXANDRE-LOUIS LELOIR
1843-1884

14. *Choosing the Dinner* or *The Cook's Bargain*,
 1872
 Oil on canvas, 12 1/4 x 18 3/8 in. (31.1 x
 46.7 cm)
 Signed and dated lower right: *Louis Leloir 72*
 The Metropolitan Museum of Art, New York,
 bequest of Catharine Lorillard Wolfe, 1887,
 Catharine Lorillard Wolfe Collection

Provenance: Purchased from the artist in Paris by Catharine
Lorillard Wolfe, 1872.

Literature: *Wolfe*, 1887?, p. 7, no. 3; Strahan, *Treasures*, I,
1879, p. 134; Champlin and Perkins, 1888, III, p. 57; *Wolfe*,
1897, p. 25, no. 96; Sterling and Salinger, 1966, p. 199.

Both Leloir's parents were artists—his father,
Auguste, a painter, and his mother a miniature painter.
His brother also became a painter. Leloir attained the
Deuxième Prix de Rome in 1861 and rose rapidly as a
specialist in historical genre. He was also a skilled
watercolorist and noted for his fan decorations.

At the Exposition Universelle of 1878 the selection
of Leloir's works led the critic Jules Claretie to declare
that he was "of all the genre painters, the finest and
most delicate."[1] The high quality is evident in this
seventeenth-century scene. In a rough-hewn courtyard
a large cook reviews the selection of game offered by a
huntsman. The textures and atmosphere of this
anecdotal view of everyday life in earlier times are
handsomely rendered.

1. Claretie, 1884, I, p. 226.

Louis Lelaire 72.

JEAN-LOUIS-ERNEST MEISSONIER
1815-1891

15. *Les trois amis (The Three Friends)* or *Les bons
amis (The Good Friends)*, 1847
Oil on panel, 9 1/2 x 10 5/8 in. (24.2 x 27 cm)
Signed and dated lower left: *EMeissonier 1847*
Taft Museum, Cincinnati, bequest of Mr. and
Mrs. Charles Phelps Taft

Provenance: Queen Victoria and Prince Albert, London,
1848; Edward VII; Princess Louise, in Feb. 1901; Arthur
Nattali, Petworth, Sussex; J. Nattali, London; Arthur Tooth
and Sons, London and New York, by Apr. 1901; acquired by
the Tafts, Oct. 1902.

Exhibitions: *Salon*, Paris, 1848, no. 3250; Detroit, 1954,
no. 29.

Literature: L. Clement de Ris, "Salon de 1848," *L'Artiste*,
Apr. 9, 1848, p. 69; F. de la Genevais, "Le Salon de 1848,"
Revue de deux mondes, Apr. 15, 1848, p. 297; Théophile
Gautier, "Feuilletons de la Presse—Salon de 1848," *La Presse*,
May 6, 1848; A. J. du Pays, "Beaux-arts—Salon de 1848,"
L'Illustration, May 21, 1848, p. 188, ill. p. 189; Chaumelin,
1887, p. 40, no. 24; Bénédite, p. 27; Brockwell, 1920, pp.
xxiv, 186, no. 75; *Catalogue of the Taft Museum*, Cincinnati,
1939 and 1958, no. 371; Hungerford, 1980, p. 96; *The Taft
Museum: A Cincinnati Legacy*, Cincinnati, 1988, ill. p. 15;
Hungerford, 1989, p. 76.

Meissonier had already established his fame with his
miniature depictions of soldiers of the *ancien régime*
when he included this intimate genre scene among the
six works he exhibited at the Salon of 1848. Gautier
singled it out as "a miracle of retrospective intuition"
and praised Meissonier as "the equal of Metsu." The
high regard in which the work was held is indicated by
the fact that Queen Victoria purchased it from the
Salon (for the substantial price of 8,000 francs) as a gift
for Prince Albert.

Meissonier repeated the composition in even
smaller format as *Les trois fumeurs (The Three Smokers)*
in 1857—a work once in the Secrétan collection and
now in the Musée d'Orsay.[1] This modest subject, with
gentlemen seated at a table, was to be elaborated in
many later works by the artist, such as the deluxe *Chess
Game* (fig. 38), formerly in the Belmont collection.[2]

1. Reproduced in Gréard, 1897, p. 40, when in possession of M.
Thiery, as *The Three Smokers*. See also Guilloux, 1980, ill. p. 26.
2. See Strahan, *Treasures*, I, 1879, pp. 107-8.

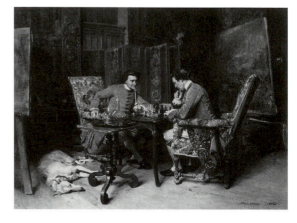

Fig. 38. *J.-L.-E. Meissonier,* The Chess Game, *location
unknown, photograph courtesy of M. Knoedler & Co.*

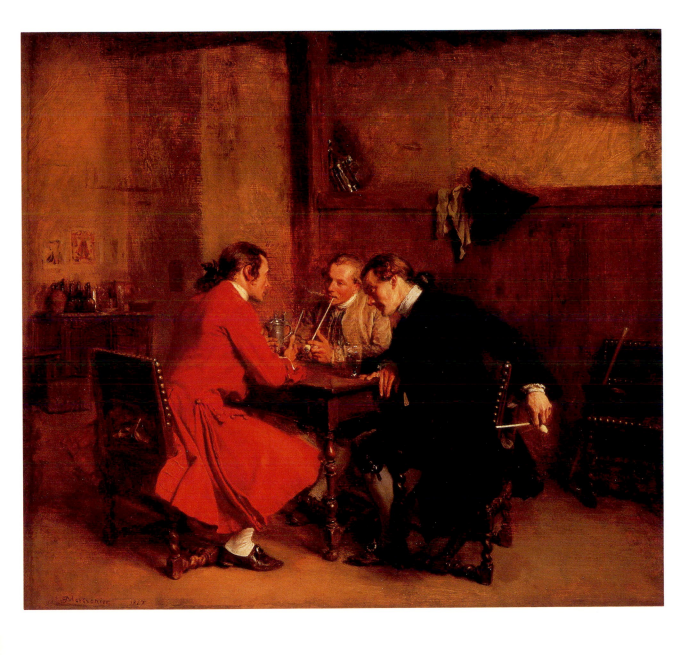

JEAN-LOUIS-ERNEST MEISSONIER
1815-1891

16. *The Reader in White* or *Man Reading*, 1851
Oil on panel, 6 3/4 x 5 1/8 in. (17.1 x 13 cm)
Signed and dated lower right: *EMeissonier 1851*
Sterling and Francine Clark Art Institute,
Williamstown, Mass.

Provenance: E. Secrétan, Paris; sale, Sedelmeyer Galleries,
Paris, July 1, 1889, no. 52; M. Goetz; Ernest Dreux; sale,
Galerie Georges Petit, Paris, Dec. 5-6, 1911, no. 22; Le Roy;
M. Knoedler and Co., New York; acquired by Robert Sterling
Clark, Mar. 30, 1929.

Exhibition: Paris, 1884, no. 13.

Literature: Chaumelin, 1887, p. 41, no. 33 (as "*liseur à la
veste grise,*" or reader in a gray vest); Gréard, 1897, p. 366; I.
Errera, *Répertoire des peintures datées*, Brussels, 1920, II, p.
657; *Clark*, 1972, p. 64, no. 812.

This is one of a number of diverse *liseurs*, or readers,
that Meissonier painted throughout his career. The
particular title of this one probably dates from the time
of the Secrétan sale when it was dubbed *Le liseur blanc
(The Reader in White)* to distinguish it from the same
collector's *Le liseur rose*, a painting of 1857, which
showed a man dressed in a rose-colored Louis XV-
period vest. This *Liseur blanc*, as noted in the Secrétan
sale catalogue, is actually in gray. Totally absorbed in
his book, the elegantly attired and bewigged gentleman
is ensconced in his private study. To the right is a
lovely Louis XV-style rosewood bureau cluttered with
other books and papers. Several large figures are visible
in the tapestry, which forms the backdrop to this cozy
chamber. Another *Liseur blanc* (1857) by Meissonier is
in the Musée d'Orsay. The Clark *Reader* is closest in
mood to yet another *Liseur rose* formerly in the
Beistegui collection.[1]

Meissonier is quoted as saying:

If I had to excuse myself for having multiplied readers of a
past century, I might reply: "They really were numerous in
those times when a man handled his volume daintily, as a
lover of good books and fine bindings should do." If I were
to paint a modern reader, I should have to put a newspaper in
his hand, and to furnish his shelves with pamphlets not worth
the trouble of binding.[2]

1. See Gréard, 1897, p. 184.
2. Ibid., p. 235.

17. *Gentilhomme faisant de la musique* or *The
Musician,* 1858
Oil on panel, 9 7/16 x 6 13/16 in. (24 x
17.3 cm)
Signed and dated lower left: *EMeissonier 1858*
Sterling and Francine Clark Art Institute,
Williamstown, Mass.

Provenance: Paul Demidoff, Paris; sale, Galerie Georges Petit,
Paris, May 25-26, 1864, no. 10; Edward Bocquet, Brompton;
sale, Christie's, London, June 24, 1871; Laurent Richard,
Paris; sale, Hôtel Drouot, Paris, Apr. 7, 1873, no. 37; Baron
Adolphe de Rothschild, Paris, by 1884; Marshall Field,
Chicago; M. Knoedler and Co., New York; acquired by
Robert Sterling Clark, June 1, 1922.

Exhibitions: Paris, 1884, no. 45; Paris, 1893, no. 1007;
Williamstown and Hartford, 1974, no. 49.

Literature: Ménard, 1873, p. 321; Mollett, 1882, pp. 70-71;
Robinson, 1887, p. 28; Chaumelin, 1887, p. 45, no. 81;
Gréard, 1897, p. 368; *Clark*, 1972, p. 66, no. 810.

The date on this work appears to be 1858, as
indicated in the early Paris exhibitions, although it has on
occasion been read as 1859. Meissonier painted a
number of amateur musicians in period costume, and
this one, like the soldier in the Metropolitan Museum of
Art[1] and the cavalier in Dublin,[2] is playing not a guitar or
a mandolin, as sometimes stated, but a theorbo, a
popular seventeenth-century instrument that often
appears as a detail in Meissonier's interiors (see nos. 18,
19). A slightly larger panel painting, *Joueur de théorbo
(Theorbo Player)* was in the Meissonier atelier sale.[3]

This gentleman of the Louis XIII era, wearing a wig
and the loose-fitting garments of the period, intently
follows the score, seeming both to play and to sing. On
the table behind the music are a number of beautifully
rendered pieces of Venetian glass. As in *The Reader in
White* (see no. 16), a tapestry, possibly a mythological
scene of Hercules, forms the backdrop. These intimate
scenes of the solitary pursuits of readers and musicians are
marvelous examples of what Michel called Meissonier's
"monologues."[4]

1. See Sterling and Salinger, 1966, p. 151.
2. See Calais, 1989, pp. 110-11, no. 35; also ill. in Sheldon, 1882, p. 110.
3. Galerie Georges Petit, Paris, May 12, 1893, no. 11.
4. Michel, 1884, p. 12.

JEAN-LOUIS-ERNEST MEISSONIER
1815-1891

18. *The Artist in His Studio*, 1855
Oil on panel, 10 1/2 x 8 3/8 in. (26.7 x 21.3 cm)
Signed and dated lower right: *EMeissonier. 1855*
The Cleveland Museum of Art, gift of Mrs. Noah
L. Butkin, 1982

Shown only in Cincinnati

Provenance: Countess Lehon; sale, Paris, Apr. 2-3, 1861, no.
10?; J. Grant Morris, Allerton Priory, Liverpool, 1883;
Samuel P. Avery;[1] William H. Vanderbilt, New York; George
W. Vanderbilt; Brigadier General Cornelius Vanderbilt; Mrs.
Cornelius Vanderbilt; sale, Parke-Bernet, New York, Apr. 18-
19, 1945, no. 42; Mrs. Derek Spence, New York; Mr. and
Mrs. Noah L. Butkin, Cleveland.

Exhibitions: *Salon*, Paris, 1857, no. 1884; *International
Exhibition*, London, 1871, no. 1454?; on loan to The
Metropolitan Museum of Art, 1902-20; *The Artist and the
Studio in the Eighteenth and Nineteenth Centuries*, The
Cleveland Museum of Art, 1978, no. 5; *Year in Review, 1983*,
The Cleveland Museum of Art, 1984, no. 19.

Literature: Maxime du Camp, *Le Salon de 1857*, Paris, 1857,
p. 54; Burty, 1866, p. 86; Gréard, 1897, ill. p. 205; Strahan,
Vanderbilt, 1883, III, p. 48; *Vanderbilt*, 1884, p. 25, no. 41;
Durand-Gréville, 1887, p. 252; Chaumelin, 1887, p. 43, no.
55; Stranahan, 1897, p. 344; Avery, *Diaries*, 1979, p. li, fig.
74; *The Bulletin of the Cleveland Museum of Art*, Feb. 1984,
ill. p. 61; Patterson, 1989, p. 105.

The diligent artist of the eighteenth century was a
theme that Meissonier painted many times.[2] This
version dated 1855 (although the area of the date
appears somewhat abraded and repainted) is rather
more cluttered in its studio surroundings than another
formerly in the Chauchard collection, which seems to
be the one exhibited in the 1855 Exposition
Universelle as *Le dessineateur (The Draftsman)*.[3] In the

present example the artist is hard at work on a small
canvas of a reclining nude, possibly Antiope. Amid the
volumes, portfolios, and drawings littered about to
attest to the creative endeavor, there is also Meissonier's
favorite period prop, the theorbo. As in *The Two Van
de Veldes* (see no. 19), Meissonier also included a
crumpled piece of paper and a brush on the foreground
floor, the kind of detail his pubic greatly admired.

The Cleveland painting is most likely the one
shown at the Salon of 1857 when in the collection of
the Countess Lehon. It then had measurements of 31
x 23 centimeters. A reproduction of what is certainly
the present painting (misidentified as in the Chauchard
collection) in Gréard, the photograph of it by Bingham
in Avery's photo album,[4] and the illustration in the
Vanderbilt sale catalogue show that it formerly
extended more on the top and right edges. Almost the
entire framed painting, a portrait, at the upper left was
visible, as was the full width of the jug at the right.
Thus, sometime after 1945 the painting was trimmed.

1. Avery visited the collection of J. Grant Morris at Allerton Priory on
Oct. 4, 1882, and two days later wrote the collector asking for prices
on various works in his collection. See Avery, *Diaries*, 1979,
pp. 726-28.
2. Guilloux, 1980, p. 27, says there are more than fifteen of the
subject. This one, when in the Vanderbilt collection, was called *Artist
at Work (Period of Boucher)*.
3. Now in the Musée National du Château de Compiègne. See
Guilloux, 1980, pl. 19.
4. Bingham's photograph of the painting appears in Avery's album of
works that he sold with the annotation that it was in the W. H.
Vanderbilt collection. See *Photographs from Paintings by Meissonier . . .*,
AV 33, Avery Library, Columbia University.

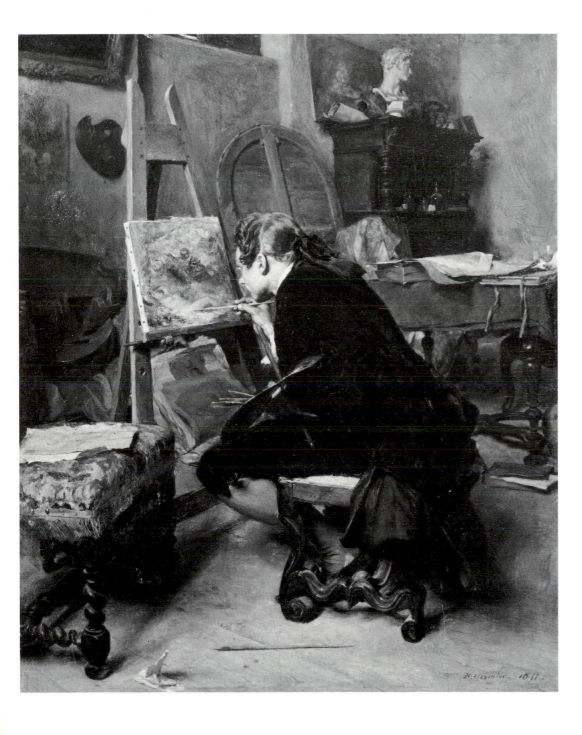

19. *The Two Van de Veldes* or *Visit of a Collector*,
1856
Oil on panel, 10 1/4 x 8 in. (26 x 20.3 cm)
Signed lower left: *EMeissonier*
Mr. and Mrs. Don Purdy

Provenance: Baron Michel de Trétaigne, Paris, by 1860; sale,
Hôtel Drouot, Paris, Feb. 19, 1872, no. 46; Febvre, Paris;
Laurent Richard; sale, Hôtel Drouot, Paris, May 23, 1878,
no. 45; Catharine Lorillard Wolfe, New York, 1878-87;
bequest to The Metropolitan Museum of Art, New York,
1887; sale, Christie's, New York, May 29, 1981, no. 12;
Panonia Galleries, New York, 1982; Hammer Gallery,
New York.

Exhibitions: *Salon*, Paris, 1857, no. 1887; *Tableaux de l'école
moderne tirés de collections d'amateurs*, 26 boulevard des
Italiens, Paris, 1860, no. 259.

Literature: Louis Auvray, *Exposition des beaux-arts, Salon de
1857*, Paris, 1857, p. 49; Eugène Loudun, *Le Salon de 1857*,
Paris, 1857, p. 28; A. de Lostalot, in *GBA*, XVII (1878), p.
471; *The Art Journal*, 1879, p. 48, ill. opp. p. 48; Strahan,
Treasures, I, 1879, p. 125; Mollett, 1882, p. 35; Burty, 1882,
ill. opp. p. 274; Michel, 1884, ill. p. 11; Chaumelin, 1887, p.
15, no. 56; Cook, 1888, I, pp. 69-71; Robinson, 1887, p. 9,
ill. opp. p. 10; *Wolfe*, 1887?, p. 12, no. 62; Gréard, 1897, p.
379, ill. p. 61; *Wolfe*, 1897, p. 8, no. 22; Stranahan, 1897, p.
344; "Meissonier," *Masters in Art*, Boston, 1904, pp. 40-41,
pl. x; Ten Doesschate Chu, 1974, p. 36, fig. 47; Guilloux,
1980, ill. p. 27.

Meissonier exhibited his first *Peintre dans son atelier
(Painter in His Studio)* in 1843. This work showing an
artist of the seventeenth century receiving his patron
won great praise and helped garner Meissonier the first-
class medal at the Salon. He went on to paint the
theme a number of times.

In the Salon of 1857 the present painting was titled
*Amateur de tableaux chez un peintre (Painting Collector
Visiting a Painter)* and at the 1860 exhibition *Amateur
chez un peintre*. *The Art Journal* of 1879 called it *The
Critics*, but already De Lostalot, describing it in 1878
when in the Laurent Richard collection, identified the
seated figure as the seventeenth-century Dutch painter
Adriaen van de Velde and the standing artist as his
elder brother, Willem. Chaumelin in 1887 plays it safe
by calling it *L'Amateur chez un peintre* or *Les deux Van
de Velde* and describes it as a "*morceau d'une exquise
finesse*" (morsel of exquisite elegance). A later work by
Meissonier was also identified as *The Two Van de
Veldes*,[1] but in the present case, one is hard pressed to
accept this as the subject. The brothers Van de Velde,
Willem (1633-1707) and Adriaen (1636-1672), were
Dutch painters who primarily specialized in marine
and animal subjects, and one would expect the careful
Meissonier to have included more specific details of
such subject matter in their atelier. Instead, the seated
gentleman in a more elaborate costume looks as if he
has just come in from outside specifically to inspect the
painting on the easel. Would the artist's brother
assume such a critical attitude, as if deciding whether
the price is right or the quality high enough, and is not
the pose of the standing artist one of proud yet
attentive condescension? The same theme seems to be
repeated in the later *Visite à l'atelier (Visit to the Studio)*
at Lille.

Ten Doesschate Chu has called the work "an
amalgamation of motifs taken from Dutch genre
painting." Sterling and Salinger proposed that
Meissonier was "deliberately emulating the Dutch" and
that "very probably such a painting as Gerrit
Berckheyde's *Visit to the Studio*, now in the Hermitage,
gave him the idea for his treatment of the theme."

For Strahan, who mistakenly thought the two Van
de Veldes were father and son:

The blonde complexions, the light hair shaken loose, the
worthy and sincere characters of the two painters here
laboring in a pleasant partnership of ideas, are completely
Dutch; and the pure Holland types are interpreted in the pure
Holland truthfulness of impression, with temperate and
reasonable illumination and composition, and detail carried
just far enough, in the admirable manner of Jan Steen. The
chair, the plain carpentry of the easel, the panel cradled at the
back, the carved cabinet supporting a *grès de Flandre* pitcher, a
mandolin, and a simple helmet descended from the wars of
Prince Moritz, are all in perfect keeping. The very paintbrush
that has rolled into the foreground assists the composition
and connects the grouping with its line.

1. A study for one of the figures dated 1862 was in the Meissonier
atelier sale, Galerie Georges Petit, Paris, May 12, 1893, no. 44, later in
the collection of Maximilian Beyer. See Gréard, 1897, p. 128.

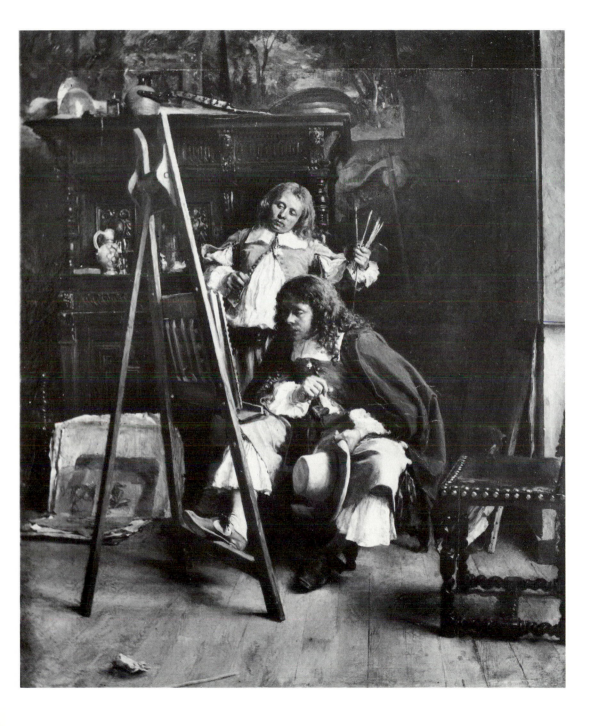

JEAN-LOUIS-ERNEST MEISSONIER
1815-1891

20. *Napoléon I in 1814*, 1862
Oil on panel, 12 3/4 x 9 1/2 in. (32.4 x 24.2 cm)
Signed and dated lower right: *EMeissonier 1862*
The Walters Art Gallery, Baltimore, Md.

Shown only in Cincinnati

Provenance: Prince Napoléon, Paris; sale, Hôtel Drouot, Paris, Apr. 4, 1868, no. 18; Bouruet-Aubertot; John Ruskin, London; sale, Christie's, London, June 3, 1882, no. 111;[1] Defoer collection; sale, Hôtel Drouot, Paris, May 22, 1886, no. 23; acquired by George Lucas for William T. Walters.

Exhibitions: *International Exhibition*, London, 1862, no. 190; studio of the photographer M. Bingham, Paris, Jan. 1863; Royal Institution, London, 1869; Paris, 1884, no. 70; Baltimore, 1977, no. W1.

Literature: "Nouvelles," *Chronique des arts et de la curiosité*, May 25, 1862, p. 3; ibid., Jan. 25, 1863, p. 103; Burty, 1866, p. 88; Mollett, 1882, p. 44; Robinson, 1887, pp. 11, 21, 29; Matthews, 1889, p. 6; Lamb, 1892, p. 248; Walters, 1893, p. 94, no. 154; Reizenstein, 1895, p. 550; Gruelle, 1895, pp. 112-13; Tarbell, 1895, p. 196; Gréard, 1897, pp. 284, 370; Stranahan, 1897, p. 344; John Ruskin, "Notes on Proust and Hunt," *Complete Works of John Ruskin*, London, 1903-12, XIV, pp. 381, 438-39; Walters, *Selection*, 1965, no. 8; Lucas, *Diary*, 1979, I, fig. 94, II, p. 630; Avery, *Diaries*, 1979, pp. 654, 656; Hungerford, 1980, pp. 98, 100; Guilloux, 1980, p. 97, fig. 27; Johnston, 1982, pp. 112-13, no. 117.

Although he turned to large-scale depictions of military subjects devoted to both Napoléon I and III beginning in the early 1860s, Meissonier was still at his most effective when he limited his scope to small-scale renderings such as this—one of his most gripping historical scenes. At the Salon of 1864 he displayed a large painting titled *1814, The Campaign of France* (now in the Musée d'Orsay, fig. 39), which shows Napoléon on his striding white horse leading his devoted troops in retreat along a rough, snow-covered road toward the right. He has his overcoat fully buttoned and his right hand in the familiar pose on his heart. Completed earlier and dated 1862, the present painting, which originally belonged to Napoléon III's cousin, Prince Napoléon, was exhibited in London in 1862 as simply *H.M. the Emperor Napoléon I* and in Paris the following year as *L'Empereur Napoléon Ier pendant la campagne de France*. In this work the emperor is shown on the motionless horse facing to the left; his coat is open and his hand by his side. Two other mounted horsemen can be seen with difficulty behind the hill to the right.

The year in the title of the Musée d'Orsay painting is now also incorporated into the title of the Walters painting. It was in fact a decisive year for the fortunes of Napoléon, and his impending downfall is implied by the lowering dark clouds in the sky, the bleak landscape, and especially the emperor's grim expression and heavy, slightly slouched posture and rumpled appearance, perhaps recalling a famous composition by Delaroche.[2] Only the handsome horse seems to maintain its nobility. John Ruskin, who owned the work and admired its execution but not the "nearly unintelligible" landscape, identified the moment depicted as Napoléon in 1814 on the Chaussée of Vitry just after the battle of Arcis-sur-Aube. Hungerford, following Meissonier,[3] relates it to the Campaign of France, specifically Napoléon returning from Soissons after the Battle of Laon. She writes that Meissonier employed the date 1814 in the title, because it was the year France was invaded and therefore evoked a great outpouring of patriotism as Napoléon had one final burst of brilliant victories.

Meissonier went to great pains to present a realistic image of the emperor: for example, he had a copy of Napoléon's overcoat made and wore it himself as the model; he also borrowed the emperor's saddle from Prince Napoléon. The nobility of the immobile horse, looking more undaunted than the rider, was also drawn from life—in this case Meissonier's beloved Bachelier.[4] The result of this care was what Gruelle called "the triumph of Meissonier's art."

Meissonier also painted a grisaille version of the composition for the purpose of engraving. That version dated 1863, in which the two mounted soldiers are more clearly evident, is now in the Musée de l'Armée, Paris.[5] The popularity of this composition as an almost iconic image is attested to by copies and variants by lesser artists.[6]

1. It is interesting to note that Mr. Walters's agent and friend Samuel P. Avery saw the picture at Christie's in May 1882 when Ruskin was selling it and sent a bid of 2,000 guineas from Paris on June 2, 1882. He did not acquire it, since it sold for 5,900 guineas. Four years later their mutual friend Lucas was able to obtain it in Paris for Mr. Walters for 128,000 francs.
2. For Delaroche's *General Bonaparte Crossing the Alps* of 1848, see *All the Banners* Wave, exh. cat., Brown University, Providence, 1982, pp. 101-2, no. 42.
3. Gréard, 1897, p. 257.
4. An oil sketch of the horse was sold at Galerie Fieviz, Brussels, June 14-15, 1927, no. 257.
5. See Gréard, 1897, p. 284, ill. p. 281. It was exhibited at Paris, 1884, no. 98, and sold at the Palais Galleria, Paris, June 5, 1974, no. 56.
6. See for example the work sold at Christie's East, New York, Oct. 15, 1991, no. 412.

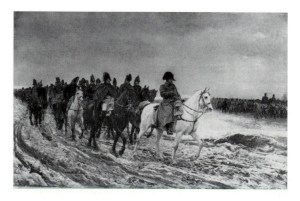

Fig. 39. *J.-L.-E. Meissonier*, 1814, **The Campaign of France**, *Musée d'Orsay, Paris.*

JEAN-LOUIS-ERNEST MEISSONIER
1815-1891

21. *The Cardplayers* or *La Partie Perdue (The Lost Game)*, 1863
Oil on panel, 13 7/8 x 10 1/2 in. (35.2 x 26.7 cm)
Signed and dated lower left: *EMeissonier 1863*
The Metropolitan Museum of Art, New York, bequest of Collis P. Huntington, 1900

Provenance: James H. Stebbins, New York, by 1879; sale, American Art Galleries at Chickering Hall, New York, Feb. 12, 1889, no. 72; Collis P. Huntington, New York, 1889-1900.

Literature: Strahan, *Treasures*, I, 1879, p. 98, ill. p. 97; Chaumelin, 1887, p. 49, no. 109; Durand-Gréville, 1887, p. 73; Robinson, 1887, p. 21, ill. p. 22; Champlin and Perkins, 1888, III, p. 236; Gréard, 1897, p. 370; Ten Doesschate Chu, 1974, p. 36, fig. 44; Theodore Reff, "Cézanne's *Cardplayers* and Their Sources," *Arts Magazine* (Nov. 1980), p. 115, fig. 23; Guilloux, 1980, ill. p. 23; Mary Tompkins Lewis, *Cézanne's Early Imagery*, Berkeley, 1989, p. 133, fig. 68.

Meissonier painted many guardroom scenes inspired by Dutch seventeenth-century examples. As Ten Doesschate Chu observes, this work calls to mind the Flemish artists Adriaen Brouwer and David Teniers the Younger, "particularly in the motif of the obliquely placed bench carrying a pipe in the foreground."

Originally known as *Four Soldiers of Louis XIII*, the painting was later called *La Partie Perdue (The Lost Game)*, a title more appropriately given to two other works—one of 1858 in the Wallace Collection[1] and another formerly in the Steengracht collection, The Hague.[2]

When in the Stebbins collection, this work was described in overabundant detail by Strahan:

"The Game Lost" is one of our artist's inimitable interiors, with a party of card-players, clothed in those antique costumes which we more usually associate with card-playing; not that play is not high now, very often, but that in the past the habit entered visibly into the manners of society, whereas now it shuts itself into clubs with an edifying sense of decorum, and hides. These soldiers of Vauban, in the interval of laying waste the Palatinate, gamble without fear and without reproach. The slouching and provisory air of the guard-room pervades the group—each individual ready to fly to arms at a moment's warning. In the treatment of the subject, a puzzled player's dilemma, we see a study of five different temperaments—cynical, curious, insulting, contemplative, indifferent—all watching the face of the loser. He himself is a whole drama of indecision, a doubting swashbuckler Hamlet. The grouping and lighting are eminently beautiful, in a merry shaft of sunshine from a supposed window, that plays upon the heads with the vibrating resonance of a peal of bells.

1. See Guilloux, 1980, pl. 5.
2. Gréard, 1897, ill. p. 33; see *Wallace*, 1968, p. 197.

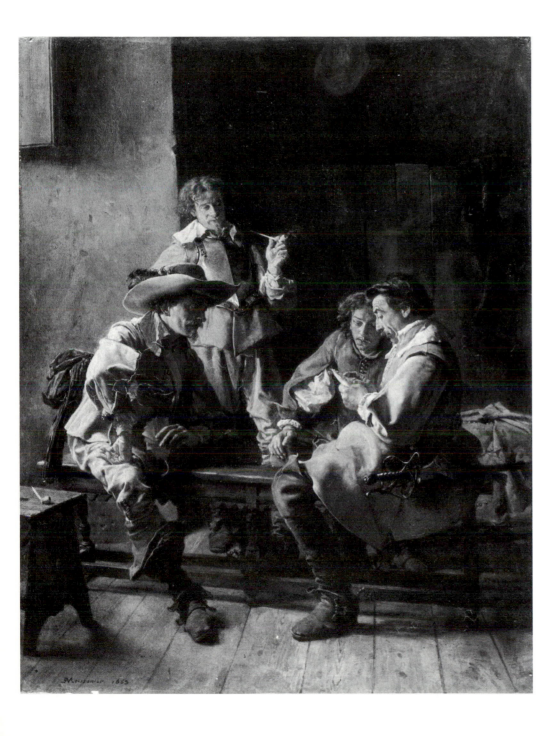

JEAN-LOUIS-ERNEST MEISSONIER
1815-1891

22. *A Cavalier Awaiting an Audience* or *A Gentleman
of the Time of Louis XIII*, 1866
Oil on panel, 15 x 9 5/16 in. (38.1 x 23.7 cm)
Signed and dated lower right: *EMeissonier 1866*
Edward Wilson, Fund for Fine Arts, Chevy
Chase, Md.

Provenance: Henry C. Gibson, Philadelphia; bequeathed to
The Pennsylvania Academy of the Fine Arts, 1896-1986; sale,
Sotheby's, New York, Oct. 28, 1986, no. 177.

Literature: Strahan, *Treasures*, I, 1879, pp. 69-70, ill. p. 71;
Chaumelin, 1887, p. 51, no. 130; Charles Henry Hart, "The
Collection of Mr. Henry C. Gibson, Philadelphia," in
Montgomery, ed., 1889, p. 119; Gréard, 1897, p. 371;
Larroument, 1893?, ill. opp. p. 8; *The Pennsylvania Academy
of the Fine Arts: Descriptive Catalogue of the Permanent
Collections*, Philadelphia, 1900, p. 145, no. G.858; Helen W.
Henderson, *The Pennsylvania Academy of the Fine Arts and
Other Collections of Philadelphia*, Boston, 1911, p. 180;
Pennsylvania Academy of the Fine Arts, Check List,
Philadelphia, 1969, p. 92.

Recognizing the somewhat gloomy or worried
aspect of this cavalier, some French texts refer to the
painting as *Mauvais humeur (Bad Humor)*. In America
it was given a more positive interpretation. Strahan,
describing the painting when in the Gibson collection,
waxed ecstatic, calling it "worthy of his best moments
. . . deep yet not dull, and rich without a particle of
vulgar glitter." He invented the following plot line
for it:

Some fast-riding post of Tureene or the Grand Condé, come
with news to the king of the victory of Fribourg, or the
burning of Heidelberg, warms himself at the ante-chamber
fire as he waits the royal pleasure. One spurred and booted
foot he lifts on the hob, while his hand leans on the

sculptured hood of the chimney-piece, and the draggled
features nodding from his broad and weather-beaten hat tell
of travel and haste.

Also according to Strahan, the setting is the great
stone fireplace at Meissonier's studio at Poissy, which
appears in a number of the painter's other seventeenth-
century scenes.[1] As Hart rightly noted, "The picture is
executed with that delicate manipulation and minute
care of detail which has yielded the artist his immense
reputation." What is either a preliminary drawing or a
study after the composition was in an exhibition of
1962.[2]

1. See for example *L'Attente de l'audience (Waiting for an Audience)* of
1869, sold at the Hôtel Drouot, Paris, June 18, 1930, no. 61.
2. See *The Non-Dissenters*, The Drawing Shop, New York, 1962,
no. 26.

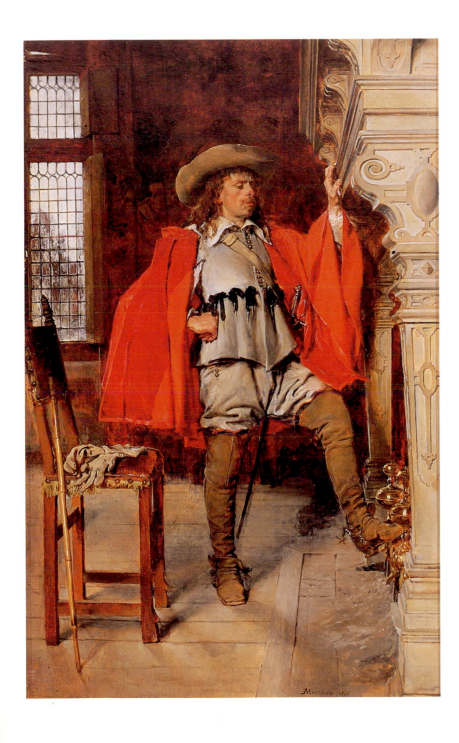

JEAN-LOUIS-ERNEST MEISSONIER
1815-1891

23. *Maurice, Comte de Saxe with His Troops*, 1866
 Oil on panel, 8 3/4 x 11 in. (22.2 x 27.9 cm)
 Signed and dated lower left: *EMeissonier 1866*
 Mrs. Harry Glass

Provenance: Galerie Georges Petit, Paris; John Taylor
Johnston, New York; sale, Chickering Hall, New York, Dec.
19-22, 1876, no. 165; Darius O. Mills, New York and San
Francisco; sale, Sotheby's, New York, May 22, 1991, no. 45;
Harry Glass; inherited by Bernice Glass.

Exhibition: *International Exhibition*, Munich, 1869.

Literature: Clement and Hutton, II, 1879, p. 107; Strahan,
Treasures, II, 1880, pp. 109-10, ill. p. 113; Viardot, 1882, II,
p. 4; Durand-Gréville, 1887, p. 74; Robinson, 1887, pp. 14,
21; Gréard, 1897, p. 371; Stranahan, 1897, pp. 336, 344;
Hungerford, 1980, p. 106; Guilloux, 1980, p. 11.

One of the most immediately appealing of
Meissonier's historical subjects, this painting represents
Maurice, Comte de Saxe, known as Marshal Saxe
(1696-1750), on patrol with his troops. The son of
Augustus II, Elector of Saxony and King of Poland, and
Countess Aurora Königsmark, Maurice was one of the
most dashing military figures of the eighteenth century
and was also known for his liaison with the famous
actress Adriana Lecouvrer. According to some older
sources, the scene shown here is Marshal Saxe and his
troops on the eve of his greatest triumph at the Battle
of Fontenoy in 1745.

John Taylor Johnston, the first president of the
Metropolitan Museum, saw the painting at Petit's
gallery in Paris on October 19, 1868, and described it
in his diary as "a beauty by Meissonier being a
squadron of horse with Marshal Saxe at their head."[1]
So taken with the picture was Johnston that he bought
it. At his 1876 sale, it was acquired by another major

collector, Darius O. Mills, who took it to San
Francisco.

Strahan reports that he examined the work "under
the bright sky" there and gave the following elaborate
description of the subject and its merits:

> Meissonier's "Marshal Saxe and Staff" is a truly beautiful and
> notable example, showing in the highest lustre the painter's
> occasional success in combining a complicated open-air group
> with a harmony of atmosphere and scenery. The landscape is
> sunny and free, the sky patterned with gray ranks of cloud. A
> shepherd in the picturesque contadino costume pastures his
> flock in the distance, while the middle space of the picture is
> occupied with the crowd of officers on horseback surrounding
> the gallant figure of the son of August the Strong. The
> cocked hats of the cavalcade, set at various angles against the
> sky, cut upon the clouds with a serrated sharpness, and the
> easy figures sit their steeds with that quiet perfection of
> horsemanship which no painter represents better than
> Meissonier. The tranquil audacity of a set of eighteenth-
> century soldiers of fortune is shown without exaggeration, yet
> with pleasant assurance; that their pay comes from the
> pawned jewels of Mademoiselle Lecouvrer is the least of their
> cares. Meissonier's cavalry groups are always fine; the present
> specimen, with the "Solferino" in the Luxembourg, and such
> ambitious compositions as Mrs. Stewart's "1807" and the
> "Retreat from Russia," shows an expertness in treatment of
> military subject which Velasquez, indeed, prefigured in "The
> Lances," but which otherwise the world had to wait for our
> century to get in the full perfection demanded, of equipment-
> erudition and landscape harmony.

As Hungerford points out, the format of this work
is derived from Meissonier's own *1814, The Campaign
of France* (see fig. 39), but whereas that work is full of
gloomy foreboding, this one has both brighter colors
and jaunty figures of youthful charm.

1. See Katherine Baetjer, "Extracts from the Paris Journal of John
Taylor Johnston," *Apollo* (Dec. 1981), p. 414.

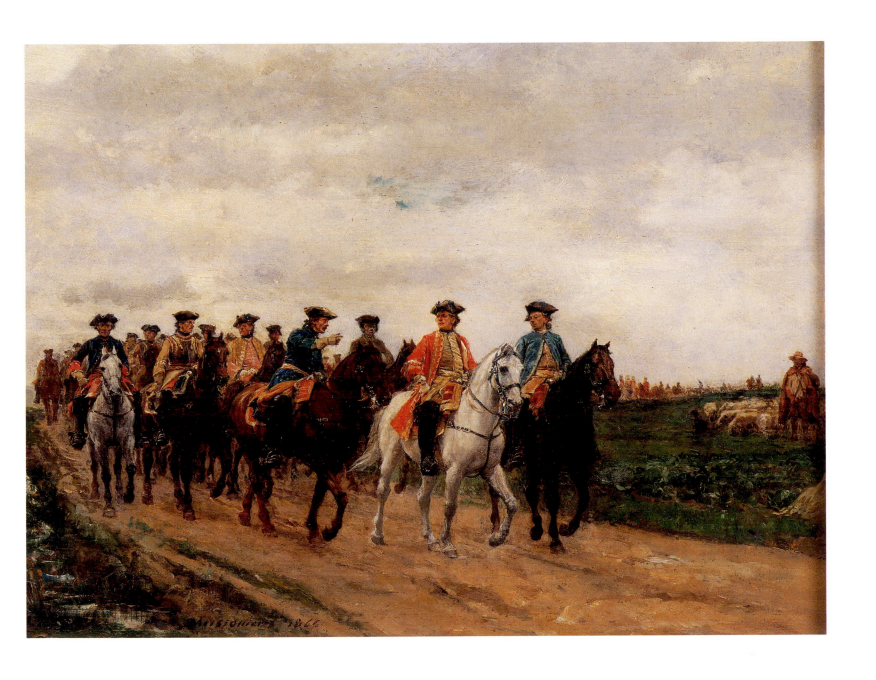

JEAN-LOUIS-ERNEST MEISSONIER
1815-1891

24. *The Stirrup Cup*, 1866
 Oil on panel, 5 x 3 1/2 in. (12.7 x 8.9 cm)
 Signed and dated lower right: *EMeissonier 1866*
 Arnot Art Museum, Elmira, N.Y., bequest of
 Matthias H. Arnot, 1910

Provenance: James H. Stebbins, New York; sale, American Art Galleries at Chickering Hall, New York, Feb. 12, 1889, no. 73; acquired by Matthias H. Arnot.

Exhibition: Arnot, 1989, no. 15.

Literature: Strahan, *Treasures*, I, 1879, p. 98; Durand-Gréville, 1887, p. 73; Stranahan, 1897, p. 344; *Arnot*, 1936, no. 15; Towner, 1970, p. 122; *Arnot*, 1973, p. 118.

Meissonier painted a number of variants on this subject. The earliest, titled *A Towne Bride*, appeared in 1860 and was followed a few years later by one generally called *Le halte (The Rest)* and *The Roadside Inn* of 1865 both now in the Wallace Collection.[1] Another small (6 3/4 x 4 1/2 inches) painting titled *The Stirrup Cup* of 1864 was in the collection of William H. Stewart. It showed the gentleman on horseback facing to the left and, in addition to the innkeeper, his wife and child in the doorway.[2] This one from the Stebbins collection, described by Towner as "smaller than a penny postcard," is in fact a detail taken from yet another larger version, *The Inn Door*, formerly in the Chauchard collection, which also included two other horsemen and a view down the road at the right.[3] In the Stebbins sale of 1889, where the small work sold for the amazing price of $7,100, the catalogue supplied a thorough description of the painting:

 It is a white, hot, midsummer day. On one of the dusty highways of the South of France the air is ablaze with heat as

from a furnace. The traveller has halted for breakfast at a humble wayside inn and having refreshed and rested himself has remounted to resume the road and is being served in the saddle with a parting draft of wine by his host. The traveller is in a pink silk coat of the style of the last century. His back is towards the spectator and the horse is seen foreshortened. The innkeeper stands at the horse's head facing forward and holding a wine jug in his hand and a glass on a tray.

 In spite of the miniature dimensions of the panel, every detail is rendered with the most exquisitely scrupulous exactitude—the button on the traveller's coat, the harness of the horse, the glint of light on the glass. At the same time the picture has the brilliancy and vigor of the largest and most dashingly executed work.

1. See Guilloux, 1980, pls. 17, 18; *Wallace*, 1968, pp. 195, 197.
2. Sold at American Art Galleries, New York, Feb. 3-4, 1898, no. 101.
3. See Gréard, 1897, ill. p. 182.

JEAN-LOUIS-ERNEST MEISSONIER
1815-1891

25. *Les renseignements: Le général Desaix à l'armée de Rhine et Moselle (Information: General Desaix and the Peasant)*, 1867
Oil on panel, 12 3/8 x 15 15/16 in. (31.4 x 40.5 cm)
Signed and dated lower left: *EMeissonier 1867*
Dallas Museum of Art, Foundation for the Arts Collection, Mrs. John B. O'Hara Fund

Provenance: Prosper Crabbe; Meyer collection, Dresden, by 1880; William H. Vanderbilt, New York, 1880-85; George W. Vanderbilt; Brigadier General Cornelius Vanderbilt; Mrs. Cornelius Vanderbilt; sale, Sotheby's, London, Oct. 13, 1978, no. 219.

Exhibitions: *Exposition Universelle*, Paris, 1867, no. 462; Atlanta, 1983, no. 51.

Literature: *Exposition Universelle de 1867 à Paris: Catalogue général*, Paris, 1867, I, p. 35; Mantz, 1867, p. 322; Maxime du Camp, *Les beaux-arts à l'Exposition Universelle et aux Salons de 1863-67*, Paris, 1867, p. 338; Blanc, 1876, p. 421; Mollett, 1882, pp. 60, 65; Bellier and Auvry, 1882-87, II, p. 65; Strahan, *Treasures*, III, 1880, p. 107; *Vanderbilt*, 1882, p. 13, no. 25; Strahan, *Vanderbilt*, IV, 1883, pp. 48, 49, ill. opp. p. 50; "Mr. W. H. Vanderbilt's House," *Artistic Houses*, 1883, p. 123; *Vanderbilt*, 1884, p. 28, no. 48; Claretie, 1884, pp. 14-16; Eugène Montrosier, "Meissonier," *Grands peintres français et étrangers*, Paris, 1884, II, p. 302-3; Chaumelin, 1887, pp. 25-26, 51, no. 133; Durand-Gréville, 1887, p. 252; Robinson, 1887, pp. 14, 27; Larroument and Burty, 1893?, ill. p. 49; Gréard, 1897, pp. 67, 371; Stranahan, 1897, pp. 336, 344; Doucet, 1905, p. 221; *Catalogue of Paintings in the Metropolitan Museum*, 1905, p. 206, 1914, p. 178, and 1916, p. 194; Avery, *Diaries*, 1979, p. xlvii, fig. 60; Anne R. Bromberg, *Dallas Museum of Art, Selected Works*, Dallas, 1983, p. 117, no. 114; Patterson, 1989, pp. 102-3.

This work set in 1796 depicts the young Napoleonic General Louis-Charles-Antoine Desaix (1768-1800), who later distinguished himself in Egypt and was killed at Marengo. According to Napoléon, Desaix's last words were: "Go tell the First Consul that I die with the regret of not having done enough to live in posterity."

During a temporary retreat by the Army of the Rhine, Desaix interrogates a peasant to determine the position of the Austrian forces. Meissonier explained that he carefully calculated the position of each figure so that "all the witnesses of the scene, even to the hussars in the glade of the background, have their eyes fixed on Desaix, who endeavors to read the looks of the hostage, and this concentrated gaze holds our own."[1]

The following appreciation of this work by Jules Claretie gives us some idea of the esteem in which Meissonier was held by his contemporaries:

Of all the paintings which were represented then in the Champ de Mars, and which became famous, one of the best ones was "Les Renseignements." In a forest of Alsace, during the winter, a republican general has stopped; this is Desaix. Gathering his staff around the fire, he stands with his right hand in his blue *houppelande*, as he interrogates a brave peasant, who answers while fiddling with his furlined cap. An officer takes his papers and examines them. To the right, a lieutenant, adjusting his coat, warms his legs by the fire. An orderly, magnificent in his bright red uniform, his hand supporting the point of his sword, warms his wet boots in the fire. Two green *missards*, on horseback behind the peasant, swords in hand, look on, bristling in their moustaches, with the impassive regard of combat soldiers. A screen of *dragoons* in the rear guard complete the scene. The uniforms stand out brightly from the edge of the gray and foggy forest. This is really Alsace, and an accurate depiction of its damp, cold season. A thick moss, with colors brightened by the rain which soaks it, covers the upper side of the large branches and stays there like a green snow which never melts. With what artistry has Mr. Meissonier brought these soldiers of the past to life! These troops do not frequent the studio or the barracks; they are not the troops encountered at Poissy and sketched in passing, nor paid models; they are the soldiers of the Republic, the warriors who quickly forced the Austrians to retreat across the Rhine.[2]

According to Croffut, when William H. Vanderbilt, one of Meissonier's greatest patrons, was having his portrait painted by the artist and asked him what he considered his finest work, Meissonier replied, "*Les renseignements.*" Learning that the painting belonged to the German collector Meyer, Vanderbilt purchased it for $50,000 and had it delivered to Paris. He then invited the unsuspecting artist to give him his judgment on a new acquisition. Croffut describes the scene:

Mr. Vanderbilt's attendant uncovered the picture, and behold! it was Meissonier's masterpiece. The effect was electric. The artist threw up his arms, uttered exclamations of delight, got down on his knees before the canvas, sent for his wife, and danced about as only a mad French artist can.[3]

There is evidently a good deal of truth in this story, for entries in the diaries of Samuel P. Avery attest to the agent contacting Meyer in Germany, negotiating a price, and bringing the work to Paris. Both Avery and Lucas record going with Mr. Vanderbilt and the painting to Meissonier's on June 17, 1880.[4] The painting was then sent to New York where it became one of the chief adornments of the picture gallery in Vanderbilt's palatial mansion at Fifth Avenue and Fifty-first Street.

1. Quoted in Gréard, 1897, pp. 66-67.
2. Claretie, 1884, pp. 15-16.
3. W. A. Croffut, *The Vanderbilts*, Chicago and New York, 1886, pp. 168-69; the story in abridged form is told by Strahan, *Vanderbilt*, 1883, III, p. 49.
4. Lucas, *Diary*, 1979, II, p. 499; Avery, *Diaries*, 1979, pp. 321, 457, 561, 566, 569, 570, 571, 574. Avery reports that he originally visited Meyer's private collection in Dresden in July 1875, but only on May 11, 1878, after a visit to Vanderbilt at his Paris hotel does he write Meyer "asking prices of Meissonier." Then in May 1880 after Meissonier has agreed to paint Mr. Vanderbilt's portrait for about $20,000, he writes to Meyer again asking if he "will sell Meissonier for £10,000." The collector responded positively by telegram June 4, 1880, and the work was sent to Paris. Avery probably took a commission on its sale, for he includes a photograph of the painting in the volume of photographs of works he handled, now at the Avery Library, Columbia University, vol. AV31, *Photographs from Paintings by Knaus, Cabanel, Breton, . . .*

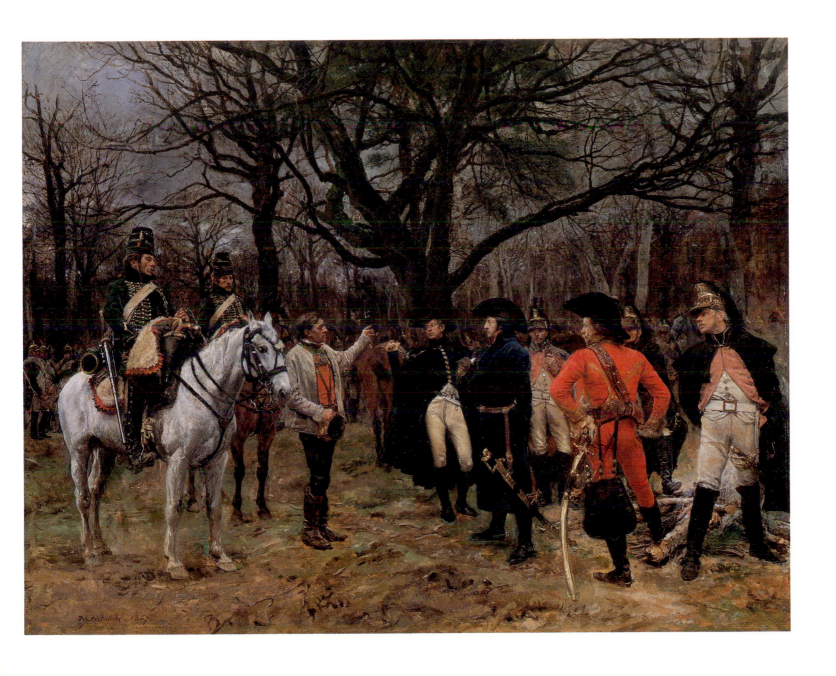

JEAN-LOUIS-ERNEST MEISSONIER
1815-1891

26. *The Cavalier: Portrait of the Artist*, 1872
Gouache, watercolor, and wash on paper, 13 1/4
x 8 7/8 in. (33.7 x 22.6 cm)
Signed and dated lower right: *EMeissonier 72*
The New-York Historical Society, New York; the
Robert L. Stuart Collection on permanent loan
from the New York Public Library

Shown only in Cincinnati and Washington, D.C.

Provenance: The artist; donated to the sale of foreign
paintings contributed by artists in aid of the Chicago fire
sufferers, 1872; purchased by Robert L. Stuart, New York;
Mrs. Robert L. Stuart, New York, 1882; gift to the New York
Public Library, 1892.

Exhibitions: *The Pedestal Fund Art Loan Exhibition*, National
Academy of Design, New York, 1883, no. 1; *In Support of
Liberty*, The Parrish Art Museum, Southhampton, and
National Academy of Design, New York, 1986, no. 14.

Literature: Strahan, *Treasures*, II, 1880, pp. 123, 124.

Single, standing cavaliers had long been one of
Meissonier's special subjects; as his fame increased and
his bearded features assumed the nobility of old age, he
more and more saw himself in the role of either the
older cavalier or the philosopher. In the former guise
he was able to make ample use of his large collection of
garments and armaments of earlier periods. Here, as
described by Strahan, the "truculent capitaine in a
morion helmet" stands firm guard before a fortress-
like backdrop. It is perhaps not by chance that the
artist chose this strong image of self determination as
his contribution to aid the victims of the great
Chicago fire.

A similar costumed self-portrait, *Captain of the
Guard—Louis XIII: Portrait of the Artist* of 1865, was in
the Stebbins collection.[1]

1. Sold, American Art Galleries at Chickering Hall, New York, Feb. 12,
1889, no. 56. See Strahan, *Treasures*, I, 1879, ill. p. 96.

JEAN-LOUIS-ERNEST MEISSONIER
1815-1891

27. *The Sign Painter*, 1872
Watercolor, 9 1/2 x 7 1/4 in. (24.1 x 18.4 cm)
Signed lower right: *EMeissonier 1872*
The Metropolitan Museum of Art, New York,
bequest of Catharine Lorillard Wolfe, 1887,
Catharine Lorillard Wolfe Collection

Shown only in Washington, D.C.

Provenance: Acquired in Paris by Catharine Lorillard Wolfe,
1872.

Literature: *Wolfe*, 1887?, p. 18, no. 137; Strahan, *Treasures*, I,
1879, pp. 125-26; *Wolfe*, 1897, p. 7, no. 19; Gréard, 1897,
ill. p. 60; Stranahan, 1897, p. 344; H. Stanley Todd, "The
Giant Artists of France," *Munsey's Magazine* (Sept. 1902), ill.
p. 933.

This is a variation of one of Meissonier's cleverest
compositions that he repeated a number of times in
different media. The most elaborate is an oil dated
1871 now in the Kunsthalle, Hamburg (fig. 40).[1] A
replica of it was in the collection of Lady Wallace.[2]
Both show what Strahan took to be an innkeeper
outside his establishment, studying the product of an
old-fashioned sign painter who, in the manner of
Boucher, has depicted a near naked "Bacchus in the
attitude of a capital A" straddling a wine barrel and
imbibing from a goat skin.[3] The barrel is at the
forefront, serving as a table for the painter's brushes
and oils. Meissonier executed some remarkable
drawings in preparation for the Bacchus.[4]

The watercolor that Catharine Lorillard Wolfe
acquired during her Parisian sojourn of 1872 is a more
polite version, showing a different gentleman
contemplating not a Bacchus signboard for an inn but
a standing figure, presumably his own portrait. The

barrel has been eliminated, the background is rather
different, and so too is the little painter, who here
seems even coarser, as he tries to convince the dubious
patron of his skill. Perhaps this work should more
aptly be called *The Portrait Painter*.[5]

1. Kraft and Schüman, 1969, p. 209, no. 1289.
2. Gréard, 1897, ill. opp. p. 176.
3. Strahan confusingly reproduces a facsimile of a sketch after the
Hamburg/Wallace composition and describes it in his text rather than
the one actually belonging to Miss Wolfe.
4. The one specifically for the painting is in the Fogg Art Museum,
Cambridge, Mass., and a grander variation is in a New York private
collection. See *The Male Nude*, Sterling and Francine Clark Art
Institute, Williamstown, 1980, no. 11.
5. It may indeed be identical with Chaumelin's no. 154, *Le peintre de
village faisant un portrait (The Village Painter Making a Portrait)*, signed
and dated 1872, which he includes in his section of paintings. See
Chaumelin, 1887, p. 52.

Fig. 40. *J.-L.-E. Meissonier*, The Sign Painter, *Hamburger
Kunsthalle.*

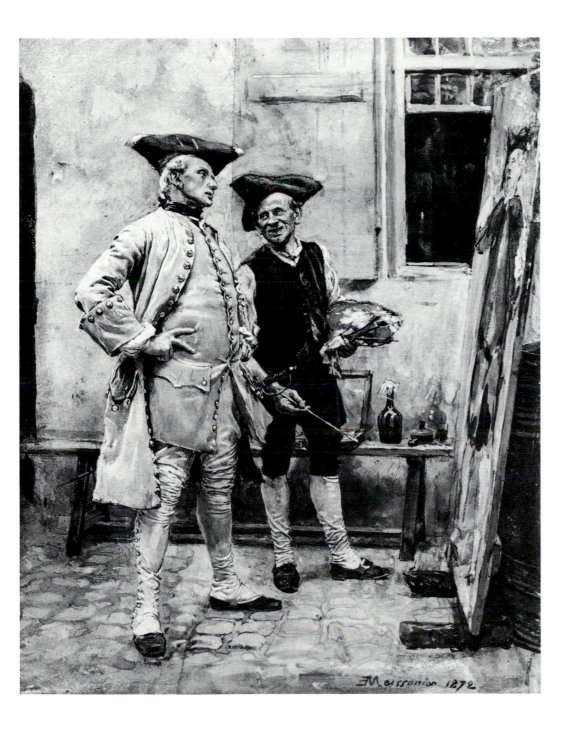

JEAN-LOUIS-ERNEST MEISSONIER
1815-1891

28. *The Smoker*, 1873
Watercolor and gouache, 13 3/4 x 8 9/16 in.
(34.9 x 21.7 cm)
Signed and dated lower right: *EMeissonier 1873*
Private collection

Provenance: Mr. Raphael; private collection, England, 1988;
Sandorval & Co., Inc., New York.

Literature: Gréard, 1897, ill. p. 213.

As Bénédite noted:

The success of Meissonier's "Smokers" and "Readers" was so
great, that between 1840 and 1860 he repeated these themes
many times. To distinguish them one calls them simply . . .
"Smokers seated" or "Smokers standing" etc. but none is
repetitious and each, by its attitude, its gesture, the character
of its face, of its isolation, of its setting, its furnishings, of the
private decor in which it breathes, speaks not only of its social
position, but also of the idiosyncrasies of its particular
individuality.[1]

Of Meissonier's innumerable "Smokers" this is one
of the most sensitive and touching. The model and
even his costume is that of the gentleman who appears
in the Hamburg version of *The Sign Painter* (see fig.
40). Here, as there, he is shown in profile with his
hand in his pocket. However, instead of dangling a
cigarette from his mouth he is smoking a pipe, and
instead of gazing at the remarkable Bacchus he seems
lost in a personal reverie. The delicate tones of the
watercolor and gouache complement this fleeting,
pensive mood.
 A watercolor sketch of a figure in almost the same
pose but without the pipe was also reproduced by
Gréard,[2] and the same model is shown seated holding
his pipe in a work called *Le Café*.[3]

1. Bénédite, p. 56.
2. Gréard, 1897, ill. opp. p. 248.
3. Larroument and Burty, 1893?, ill. p. 12.

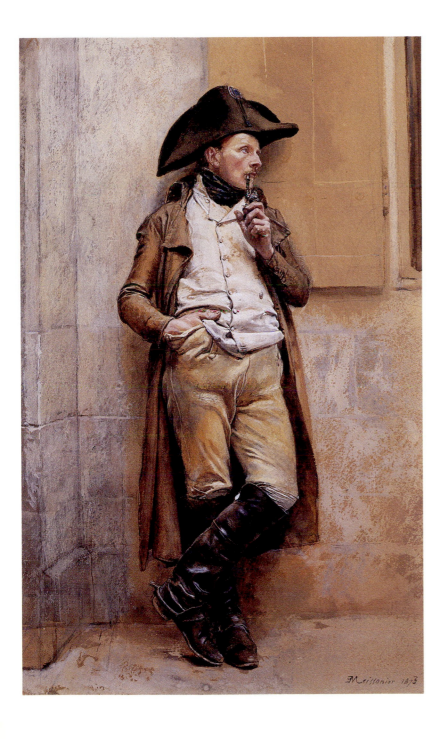

JEAN-LOUIS-ERNEST MEISSONIER
1815-1891

29. *Sous le balcon (Under the Balcony)* or *Courtyard of the Artist's Studio*, 1877
Watercolor on paper, 13 3/4 x 7 7/8 in. (34.9 x 20 cm)
Signed and dated lower left: *EMeissonier / 1877*
The Walters Art Gallery, Baltimore, Md.

Shown only in Washington, D.C.

Provenance: F. Boucheron, Paris.

Exhibitions: Paris, 1884, no. 96; Paris, 1893, no. 425 or 883.[1]

Literature: Chaumelin, 1887, p. 54, no. 171; Champlin and Perkins, 1886, II, p. 236; Gruelle, 1895, pp. 178-79, no. 221.

Of Meissonier's many gentlemen from the time of Louis XIII, this is one of the best in capturing the sense of a swashbuckling musketeer who seems to have just stepped out of the pages of a Dumas novel.

A perfect appreciation of it was written by Gruelle:

One of Meissonier's finest watercolors is of the open courtyard of his studio. It has all of the strength and depth attained by him at his best in the stronger medium of oil. A beautifully caparisoned cavalier, graceful and elegant of figure, is seen leaning against the wall of a court. His aspect is one of gayety, as with upturned face he seems to be singing a ditty to some fair one above. In his hands he holds a slender whip which he bends into a graceful curve. He is the height of picturesque beauty in his black slouch hat, gray coat, broad lace collar, tan colored boots and broad leather straps across his shoulders, from which hangs a sword. His face fairly beams with life. His ruddy complexion, sandy hued hair and artistic costume make a charming effect of color.

As Meissonier observed in another context, "water-color allowed me to introduce fresher tints,"[2] and the brilliance of this work proves the truth of his words.

1. The Walters watercolor seems identical to that reproduced as no. 425 in an etching in the sale catalogue, except that the artist's signature and date are placed at the lower right and the catalogue mistakenly gives the date as 1874; the same work then seems to be described as no. 883, but there the correct date is given. It is possible that Meissonier did two nearly identical versions.
2. Gréard, 1897, p. 253.

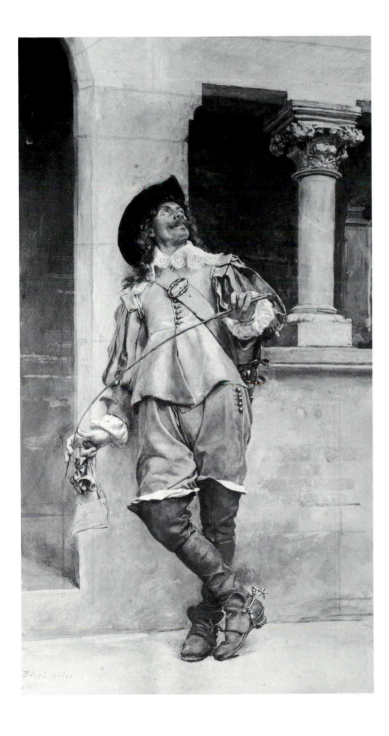

EMILE MEYER
NINETEENTH CENTURY

30. *The Letter*
 Oil on panel, 21 1/8 x 25 3/4 in. (53.7 x
 65.4 cm)
 Signed lower left: *Emile Meyer.*
 The Currier Gallery of Art, Manchester, N.H.,
 Florence Andrews Todd bequest, 1937

Little is known of Meyer, who showed at the Salon
from 1880 to 1896. His works included portraits and
genre subjects. Initially he was listed as a pupil of Jules
Delaunay, Pierre Puvis de Chavannes, and Jean-Jacques
Henner, but beginning in 1892 the name of Vibert was
added. Among his few known works are several of
cardinals very much in Vibert's manner.[1] They are
perhaps a bit more finicky and lack that final touch of
polish and high wit that Vibert brought to such
subjects.

In this example the tapestried walls and bearskin rug
are taken directly from Vibert. Both figures are
cardinals, the seated one wears the red biretta and shoes
appropriate for at home, while the standing visitor has
the black shoes and wide brimmed hat (on the chair)
that are worn for traveling. His red portfolio that
contained the epistle of good news is on the table.
Lacking one of Vibert's amusing texts, viewers must
invent their own plot line for the action. Is it some
church business or, more likely, some mundane matter
that brings smiles to their faces?

1. For example, one described in a sale at the American Art
Association, New York, Feb. 20, 1930, no. 43, and one sold at
Christie's, New York, May 24, 1989, no. 42.

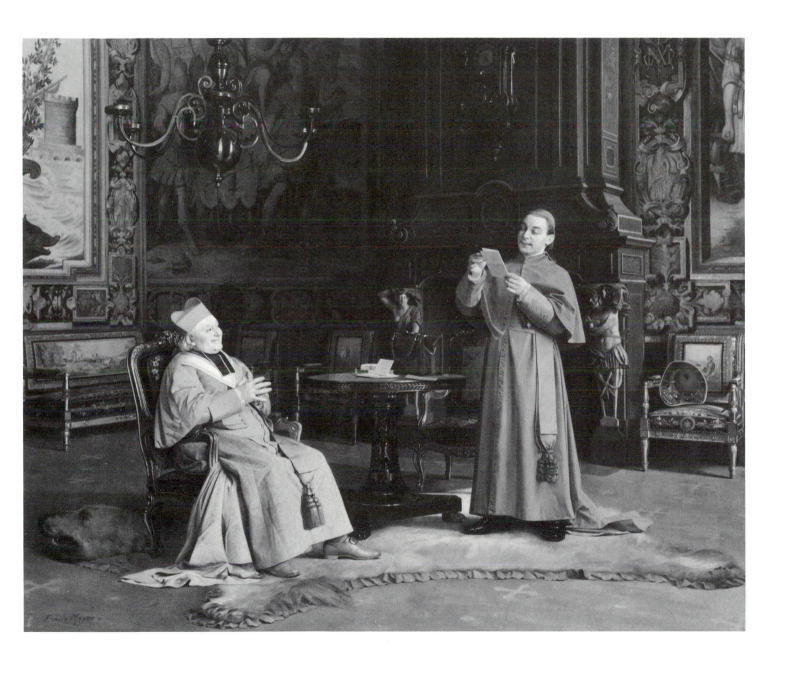

JEHAN-GEORGES VIBERT
1840-1902

31. *Toreros at Prayer before Entering the Arena,*
ca. 1871
Oil on canvas, 17 7/8 x 33 1/4 in. (45.4 x
84.5 cm)
Signed lower left: *J.G. Vibert.*
The Walters Art Gallery, Baltimore, Md.

Provenance: Goupil and Co., Paris; William Schaus, New
York, 1882;[1] acquired by William T. Walters between 1882
and 1884.

Exhibition: Baltimore, 1970, no. 31.

Literature: *Walters*, 1884, p. 17, no. 17; Gruelle, 1895, p.
162, no. 17; Vibert, 1902, I, p. 81; Johnston, 1982, pp. 115-
16, no. 125; Atlanta, 1983, p. 164; Mary Lublin, *19th- and
20th-Century Paintings*, Jordan-Volpe Gallery, New York,
1989, p. 110.

Vibert and the young Spanish painter Eduardo
Zamacoïs became friends in Paris and together visited
Spain sometime in the early 1860s. The visual proof of
this trip is the painting on which they collaborated and
exhibited at the Salon of 1866, *Entrée des toreros
(Entrance of the Toreros).*[2] For some time the present
painting has been identified as this work. However, it
is clearly a different scene of the bullfighters at prayer
in their chapel before entering the arena. What is
certainly the collaborative painting (and bears both
artists' signatures) is a work last seen in the New York
art market (fig. 41).[3] Not only does it better fit the
Salon title but its subject also accords with the one
fulsome review of the Salon painting written by
Edmond About.[4] He mentions both the somewhat
caricatured toreros and the public in the stands and
suggests the two artists needed a third collaborator to
achieve the proper perspective. Vibert in the *Comédie
en peinture* text for his chapter on the bullfights points

out that Zamacoïs appears in the painting as the
gentleman in the top hat near the gate at the lower
right. Vibert himself is seen in profile at the next level
up also wearing a rather outlandish top hat.[5]

In this same text Vibert reproduces the Walters
painting but with the date of 1871 clearly visible to the
right of his signature. The confusion over identifying
the painting stems in part from the fact that it does not
now have a date on it. So it has usually been assumed
that Vibert reproduced a replica in his book.[6]
However, careful examination of the area around the
signature reveals that it has been repainted.[7] It is thus
most likely the same painting but reworked, at least in
this area, after the photograph was made.

Vibert's text provides a detailed description of the
subject:

> The toreros in their brilliant costumes all kneeling on the
> stone floor are like a bouquet of flowers. They prostrate
> themselves in a fervent prayer. The soul easily ascends to God
> among those who are perhaps about to die.
> Only the tall picadors remain standing, unable to bend
> their knees because of their heavy protective leggings.
> At the side, behind the balustrade people pass and speak
> in lowered voices.
> The arrangement of this room dedicated to prayer is not
> felicitous. The altar is installed in the recess of an abandoned
> arcade. It is made of a fire place of which the shelf is
> decorated with ordinary vases filled with paper flowers. The
> single bench is of Arabic faience, and the trophies, the spoils
> [of the bullfight] are the only ornaments hung on the walls.

Vibert goes on to say this sad refuge cannot be
compared to the rich chapel where in former times the
toreros attended mass in the presence of the king and
all the court.[8] Nevertheless, there is a sparkling exotic
richness to this picture, which as Gruelle wrote in 1895
"is full of vital characters and drawing and reveals in its
finish the thoroughness of Vibert's method."

1. According to the article "Pictures and Statues" in *The New York Times*, Dec. 31, 1882, p. 5, Mr. William Schaus, formerly the New York agent of Goupil and now an independent dealer, had brought over in the course of the year Vibert's "Torreadors," which "gave the scene of the prayer before the beginning of the fantastic and often bloody work in the modern Spanish arena."
2. Exhibited under Zamacoïs's name, no. 1990.
3. It passed from the Schweitzer Gallery to the Bartfield Gallery.
4. Edmond About, *Salon de 1866*, Paris, 1867, pp. 64-65.
5. Vibert, 1902, I, p. 74.
6. Johnston, 1982, pp. 115-16.
7. As reported by E. Melanie Gifford, senior conservator of paintings at the Walters Art Gallery, in a letter of Nov. 1991.
8. The same subject as Vibert's painting was later treated by the Spanish artist José Gallegos Arnoso (1859-1917). See González and Martí, 1987.

Fig. 41. *J.-G. Vibert and E. Zamacoïs,* **The Entrance of the Toreros,** *private collection, photograph courtesy of Schweitzer Gallery.*

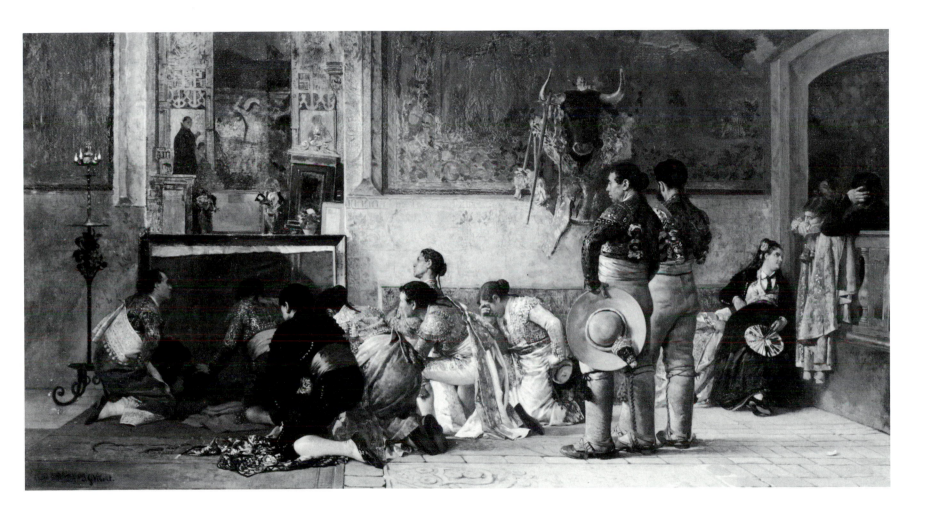

JEHAN-GEORGES VIBERT
1840-1902

32. *Le matin de la noce (Morning of the Wedding Day)*, 1869
Oil on panel, 12 x 16 in. (30.5 x 40.6 cm)
Signed lower right: *J.G. Vibert*.
Private collection

Provenance: William Schaus, New York, by Dec. 1882;[1] sale Parke-Bernet, New York, May 10-11, 1940, no. 4.

Exhibitions: *Salon*, Paris, 1869, no. 2356; Lexington, 1973, no. 69.

Literature: Paul Casimir Perier, *Propos d'art à l'occasion du Salon de 1869*, Paris, 1869, pp. 211-12; *Merveilles de . . . Salon de 1869*, p. 281; Montrosier, 1881, II, p. 123; Viardot, 1882, II, p. 17; Vapereau, 1893, p. 1561; Vibert, 1902, I, p. 185, ill.; Morton, 1902, p. 324.

The setting here is an eighteenth-century coppersmith's shop. The husband-to-be carefully dresses in authentic Louis XVI-period costume. The best man lolls, somewhat tipsily, on the small table observing his friend's preparations. With his reproduction of the painting in the *Comédie en peinture*, Vibert includes a short poem that says for this special occasion the craftsman makes an unusual effort to achieve a beautiful knot in his tie. Perhaps because of the work's small scale, the Salon reviewer Perier, who praised the painting as "*une petite perle*" (a little pearl), was the first of many to say mistakenly that the bridegroom is shaving.

Although Théophile Gautier in his Salon review for 1869 called Vibert "an artist of talent," he chose to speak of the other work exhibited by the painter, a scene of monks returning from an outing down a narrow street, called *Retour de la dîme (Return from the Tithe)*.[2] However, the anonymous author of *Les merveilles de . . . Salon de 1869* noted that "if the canvas is perhaps a little cold," it nevertheless shows "real progress" on the artist's part and that "rien de mieux éclaire, de plus fini, que cette petite scene. Les accessoires du fond . . . sont d'un faire inappréciable" (nothing is brighter, more finished than this little scene. The least significant accessories are inestimably executed).

At this time in the late 1860s Vibert was in fact perfecting his mastery of period details and producing several of the works he would later group in the *Comédie en peinture* as "Les petits gens au XVIIIe siècle" (Common Folk of the Eighteenth Century). Most relevant to the coppersmith's shop is the industrious interior of *La souricière (The Mousetrap Maker)* of the previous year.[3]

1. According to *The New York Times*, Dec. 31, 1882, p. 5, "The Wedding Day" was one of the Viberts brought to New York that year by the dealer William Schaus.
2. Théophile Gautier, "Le Salon de 1869," in *Tableaux à la plume*, Paris, 1880, p. 314. That painting is also reproduced as *La dîme* in Vibert, 1902, I, p. 128.
3. See Vibert, 1902, I, ill. p. 182.

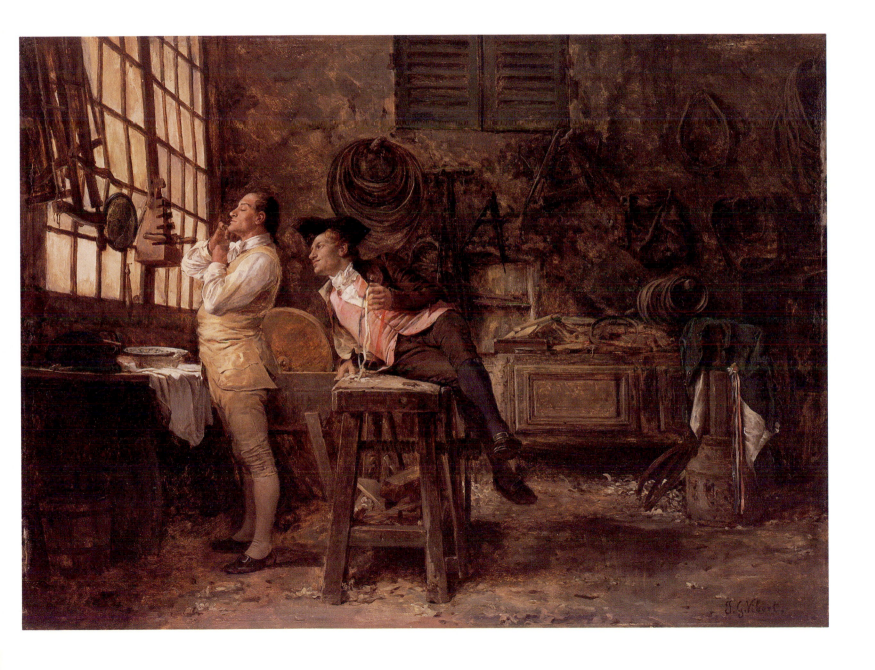

JEHAN-GEORGES VIBERT
1840-1902

33. *L'Importun (The Intruder)*, 1869
Oil on panel, 14 3/4 x 18 in. (37.5 x 45.7 cm)
Signed and dated lower right: *J.G. Vibert. 69*
Edward Wilson, Fund for Fine Arts, Chevy
Chase, Md.

Provenance: Henry Wallis, London, by 1870; P.
Langerhuizen; sale, Muller and Co., Amsterdam, Oct. 29,
1918, no. 67; sale, Sotheby's, New York, Oct. 23, 1990,
no. 317.

Exhibition: *Salon*, Paris, 1870, no. 2872.

Literature: Clement and Hutton, 1879, II, p. 322;
Montrosier, 1881, I, p. 123; Viardot, 1882, II, p. 12;
Castagnary, 1892, I, p. 437; Vapereau, 1893, p. 1561; Vibert,
1902, I, p. 157, ill.

In the text Vibert wrote to accompany this work in
his *Comédie en peinture*, he first defines *l'importun* (an
intruder or importunist) as someone "who bores, who
quickly wears out his welcome, who causes trouble and
disturbs." He then gives a quote from La Fontaine,
which concludes, "All importunists everywhere should
be chased." Vibert next tells his tale, which is one of
his most direct attacks on the Church. Having with
"the instinct of a snake" chosen a defenseless victim, the
clergyman has gained control over a young woman.
Now that she has recently married, he appears at her
home and, despite the efforts of the servants, makes his
way to the dining room. The young woman gets up,
confounded, already beginning to submit to the
influence of this man, with whom the husband will not
dare intervene. A violent tirade then follows,
denouncing "these parasites, these devouring
carnivores, these vampires preying on innocents." She
will consign her children to him or his replacements on
her deathbed. But lest we think he has gone too far,

Vibert reminds the reader that not all churchmen are as
venal as the one shown in this "*sombre tableau.*"

For this scene, evoking the dubious morality of
Molière's Tartuffe, Vibert has created an appropriate
seventeenth-century setting. The husband is in the
velvet suit and long curls of a Meissonier- or Viry-like
cavalier. His pose—seated with hand on the table—
even recalls Gérôme's depiction of Molière (see no. 7).
The obsequious interloper is the same figure that can
be seen in *Figaro and a Priest* (see no. 34).

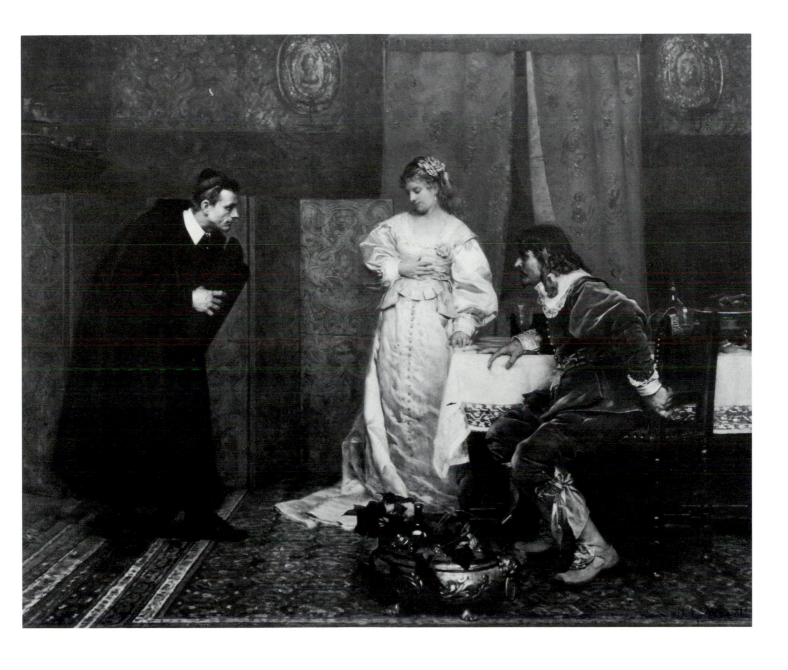

JEHAN-GEORGES VIBERT
1840-1902

34. *Figaro and a Priest*
 Watercolor, 10 1/4 x 7 1/4 in. (26 x 18.4 cm)
 Signed lower right: *J.G. Vibert.*
 Stamped lower right with the mark of the Société
 d'Aquarellistes Français
 Sandorval & Co., Inc., New York

Provenance: Private collection, London.

Literature: Vibert, 1902, II, ill. p. 141.

As part of his Spanish-inspired subject matter, Vibert did a series of works devoted to the figure he called "the gayest, trickiest, most active of all barbers," Figaro.[1] He takes the character created by Beaumarchais, and not forgetting Rossini, casts him in authentic Spanish dress and setting.

The accompanying text by Vibert in the *Comédie en peinture* relates that Figaro was awaited with impatience at the archbishop's residence, acting on private missions, delivering information and gossip. Shown here, the brilliantly dressed Figaro, carrying a sheaf of documents, leaves one of these rendezvous and encounters an obsequious priest.[2] Unhappily paying his respects to the barber, the priest has removed his large hat. Vibert undoubtedly saw such figures on his journeys to Spain. The impression they made on French visitors is recorded in Théophile Gautier's reminiscence of his 1843 voyage:

At Vergara . . . I saw, for the first time, a Spanish priest. His appearance struck me as rather grotesque, although, thank heaven, I entertain no Voltairean ideas with regard to the clergy; but the caricature of Beaumarchais' Basile involuntarily suggested itself to my recollection. Just fancy a black cassock, with a cloak of the same color, and to crown the whole an immense, prodigious, phenomenal, hyperbolical, and Titanic hat, of which no epithet, however inflated and gigantic, can give any idea at all approaching reality. This hat is, at least, three feet long; the brim is turned up, and forms, before and behind the hat, a kind of horizontal roof. It would be difficult to invent a more uncouth and fantastic shape; this, however, did not prevent the worthy priest from presenting a very respectable appearance, and walking about with the air of a man whose conscience is perfectly tranquil about the form of his headdress.[3]

This watercolor, since it bears the stamp of the Society of French Watercolorists, was probably included in one of their annual exhibitions. Its subject matter may accord with a work shown in 1881 titled *Rouge et noir (Red and Black)*, which was exhibited again that year by the artist in London.[4]

1. See Vibert, 1902, II, p. 139.
2. A watercolor titled *Figaro Ministre* was in the Vibert divorce sale, Hôtel Drouot, Paris, Apr. 21-23, 1887, no. 150.
3. Gautier, 1853, p. 20.
4. *Société d'Aquarellistes Français, troisième exposition, catalogue*, Paris, 1881, no. 2; *Catalogue of an Exhibition of Water Colour Drawings*, Goupil, London, 1881, no. 1.

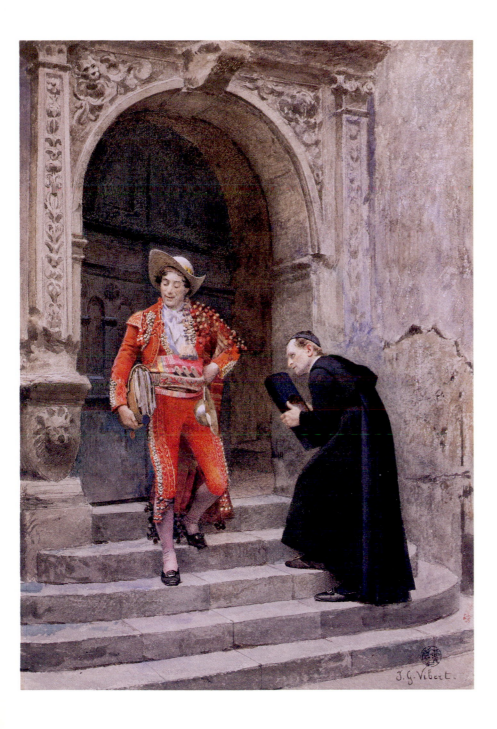

JEHAN-GEORGES VIBERT
1840-1902

35. *Le premier né (The First Born)*, 1872
Watercolor, 14 11/16 x 17 3/4 in. (37.3 x
45.1 cm)
Signed and dated lower left: *J.G. Vibert. 1872.*
The Metropolitan Museum of Art, New York,
bequest of Catharine Lorillard Wolfe, 1887,
Catharine Lorillard Wolfe Collection

Shown only in Washington, D.C.

Provenance: Acquired in Paris from the artist by Catharine
Lorillard Wolfe, 1872.

Literature: Clement and Hutton, 1879, II, p. 322;
Montrosier, 1881, p. 123; *Wolfe*, 1887?, p. 16, no. 123;
Strahan, *Treasures*, I, 1879, p. 134; Vapereau, 1893, p. 1561;
Wolfe, 1897, p. 6, no. 14; Vibert, 1902, I, detail ill. p. 175.

This scene of parental affection set in a splendid
interior of the period of Louis XV was placed by Vibert
in his *Comédie en peinture* as a frontispiece for the
section of works (including no. 32) dedicated to life in
the eighteenth century. One version of the
composition was exhibited by the artist at the Salon of
1873 where Claretie praised it as "*une petite chose
achevée*" (a perfect little thing).[1] It was then already in
the collection of James H. Stebbins of New York.[2] In
July of the previous year Vibert had shown a *First Born*
to the American dealer Samuel P. Avery.[3] Also in 1872
another New York collector Catharine Lorillard Wolfe
was in Paris acquiring a number of works, including
the present one, directly from the artists. Her
collection, bequeathed to the fledgling Metropolitan
Museum of Art in 1887, was exhibited there as a unit
for many years. Thus it appears that, as he occasionally
did with a popular subject that appealed to his
American clients, Vibert prepared two versions of this

work in 1872. The present location of the Stebbins
version is not known.

The Wolfe watercolor, although shown often during
the nineteenth century, has been little exhibited since
and is therefore in remarkably pristine condition.
Through his ceaseless scientific experimentation in this
medium, Vibert had developed a new process that he
claimed, "renders water-color imperishable and
unchangeable," according to the critic Edward Villars,
who commented further:

> The appearance of the water-color painting executed by the
> Vibert process is that of very heavy gouache or of color
> applied with wax. Naturally the transparency of real water-
> color is lost in this process; as for the advantage of being
> imperishable we shall have to wait a century or so to see
> whether M. Vibert can really guarantee immortality or not.[4]

The artist appears to have been justified in his claim.

1. Salon of 1873, no. 1442. Claretie, 1876, p. 174.
2. See Strahan, *Treasures*, I, 1879, pp. 100, 106, ill. p. 99, and Georges
Le Fenestre, "Salon de 1873," *GBA*, July 1873, p. 43. Sale, American
Art Galleries at Chickering Hall, Feb. 12, 1889, no. 61, with
measurements of 15 x 18 in.
3. Avery, *Diaries*, 1979, p. 114.
4. Edward Villars, "The Paris Water-Color Exhibition," *The Art
Amateur*, XIV (1886), p. 102.

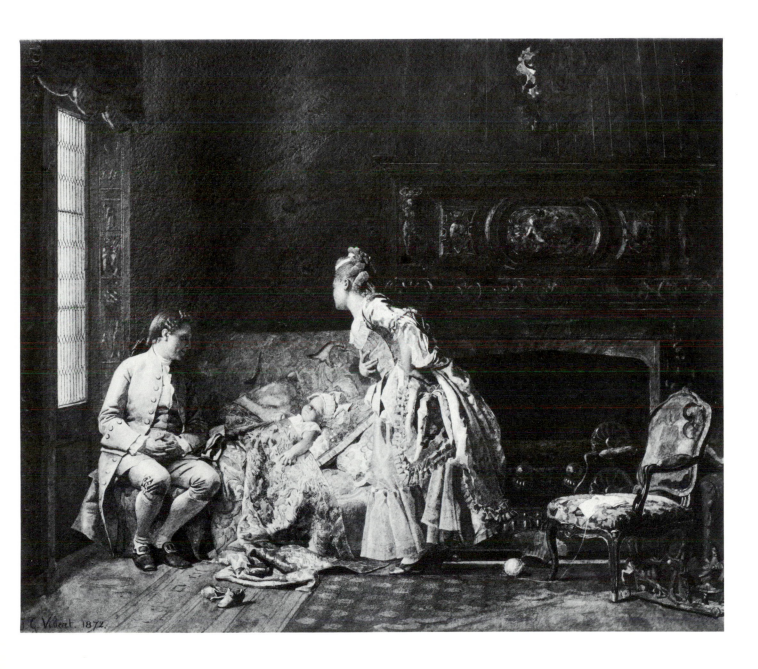

JEHAN-GEORGES VIBERT
1840-1902

36. *The Reprimand*, 1874
 Oil on canvas, 20 3/8 x 33 in. (51.8 x 83.8 cm)
 Signed and dated lower left: *J.G. Vibert. 1874.*
 The Metropolitan Museum of Art, New York,
 bequest of Catharine Lorillard Wolfe, 1887,
 Catharine Lorillard Wolfe Collection

Shown only in Cincinnati

Provenance: Catharine Lorillard Wolfe, New York, 1874-87.

Exhibitions: *Salon*, Paris, 1874, no. 1785; *Exposition Universelle*, Paris, 1889, no. 431.

Literature: Gonse, 1874, pp. 38-40; Paturot, 1874, pp. 36, 250; P. de la Flécherye, *Le Salon de 1875*, Paris, 1875, p. 123; Claretie, 1876, p. 253; J. B. F. W., 1878, p. 185; Strahan, *Treasures*, I, 1879, p. 130, ill. opp. p. 128; Clement and Hutton, 1879, II, p. 322; Montrosier, 1881, I, p. 123; Viardot, 1882, II, p. 17; *Wolfe*, 1887?, p. 8, no. 19; Cook, 1888, I, p. 194; *Famous Paintings of the World*, New York, 1894, p. 44; Vibert, 1895-96, pp. 720, 722, ill. p. 723; *Wolfe*, 1897, p. 28, no. 107; Vibert, 1902, II, p. 66, ill.; *The New York Times*, June 6, 1909, ill.; Sterling and Salinger, 1966, p. 196.

Painted for the American collector Catharine Lorillard Wolfe and lent by her to the Salon of 1874, this painting combines two of Vibert's chief concerns—Spanish subjects and depictions of the clergy. In a picturesque Andalusian town, the venerable village priest, his pet cat Minos by his side, complacently sips chocolate in a lovely garden as he receives his parishioners. Here Doña Pilar berates her solemn daughter, Conception. In this painting, described nicely by Claretie as a "*vaudeville espagnol*," the girl's exact crime is not revealed. The text of the *Comédie en peinture* tells how the wise old priest, through innuendo, reminds the mother that she too was beautiful in her youth and also caused her parents to despair, so that his punishment for Conception is to threaten her with having in her turn an equally recalcitrant child.

Gonse in his Salon review found:

> Never has Mr. Vibert, who has wit right down to his fingertips, found a cleverer subject; never has he painted with more finesse. This Reprimand is of a perfect gaiety; it is a little comic dialogue minutely executed with exquisite artistry. . . . Molière would have known how to say it in plain French by calling her a hussy. One assumes that the reprimand will not be very severe and that compromises are possible with Heaven.

Paturot, for his part, also found "the expressions perfect, each appropriate to its role, and the whole work agreeable and at the same time amusing."

As always with Vibert it is the appreciation of the details that matters. In this case one cannot help but admire the strategically placed parasol that serves to accentuate the forceful attitude of the mother. A small study for the composition dated 1873 is in the Henry Art Gallery, Seattle,[1] and a grisaille copy was included in the Vibert estate sale.[2]

1. Richard Grove, *Henry Gallery, Five Decades*, Seattle, 1977, p. 78, no. 141.
2. Paris, Nov. 25-26, 1902, no. 91.

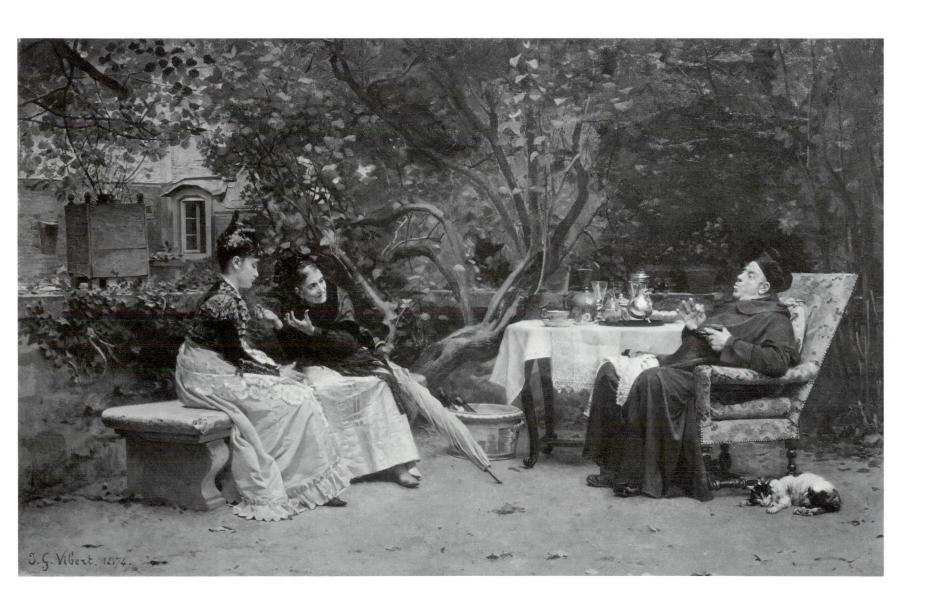

JEHAN-GEORGES VIBERT
1840-1902

37. *The Schism*, 1874
Oil on panel, 15 x 21 1/8 in. (38.1 x 53.7 cm)
Signed and dated lower right: *J.G. Vibert. 1874*
Edward Wilson, Fund for Fine Arts, Chevy
Chase, Md.

Provenance: John Duff, Boston, by 1879; inherited by his family; Le Prenner; Reichard and Co., New York, 1889; purchased by The Corcoran Gallery of Art, Washington, D.C., Nov. 8, 1889; sold to John W. Cragun, May 23, 1967; Roy Anderson, San Francisco, to 1988.

Literature: "Vibert's *'Un Schisme,'" The Art Journal*, 1875, p. 115, ill. p. 114; *The Aldine*, 1879, p. 382; Strahan, *Treasures*, III, 1880, p. 89; Sheldon, 1882, pp. 120, 124; William Howe Downes, "Boston Painters and Paintings: Private Collections," *The Atlantic Monthly* (Dec. 1884), p. 785; *The Corcoran Gallery of Art, Catalogue*, Washington, D.C., 1890 and 1892, p. 51, no. 211; Vibert, 1895-96, pp. 719-20; idem, 1902, I, p. 105, ill.; Morton, 1902, p. 328; *Catalogue of the Paintings in The Corcoran Gallery of Art*, Washington, D.C., 1905 and 1907, p. 40, no. 74, and 1908 and 1909, p. 49, no. 109; *Handbook of Paintings . . . The Corcoran Gallery of Art*, Washington, D.C., 1939, p. 95, no. 363; Bénézit, 1976, X, p. 486.

One of the most often reproduced of Vibert's compositions, this work, although small, has wonderful visual impact, making immediately clear the point of its title. As in *Les journaux* (see no. 54), the participants in this little drama are of contrasting types. The abbot is tall, bald, and jovial; a Trinitarian, he wears a white tunic with a blue scapula and red and blue cross in front; his black biretta is nearby. His companion is small with sallow skin and long gray hair, wearing the scarlet cassock and biretta of a cardinal.

As Vibert sets the scene in the *Comédie en peinture*, it is in the reception room of a rich monastery hung with old tapestries. After a lunch of a paté and much old wine, the cardinal, Ignatius Petrucci, first toasts his lifelong friend the abbot bishop Barnaby. But gradually they begin to bicker over an old theological dispute; tomes are brought from the library, and the discussion grows ever more heated with cries of "error," "heresy," and finally "schism." "A schism? so be it! At least your Eminence will find therein the joys of separation. And the two adversaries, with one impulse, falling furiously into their armchairs, remain seated back to back without speaking another word." The painter-author concludes his narrative by chiding his subjects: "Oh Gentlemen! Two venerated prelates—two friends! If an artist, lifting up the corner of a curtain, should see this scene, and then think of reproducing it, what a sad example you would set!"

This image, "an awful example of the *odium theologicum*," as Strahan called it, quickly became famous. The unidentified writer in the 1875 *Art Journal* noted, "The picture is admirably composed, and in the effect of light and shade, as well as harmony of expression in its various relations of color, it is conceded to be a masterpiece." A smaller version signed at the lower left and not dated was in the Edwin S. Chapin collection, New York,[1] and an etching of the composition was made by Mongin.[2]

1. Sold at Chickering Hall, New York, Jan. 27-28, 1893, no. 82, as *Theological Debate*, 12 1/2 x 17 1/2 in.
2. An impression was sold in the Vibert divorce sale, Hôtel Drouot, Paris, Apr. 21-23. 1887, no. 206.

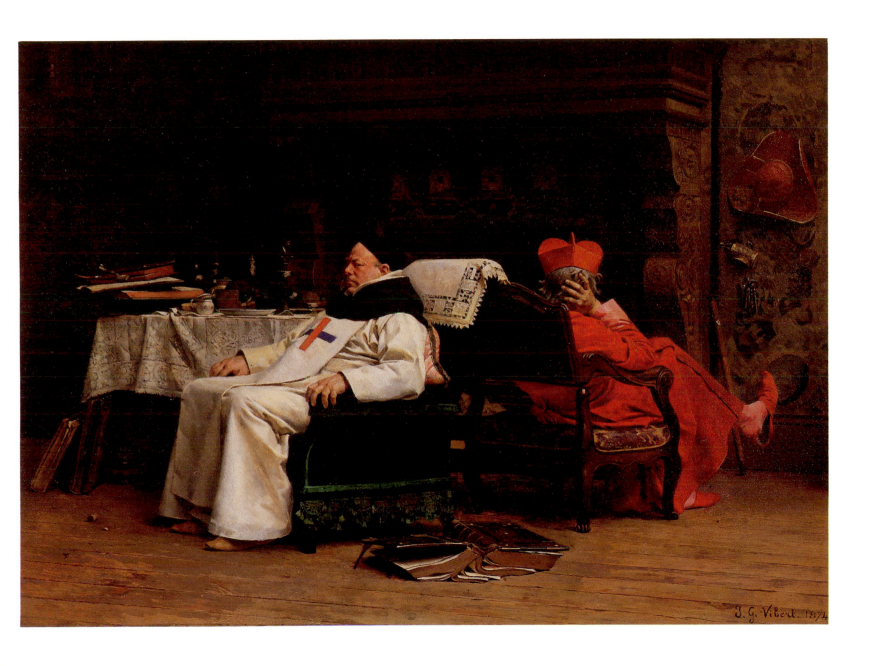

JEHAN-GEORGES VIBERT
1840-1902

38. *The Serenade*, 1877
 Oil on panel, 18 1/8 x 14 3/4 in. (46 x 37.5 cm)
 Signed lower right: *J.G. Vibert.*
 Dr. and Mrs. Howard R. Knoll, Anaheim, Calif.

Provenance: A. Dreyfus, Paris; sale, Galerie Georges Petit, Paris, May 29, 1889, no. 74; Mrs. John Stewart Kennedy, 1889; Mrs. F. L. Kellogg; sale, American Art Association, New York, Nov. 12, 1931, no. 13; Harry Hirschfield; James Coats; sale, Parke-Bernet, New York, Feb. 12, 1970, no. 93; Ira Spanierman, New York; sale, Parke-Bernet, New York, Apr. 17, 1974, no. 65; Shepherd Gallery, New York; Mr. and Mrs. Harry Glass; sale, Sotheby's, New York, Feb. 22, 1989, no. 135.

Exhibitions: *Salon*, Paris, 1877, no. 2155; *Exposition Universelle*, 1878, no. 830; Shepherd Gallery, New York, *Ingres and Delacroix through Degas and Puvis de Chavannes: The Figure in French Art, 1800-1870*, 1975, no. 147.

Literature: F. Fertiault, *Salon de 1877, Causeries d'un flaneur*, Paris, 1877, pp. 22-23; Paul de Saint-Victor, "M. Vibert" in "Un Salon composite," *L'Artiste* (July 1877), p. 26; "The Paris Salon of 1877," *The Art Journal*, New York, 1877, p. 251; J. B. F. W., 1878, p. 182; *The Aldine*, 1879, p. 384; Clement and Hutton, 1879, II, p. 322; Viardot, 1882, II, p. 17; Castagnary, 1892, II, p. 313; Vibert, 1902, I, p. 83, ill.; Bénézit, 1976, X, p. 489.

39. *Viendra t-il (He Doesn't Come)*, 1880
 Oil on canvas, 23 3/4 x 19 1/2 in. (60.3 x 49.5 cm)
 Signed lower left: *J.G. Vibert.*
 Edward Wilson, Fund for Fine Arts, Chevy Chase, Md.

Provenance: William Rockefeller, Tarrytown and New York; sale, Anderson Galleries, New York, Nov. 23, 1923, no. 1832;[1] J. Levy.

Literature: Strahan, *Treasures*, III, 1880, p. 125; Sheldon, 1882, p. 120; Vibert, 1902, I, p. 85, ill.; Lucas, *Diary*, 1979, II, p. 487; Avery, *Diaries*, 1979, p. 559.

Here again we have humorous Spanish subjects that recall incidents from Rossini's *Barber of Seville*. *The Serenade*, described fully in the various reviews, is undoubtedly the painting exhibited at the Salon of 1877.[2]

In the *Comédie en peinture* Vibert tells how the Spanish of all ranks are committed to their guitars and sets this scene of an elegant gentleman who has removed his instrument from its case and begins his serenade under the window of his beloved. The old lackey, who has been on such outings before, wisely conceals himself in a garden niche to avoid anything that might be hurled from above. Despite repeated serenading, no beloved appears, the servant falls asleep, and the enraged master may smash him with his instrument.

But as Vibert writes, "That is of little import, what would be interesting is to see what goes on up above and we can satisfy that curiosity." The scene thus shifts to the subject of the other painting, which he tells us is "taking place on a terrace facing onto the street on the opposite side of the garden." All is prepared for the meal. The table is set under a reed shade, the wine is chilling, and the soup is on the table; but, alas, it is not only the soup that is on the table. The young woman is also there, and she is not cooling off. She curses her absent guest and speculates that he is at the feet of some rival. Her duenna periodically looks out into the deserted street, but he does not come. All they can hear is the annoying serenade of the guitarist at the other side of the garden. The young woman berates the duenna and may beat her.

As Vibert concludes,

this is certainly the doing of that little capricious and mischievous god [Cupid]. If instead of loving the one who does not come she loved the one who wishes to love her, all would be happy. Her soup would be eaten hot, and the duenna and the servant instead of being beaten could sit peacefully in the kitchen, gossiping about their masters.

These two scenes thus seem ideally paired, each with a master and servant and each with a profusion of plants and other well-observed details. But are they in fact true pendants, or has Vibert woven his elaborate story as a way of linking two disparate Spanish subjects for the sake of his text? The latter would seem to be the case given their differing sizes and supports. The independent status of the two works is further suggested by information given in the diaries of Avery and Lucas. According to the entry in Avery's diary for May 17, 1880, he and Lucas visited Vibert and paid him 13,000 francs "for picture 'He does not come.'" Lucas for his part noted that Avery owned "He don't come," and that at this time it was an independent work, for he proposed to the painter Jules Worms (also renowned for his Spanish subjects) that he paint a pendant to it. Later that same day Vibert himself told Lucas he "would not make aquarelle of Dont Come without Avery wanted it."

Vibert had collected Spanish clothes and objects during his visits to Spain and continued to use them in creating authentic settings. The *señorita* in *He Doesn't Come* is reminiscent of some elegant prototypes in paintings by native Spaniards, such as Raimundo de Madrazo,[3] but Vibert also devoted a number of other works to *la maja*, that seductive embodiment of Spanish femininity.[4]

1. The painting's subject was misinterpreted, and it was given the title *A Watchful Parent*.
2. In both *The Art Journal* of 1877 and Saint-Victor's review in *L'Artiste*.
3. See the example sold in the William H. Stewart sale, American Art Galleries, New York, Feb. 3-4, 1898, no. 37.
4. See Vibert, 1902, I, pp. 66-70.

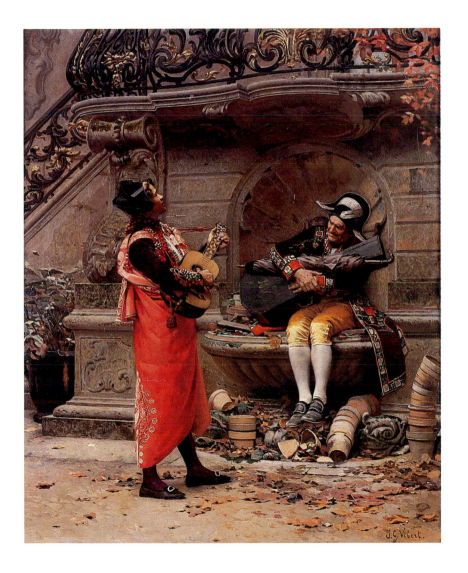

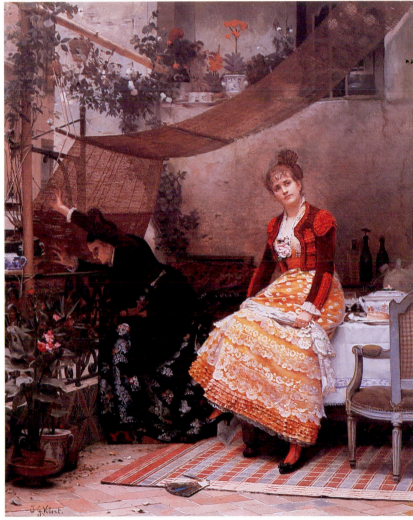

JEHAN-GEORGES VIBERT
1840-1902

40. *The Naturalists*, late 1870s
 Oil on canvas, 20 3/8 x 25 1/8 in. (51.8 x
 63.8 cm)
 Signed lower left: *J.G. Vibert*.
 The Corcoran Gallery of Art, bequest of Mr.
 August M. Whittingham, 1980

Provenance: Goupil and Co., Paris; Weenen, Mar. 29, 1898,
no. 64; Mr. August M. Whittingham.

Exhibition: *La Vie Moderne: Nineteenth-Century French Art
from the Corcoran Gallery*, Corcoran Gallery of Art,
Washington, D.C., 1983, no. 22.

Literature: Vibert, 1902, I, ill. p. 153.

In the section titled "Les victimes de l'église"
(Victims of the Church) in his *Comédie en peinture*,
Vibert depicts an ecclesiastical butterfly collector in the
work titled *La libellule (The Dragonfly)*;[1] on the
opposite page he reproduced this painting, which
shows two gentlemen in eighteenth-century costume
engaged in the same pursuit. The man with the net
and a hat full of butterflies, like the cardinal's, may be
the servant, and the gentleman with the book to
identify the species his master. Vibert also did a
drawing of a similar subject titled *Les Naturalists*,
showing two men, one with a lens and the other with a
book, admiring an insect.[2] Strahan gave the same title
to a watercolor in the collection of Samuel Hawk but
unfortunately without a detailed description.[3] The
title is appropriate for the present work as well.

1. A watercolor with the same title was included in the Vibert estate
sale, Paris, Nov. 25-26, 1902, no. 53.
2. See Montrosier, 1881, I, ill. opp. p. 123; and Strahan, *Etudes*, 1882,
p. 17.
3. Strahan, *Treasures*, II, 1880, p. 32.

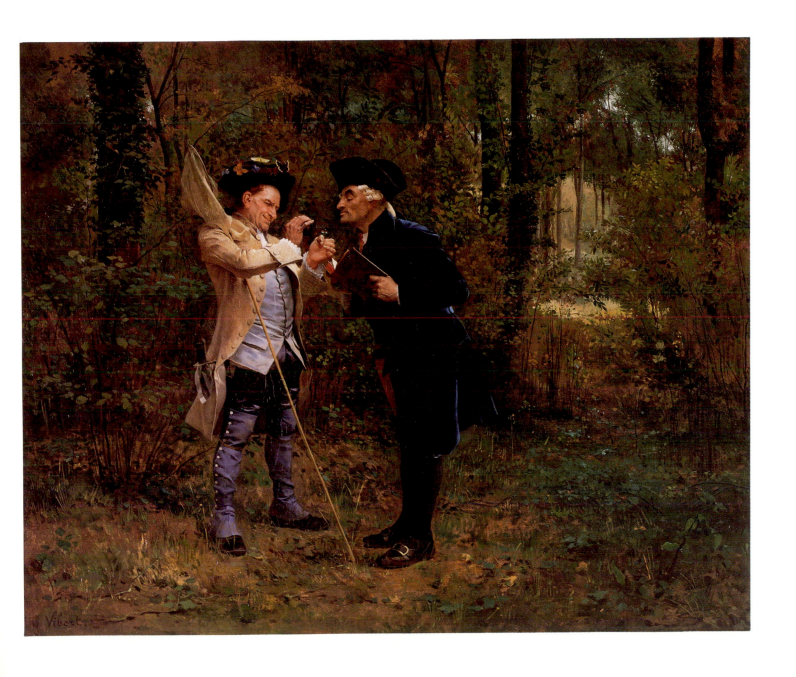

41. *Une cause célèbre* or *The Trial of Pierrot*,
ca. 1883
Oil on panel, 19 x 28 3/4 in. (48.3 x 73 cm)
Signed lower left: *J.G. Vibert.*
Private collection

Provenance: John Sellers, Jr., Philadelphia, by 1899; sale, Sotheby's, New York, Feb. 11, 1981, no. 41.

Exhibition: *Art Loan Exhibition*, The Union League of Philadelphia, May 1899, no. 72.

Literature: Vibert, 1902, I, p. 226, ill.; Morton, 1902, p. 328, ill. p. 324.

In the *Comédie en peinture* this work occurs near the end of volume I in the section "Côntes et fantasies" (Tales and Fantasies). It is given the title *Une cause célèbre* and an explanatory text. A charming young girl had married a much older man and, as is common in such cases, had taken a series of lovers. One of her spurned admirers, however, reported the affair to the husband. He had the unfaithful lovers spied on, seized, and taken to court. But both the innocent character of the young man and the obvious fabrications of the husband's lawyer introduced a doubt in the judge's mind. The charges were dropped and the husband and the wife told to go home together. After their reunion they produced several children. This unusual case of happy reconciliation became so popular as the subject of pantomime performances that it had to be banned. But the ban did not apply to painted or engraved representations and thus the present image.

Vibert has peopled his depiction of the trial with characters taken from the *commedia dell'arte.* In the early part of the nineteenth century the master mime actor Deburau resurrected the poignant character of Pierrot and gave him new currency on the Parisian stage.[1] He introduced the black skull cap seen here on the head of the naive Pierrot, cast as the sad lover in the dock. The contemporary interest in the character of Pierrot is evident in the work of several French artists, who all show Pierrot and his troupe in various modern situations.[2] Among the best known are those of Thomas Couture,[3] and in one of Gérôme's most famous paintings, *The Duel after the Masked Ball,* the victim of the duel is dressed as Pierrot and his assassin is seconded by Harlequin. Vibert, himself, produced other representations of the *commedia* characters, including one of his 1892 Salon works, *Le déséspoir de Polichinelle (The Despair of Pulchinelle),*[4] and a watercolor shown in 1869 titled *Arlequin chez l'avocat (Harlequin Visiting the Lawyer),* which is most likely the work now in the museum of Glasgow.[5]

In the present courtroom farce Vibert portrays the coy Columbine as the other hapless lover. The old man seated at the front right in eighteenth-century-style dress is the insulted husband, and whispering slander into his ear is Pierrot's traditional nemesis, the masked figure of Harlequin. It is his "*monstrueux canards*" that pop out of the basket in a clever visual pun. The cast of characters is completed by the fat Pulchinelle with false stomach and hump dressed as the pompous defense lawyer and three seemingly intoxicated soldiers.

At the 1883 exhibition of the Society of French Watercolorists Vibert showed a watercolor version of *Une cause célèbre,*[6] which is probably the work now in the Art Institute of Chicago.[7] At the time of its exhibition by the Union League Club in 1899, the oil was known as *The Trial of Pierrot.* This title and indeed Vibert's subject may have been borrowed from a well-known work by Couture of the early 1860s.[8] In it the equally sad Pierrot is accused of having stolen wine and food. He is defended in this case by Harlequin. A mustachioed soldier in uniform is present, and two judges slumber on the bench.

If the subject of Vibert's painting was not always well understood, it was, nevertheless, clear that this was one of his most sumptuous creations. The effect of the marble wall, the rich colors of the theatrical costumes, and the clever poses all unite to make it a tour de force of brilliant technique and imagination.

1. See Robert F. Storey, *Pierrot: A Critical History of a Mask,* Princeton, 1978, fig. 11, and Francis Haskell, "The Sad Clown," in *French Nineteenth-Century Painting and Literature,* ed. Ulrich Finke, Manchester, 1992, pp. 2-16.
2. Meissonier did a famous Pulchinelle of which the prime version is probably that in the Wallace Collection. See *Wallace,* 1968, p. 198. One of 1856 by Courbet is in the National Gallery of Canada, Ottawa. See Brooklyn, 1988, no. 98. For an example by Gustave Doré, see Sotheby's, New York, Oct. 29, 1987, no. 25; a large one by Alexis Vollon was sold recently at Christie's, New York, Oct. 16, 1991, no. 58. A. Carrier-Belleuse showed *Le miroir de Pierrot* in 1891. See *Exposition nationale des beaux-arts, catalogue illustré,* Paris, 1891, p. 125, no. 1002, ill. A *Peirrot* by Léon Comerre is illustrated in Cook, 1888, II, p. 119. A depiction of Pulchinelle in court is also included as one of the illustrations for a playlet by Gérôme Doucet that appeared in the *Revue illustré,* no. 9, Apr. 15, 1900.
3. See Albert Boime, *Thomas Couture and the Eclectic Vision,* New Haven and London, 1980, pp. 292-322.
4. This may be the work in Vibert, 1902, I, p. 228 or 229. Watercolors devoted to Pulchinelle were shown by Vibert at the Society of French Watercolorists, Paris, 1890, nos. 175, 177, and were later included in Vibert, 1902, I, pp. 230-31.
5. *French Paintings and Drawings: Illustrated Summary Catalogue, Art Gallery and Museum, Glasgow,* Glasgow, 1985, p. 140, no. 1214.
6. *Société d'Aquarellistes Français, cinquième exposition, catalogue,* Paris, 1883, no. 1, ill. Both preliminary studies for the composition and an etching after it were included in the Vibert estate sale, Paris, Nov. 25-26, 1902, nos. 101, 107.
7. In the A. A. Munger collection (1901.425). See *Union Club of Chicago: Catalogue of Paintings and Other Works of Art,* Chicago, 1899, p. 30.
8. Boime, fig. IX, 25. The drawing formerly in the Collis P. Huntington collection (Strahan, *Treasures,* II, 1880, pp. 99-100) is now at The Cleveland Museum of Art as part of the Butkin donation. See *Bulletin of the Cleveland Museum of Art,* June 1981, p. 182, fig. 40.

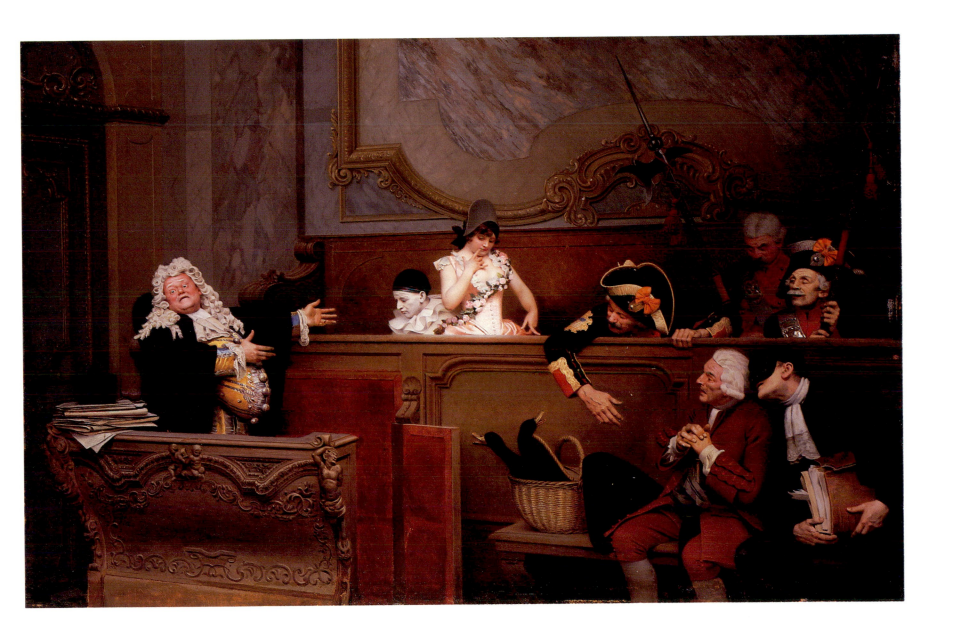

JEHAN-GEORGES VIBERT
1840-1902

42. *Les apprêts (The Preparations)*
Oil on panel, 25 3/8 x 32 in. (64.5 x 81.3 cm)
Signed lower left: *J.G. Vibert.*
Joey and Toby Tannenbaum, Toronto

Provenance: Christie's, New York, Oct. 25, 1984, no. 72.

Literature: Vibert, 1902, I, p. 71, ill.

This (like nos. 31, 36, 38, 39) is one of Vibert's many Spanish subjects. In his *Comédie en peinture* he relates that the scene is set on a summer Sunday in Seville, one hour before the bullfights are to begin. A hurried meal of fruit, biscuits, and wine has been completed and now:

The senora finishes her toilette and admires herself in the mirror; . . . her agile fingers have overturned the bouquet of roses brought to her to choose the flower which complements her capricious beauty. . . . The student who loves her regards her passionately. His smile is sweet, but the blade, which he slowly sharpens, throws off flashes of steel. She is vain, he is jealous.

Vibert has thus sought to compress into a single image those traits thought characteristic of the Spanish temperament in the nineteenth century—love, passion, and violence.

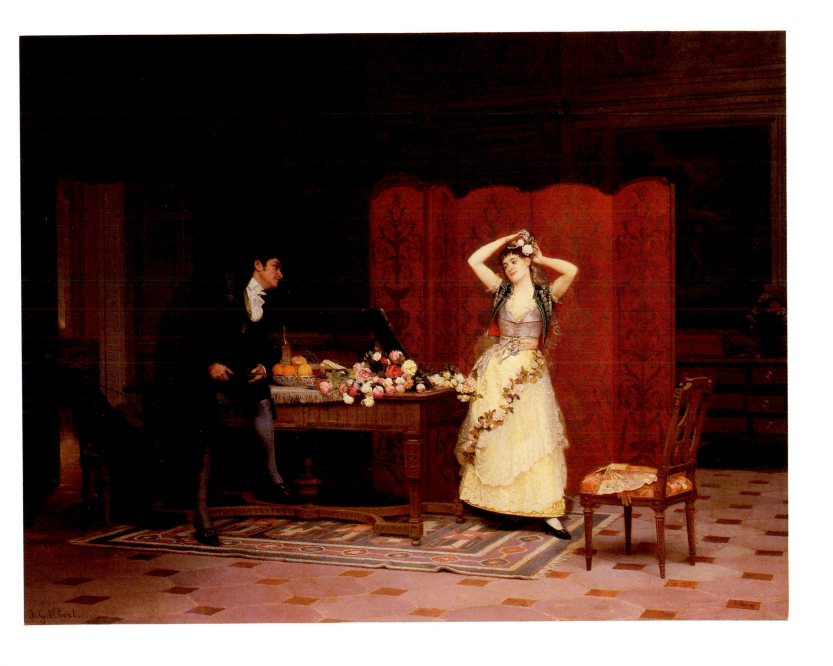

JEHAN-GEORGES VIBERT
1840-1902

43. *The Cardinal's Menu*, early 1880s
Oil on panel, 23 1/2 x 28 7/8 in. (59.7 x
73.3 cm)
Signed lower left: *J.G. Vibert.*
Arnot Art Museum, Elmira, N.Y., bequest of
Matthias H. Arnot, 1910

Provenance: Mrs. Mary J. Morgan; sale, American Art
Galleries, New York, Mar. 3-5, 1886, no. 153; M. H.
Arnot, 1886.

Exhibitions: *19th-Century French Salon Paintings from the
Arnot Art Museum*, Munson-Williams-Proctor Institute,
Utica, N.Y.; Tyler Art Gallery, SUNY, Oswego, N.Y.; and
Dulin Gallery of Art, Knoxville, Tenn., 1984-85; idem, Leigh
Yawkey Woodson Art Museum, Wausau, Wisc.; Lakeview
Museum of Arts and Sciences, Peoria, Ill.; Krasl Art Center,
St. Joseph, Mich.; and Dixon Gallery and Gardens, Memphis,
Tenn., 1987-89; Arnot, 1989, no. 20; Tulsa, 1989-90, no. 27;
People's Choice: Community Favorites from the Collection, Arnot
Art Museum, Elmira, N.Y., 1992.

Literature: Cook, 1888, I, p. 194; Stranahan, 1897, p. 348;
Vibert, 1902, I, p. 124, ill.; Morton, 1902, p. 328; *Arnot*,
1936, no. 20; *Arnot*, 1973, p. 139; Bénézit, 1976, X, p. 489.

This is one of two works of cardinals and chefs that
Vibert used to illustrate his chapter "L'Inspiration" in
the *Comédie en peinture*. The text, which relates to the
other work, sets the scene in Italy where his eminence
enters the kitchen of his favored chef Antonio Vatellini,
"the Caesar of cooking." Surrounded by all the
produce of forest, ocean, and garden, he has to devise a
remarkable dinner for the cardinal's guests of the
evening. The present picture is a variation of the
theme. The chef and cardinal are different figures from
the Vibert repertory company. In this case the chef has
seemingly been called into the cardinal's chamber,
which is filled with produce, especially a notable

number of fish and lobsters. In what could be
considered the pendant to either of these planning the
menu subjects, *Le cordon bleu*, an assembled group of
churchmen applaud the chef after their highly
satisfactory dinner.[1]

1. Shown at the Salon of 1891, no. 1656, and sold in the estate of John
Knoedler, Chickering Hall, New York, Apr. 11-14, 1893, no. 385. See
Vibert, 1902, II, ill. p. 172.

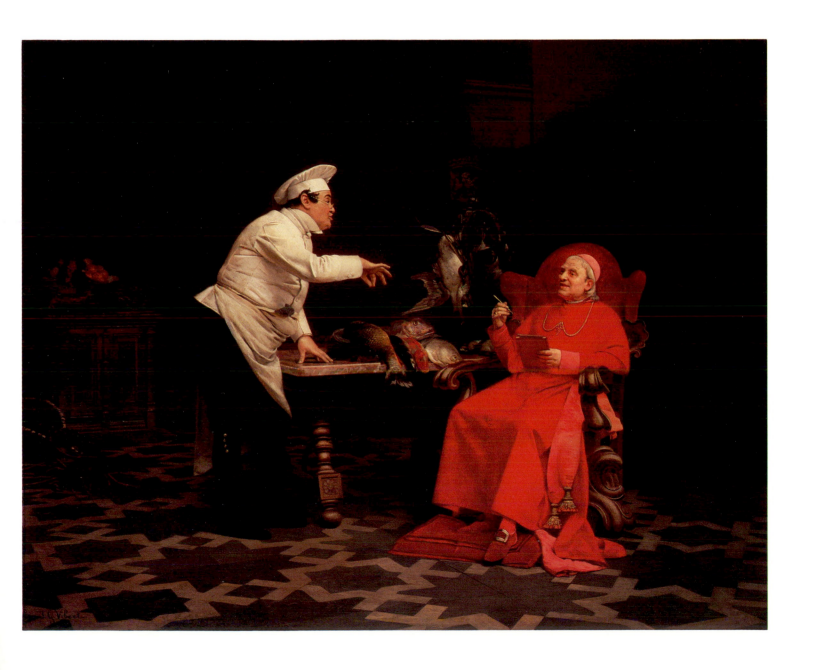

JEHAN-GEORGES VIBERT
1840-1902

44. *Surpris par la marée (Surprised by the Tide)* or
 The Cardinal's Dilemma
 Oil on panel, 8 1/4 x 10 1/2 in. (21 x 26.7 cm)
 Signed lower right: *J.G. Vibert.*
 New Orleans Museum of Art, gift of Mr. and
 Mrs. Chapman H. Hyams

Provenance: Vibert estate sale, Paris, Nov. 25-26, 1902, no. 8;
Mr. and Mrs. Chapman H. Hyams; bequest to the Isaac
Delgado Museum of Art, New Orleans, 1915.

Literature: *Hyams*, 1964, no. 31.

This is a smaller version of a work that Vibert
included in the section "Les prélats à travers le monde"
(Prelates on the Move) in the *Comédie en peinture*.[1] It
being a holiday, the monseigneur has gone to the
seashore. To avoid the tumult of *la fête nationale*, he
has his great chair moved to a small solitary beach amid
the rocks, facing the sea. His companion/secretary, the
abbé Bazile, and the valet who helps the cardinal walk
leave him alone to read his book and become distracted
skipping rocks on the waves. Unfortunately, at the
same time, the tide comes in and traps the lame
monseigneur. In this painting the figures of the servant
and secretary are eliminated, and the slightly comical
dilemma of the stranded cardinal provides the full
focus of the work. Vibert did a number of such
subjects in which churchmen are placed in
embarrassing situations by natural forces, such as losing
their hats or umbrellas (and thereby their dignity) in
the wind or encountering a bull on the road.[2]

1. Vibert, 1902, I, p. 200. This may be the Vibert painting sold as
La perplexité du cardinal at the Hôtel Drouot, Paris, June 18, 1920,
no. 83, with measurements of 30.5 x 22.5 cm, and then possibly again
as *The Incoming Tide* from the estate of Captain J. R. De Lamar, *Plaza
Hotel*, Jan. 29, 1920, no. 33 (29 x 37 in.).
2. Ibid., pp. 210-12.

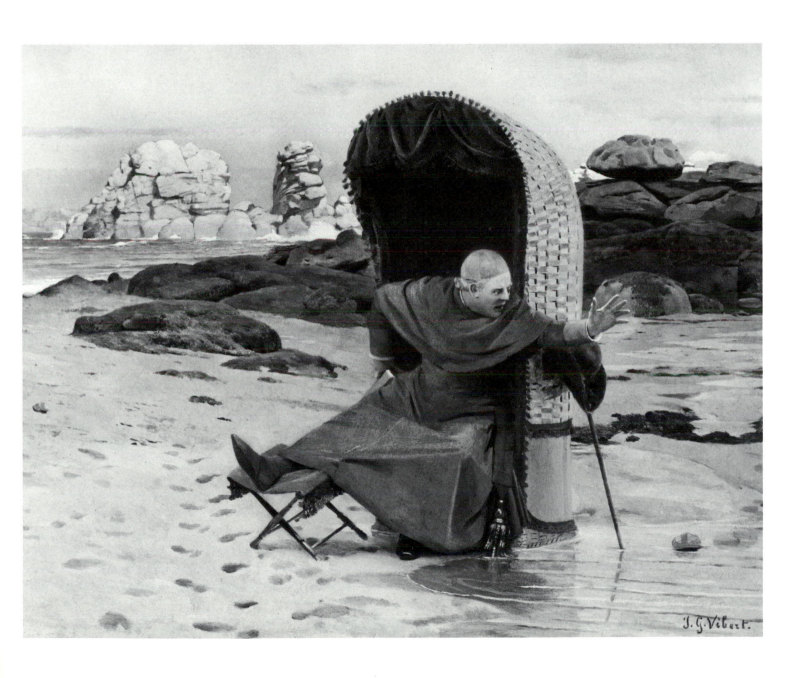

JEHAN-GEORGES VIBERT
1840-1902

45. *The Wonderful Sauce*, ca. 1890
Oil on panel, 25 x 32 in. (63.5 x 81.3 cm)
Signed lower right: *J.G. Vibert.*
Albright-Knox Art Gallery, Buffalo, N.Y., bequest
of Elisabeth H. Gates, 1899

Provenance: The artist; M. Knoedler and Co., New York;
Elisabeth H. Gates, Buffalo, 1892-99.

Exhibitions: *Inaugural Loan Collection of Paintings*, Albright
Art Gallery, Buffalo, May-July 1905, no. 154; *Fiftieth-
Anniversary Exhibition, 1892-1942*, Portland Art Museum,
Portland, Oreg., Dec. 1942-Jan. 1943, no. 71.

Literature: Vapereau, 1893, p. 1561; Vibert, 1895-96,
pp. 554-55; idem, 1902, I, p. 162, ill.; *Academy Notes*, July
1905, p. 5; *Albright Art Gallery*, Buffalo, July 1905, ill. opp.
p. 38; *Academy Notes*, Jan.-June 1922, pp. 14-15; *Albright-
Knox Art Gallery: Painting and Sculpture from Antiquity to
1942*, Buffalo, 1942, p. 279; Andrew C. Ritchie, ed.,
*Catalogue of Paintings and Sculpture from the Permanent
Collection*, Albright-Knox Art Gallery, Buffalo, 1949, p. 211,
no. 193; J. Benjamin Townsend, *100: The Buffalo Fine Arts
Academy, 1862-1962*, Buffalo, 1962, p. 12.

Vibert's text for *The Wonderful Sauce*[1] is in the form
of an interior monologue by the young cook who
unhappily works for a cardinal who is a would-be chef.
As the cook himself says, he is of the pessimistic
disposition, thin, and dressed in white, while the
master is calm, good hearted, fat, and dressed in a
scarlet robe. Unfortunately for the young chef, his
master has the mania of thinking himself a superior
cook and prefers putting on an apron, investigating the
kitchen, sampling sauces, adding spices, and burning
the butter to carrying out his religious tasks. The
worst, however, is when he "has just concocted one of
his poisons and raises his spoon towards heaven, with
the triumphant cry, 'this sauce is exquisite, it's a
wonderful sauce.'" He even forces the chef "to taste his
horrible cooking." The tale of the long-suffering chef
concludes, as Vibert's little dramas so often do, with an
appeal to heaven: "Ah, if there is justice in paradise,
where he will undoubtedly go, I hope there he will have
none other to eat!"

Vibert himself was an excellent cook and "inventor
of sauces" or at least so he claims in his autobio-
graphical note.[2] Food and cooking figure in a number
of his works,[3] and it seems certain he identified with
the corpulent amateur chef and not the professional
pessimist.

1. Although often referred to as *The Marvelous Sauce*, the present title
is the one used in Vibert, 1895-96, p. 554.
2. Vibert, 1895-96, p. 78.
3. See Vibert, 1902, I, p. 139, *La sainte collation (The Holy Meal)*; II,
pp. 218-22, *Les discours sur l'abstinence (Discourses on Abstinence)* and
Au régime (The Diet).

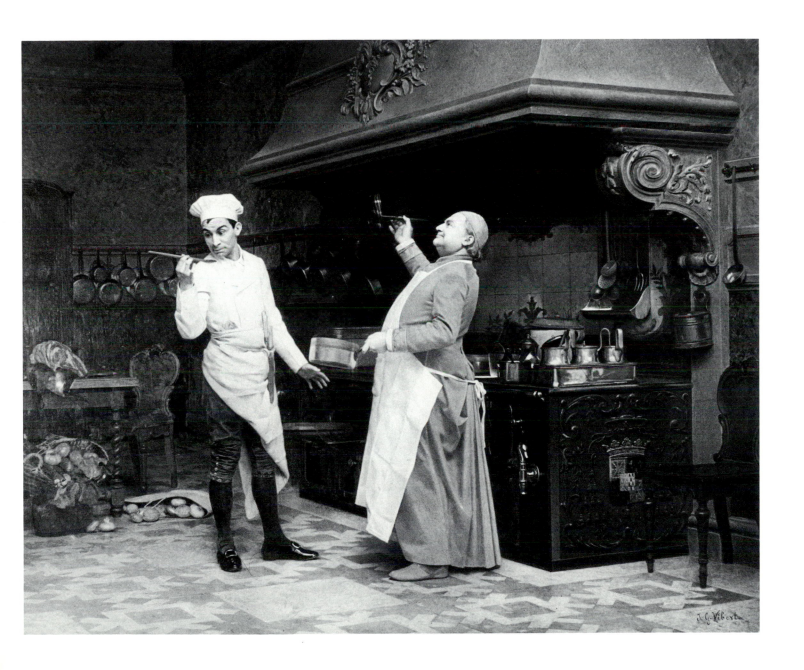

JEHAN-GEORGES VIBERT
1840-1902

46. *If I Were Pope*
Pastel on paper, 19 1/4 x 21 1/2 in. (48.9 x 54.6 cm)
Signed lower right: *J.G. Vibert.*
The Art Collection of The Union League of Philadelphia

Provenance: M. Knoedler and Co., New York; acquired by the Art Association of The Union League by June 21, 1894.

Exhibition: *An Exhibit of Genre Paintings*, The Union League of Philadelphia, Nov.-Dec. 1991.

Literature; Vibert, 1902, I, p. 101, detail; *Catalogue of the Works of Art in the Union League of Philadelphia*, Philadelphia, 1908, p. 21, no. R107; Maxwell Whiteman, *Paintings and Sculpture at the Union League of Philadelphia*, Philadelphia, 1978, p. 99.

Vibert never created a more telling *vanitas* image than this one of a self-satisfied priest regarding himself in a mirror. The sense of self absorption is remarkable. It is also a tour de force of illusionism, and Vibert made a vignette of the composition into the frontispiece for the section of *La comédie en peinture* titled "Les prélats chez eux" (Prelates at Home). Since his biretta is red, we can assume that the gentleman is already a cardinal, yet he aspires to a higher position. The only detail distracting from the face is a bouquet of violets (a gift from some admirer?) attached to the mirror. Vibert was intrigued by unusual optical effects and uses the mirror again most effectively in *Le portrait* in which a cardinal regards his portrait, which we see reflected in the mirror.[1]

The title of the work dates from the purchase records of The Union League Club in 1894 and thus has validity. Vibert used a similar title for another image of a clergyman who has taken it upon himself to

sit on a throne, probably at Versailles, and to imagine *Si j'étais roi (If I Were King)* (fig. 42).[2]

1. See Vibert, 1902, I, ill. p. 262.
2. Ibid., ill. p. 244.

Fig. 42. *J.-G. Vibert,* **If I Were King** *(after Vibert, 1902).*

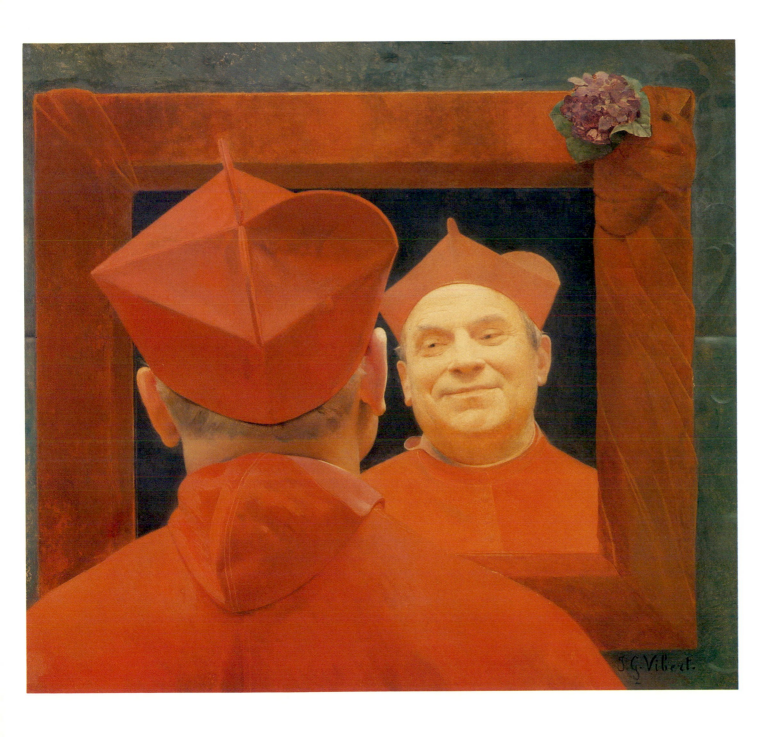

47. *Le médecin malade (The Sick Doctor)*, 1892
Oil on panel, 32 1/4 x 25 1/2 in. (81.9 x
64.8 cm)
Signed lower right: *J.G. Vibert*.
The Mr. and Mrs. James Wenneker collection

Provenance: Goupil and Co.; Vibert estate sale, Paris, Nov.
25-26, 1902, no. 52; M. Knoedler and Co., New York, 1904;
John Levy Galleries, New York; Lillia Babbitt Hyde; sale,
Parke-Bernet, New York, Mar. 7, 1940, no. 68; sale, Parke-
Bernet, New York, Oct. 16, 1941, no. 71; sale, Parke-Bernet,
New York, May 22-25, 1946, no. 780; private collection,
Kentucky, 1979.

Exhibitions: *Salon*, Paris, 1892, no. 1658; *Exposition
Universelle*, Paris, 1900, no. 1872; Atlanta, 1983, no. 66;
Lexington, 1986, p. 64; Lexington, 1989.

Literature: Larroument, 1892, p. 38; Emile Bergerat, *Le
Salon de 1892*, Paris, 1892, p. 87; Tausseret-Radel, 1892, p.
332; C. Yriarte, *Figaro Salon*, Paris, 1892, frontispiece; *Figaro
illustré*, no. 27 (June 1892), pp. xxi, xxiii, ill.; Vapereau, 1893,
p. 1561; J. G. Vibert, "The Sick Doctor," *The Century
Magazine*, LI (1896), pp. 944-47; *Exposition Universelle de
1900: Catalogue official illustré de l'exposition décénnale, 1889-
1900*, Paris, 1900, p. 105, ill.; Gustave Haller, *Le Salon (dix
ans de peinture)*, Paris, 1902, I, p. 30; Vibert, 1902, I, pp. 30-
40, ill.; Bénézit, 1976, X, p. 489.

In Vibert's autobiographical notes, published in *The
Century Magazine*, the artist's alter ego says to him:

> Using your pen as well as your brush, you have written songs
> and plays that have been applauded in the minor theatres of
> Paris; following the example of Molière, and having like him
> an extraordinary talent as an actor, you have played your own
> productions at the club and in artistic salons.[1]

Vibert's association with the stage was long and
active. His wife was an actress with the Comédie
Française, and he wrote a number of comedies that
were performed in the 1870s.

Molière's title of his satire of doctors, *Le malade
imaginaire (The Hypochondriac)*, provided the subject
for Vibert's painting shown at the Salon of 1891. He
also used the names of Molière's characters for his own
playlet *Le médecin malade*, from which this painting of
1892 derives.[2] The one-act comedy has two characters,
Argan the hypochondriac and Thomas Diafoirus the
doctor. The setting and costumes are described in the
stage directions:

> The stage represents a bourgeois salon. Gray woodwork and
> tapestries. The door to the left partly hidden by a leather-
> covered screen. At the back, a table upon which a wig already
> dressed is set on a wooden block. In front, a high-backed
> arm-chair; to the left, another arm-chair; between them, a
> small table with a cup and tea-pot. In the foreground, a
> brazier, upon which a small kettle is boiling.
>
> When the curtain rises ARGAN is asleep in the large
> arm-chair. He wears a flowered dressing-gown, a muslin
> neckerchief, fur-lined slippers, and a linen cap with yellow
> ribbons; his feet are resting on a high stool and his head is
> supported by a large pillow. In the other arm-chair
> DIAFOIRUS is seated. He wears the costume of his
> profession, a long black robe and pointed hat.[3]

During the course of the play, the doctor, after
sharing a huge lobster dinner with Argan, feels queasy.
Discovering that he accidentally took the powerful
medicine he had prescribed for his patient, he collapses,
convinced that he is dying. The painting shows Argan
reviving the doctor with a splash of water. The ironic
twist is that the tea contained no draught after all, for
Argan's servant routinely substituted water for all the
doctor's medicines.

Exhibited in the Salon of 1892, the work attracted
attention for it high price and because it was
"mysteriously and stupidly" vandalized.[4] Fortunately
this "*lacération*, whether by an anarchist or disgruntled
doctor,"[5] a series of scratches on the face of Argan, was
easily repaired, and the work was shown again at the
Exposition Universelle of 1900.

A photograph in the catalogue of Vibert's atelier sale
shows that he hung the painting in a prominent
position in the grand salon of his *hôtel* at 18 rue Bellu.

1. Vibert, 1895-96, p. 78.
2. Vibert also gave the same title to a work exhibited at the Society of
French Watercolorists in 1890, no. 176.
3. Vibert, 1902, I, p. 31, and in English in Vibert, 1895-96, p. 945.
4. Tausseret-Radel, 1892, p. 332, and Larroument, 1892, p. 38.
5. As speculated in *Figaro illustré* (June 1892), p. xxiii, which
reproduced it following the attack "to satisfy the curiosity" of its
readers. Clippings from an English language journal in the Boston
Public Library exaggerated the story, stating the painting had been
"slashed supposedly by a doctor who resented the picture's fancied
insult to his profession."

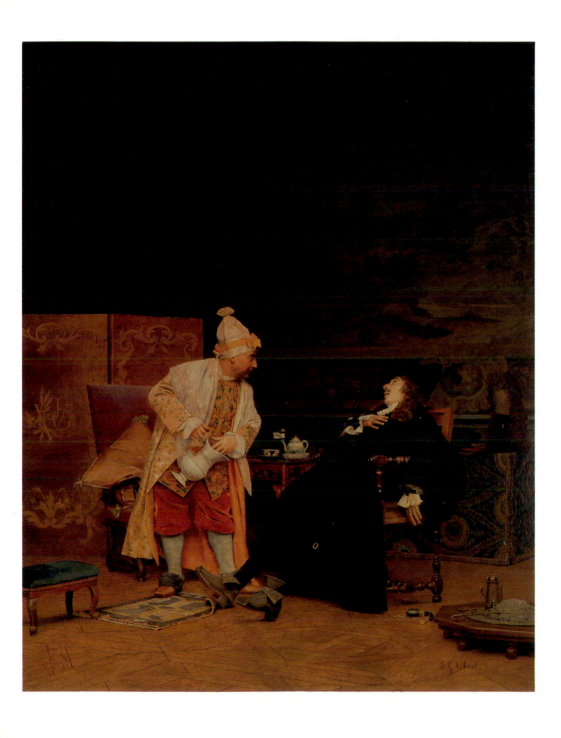

JEHAN-GEORGES VIBERT
1840-1902

48. *The Return of the Relics*, ca. 1892
Watercolor and gouache on paper, 18 7/8 x 40
in. (47.9 x 101.6 cm)
Signed lower right: *J.G. Vibert.*
Edward Wilson, Fund for Fine Arts, Chevy
Chase, Md.

Shown only in Washington, D.C., and Elmira, N.Y.

Provenance: Vibert estate sale, Paris, Nov. 25-26, 1902, no.
50; sale, Christie's, New York, Oct. 29, 1986, no. 233.

Exhibition: *Exposition Universelle*, Paris, 1900, no. 1877.

Literature: *Exposition Internationale Universelle de 1900,
Catalogue général officiel*, Paris, 1900, p. 127; Vibert, 1902, I,
pp. 136-38, ill.; Paul Jeromack, "19th-Century Paintings, N.
Y., Christie's," *Art and Auction* (Jan. 1987), p. 138.

This is one of Vibert's few religious subjects with a
serious historical, rather than satiric or humorous,
content. The tale told in the *Comédie en peinture* is
narrated by an old Breton fisherman. He remembers a
mysterious episode from his youth when at the
cessation of a war the church reopened and the white
friars returned. At night he went out to fish and saw a
ship drop anchor in an abandoned harbor; the white-
clad, ghostlike figures of the friars then appeared from
among the rocks. As day broke the friars, accompanied
by an abbot in a long purple robe and a cardinal all in
red, who had come from Italy, met a boat from the ship
carrying a huge box. From it they removed a golden
reliquary shrine and placed it on a bier covered with a
finely embroidered cloth. The friars knelt down in two
rows on either side of the planks, and the abbot
standing on the rocks began to say a prayer in a
powerful voice. Afterward they quickly dispersed and
the now empty box was returned to the ship. In fact,

this was a famous local shrine that bore the inscription:
"It is a sacrilege to hide me from the light as long as I
am in France." The return of the relics had thus to be
kept secret, because the faithful believed that they had
never left France but had only remained sealed in the
chapel.

One of Vibert's most impressive watercolors, this
large work has tremendous sweep. The expanse of
shore with purplish rocks set against the dawn sky, the
kneeling friars each one an individualized portrait, the
brilliant red of the cardinal, and the theatrical pose of
the abbot all make a powerful impression.[1]

1. A watercolor study for this work was also included in Vibert's estate
sale, Paris, Nov. 25-26, no. 87.

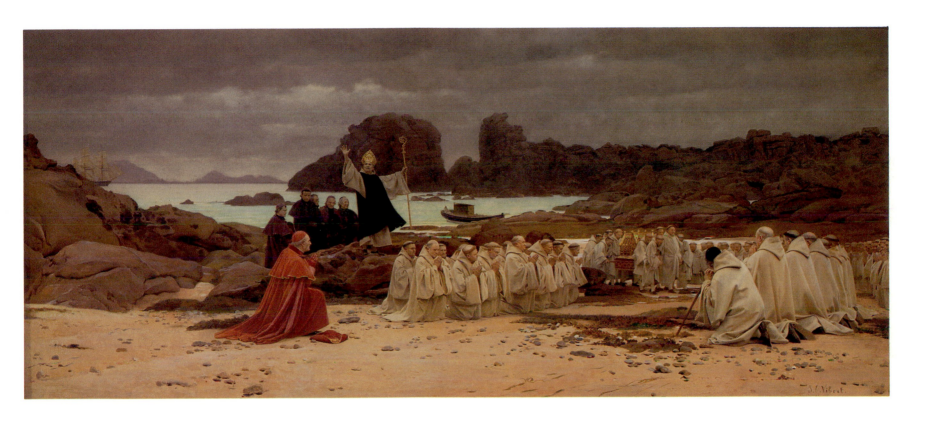

JEHAN-GEORGES VIBERT
1840-1902

49. *A Scandal*
Watercolor on paper mounted on canvas, 29 3/4
x 21 1/4 in. (75.6 x 54 cm)
Signed lower left: *J.G. Vibert.*
The Mr. and Mrs. James Wenneker collection

Provenance: William Schaus, New York, 1899; William
Randolph Hearst, New York; sale, Parke-Bernet, New York,
Jan. 5-7, 1939, no. 5; Hammer Galleries, New York, 1942;
Gimbel Brothers, New York; sale, Sotheby's, New York, Feb.
22, 1989, no. 141; sale, Weschler's, Washington, D.C., May
13, 1989, no. 17; Hirschl and Adler Galleries, New York.

Exhibition: *Exposition Universelle*, Pavillon Spécial, Paris,
1889, no. 423.

Literature: Vibert, 1902, II, p. 10, ill.; *The Compleat
Collector*, Mar. 1943, n.p. (adv. for Gimbel Brothers);
Hammer Galleries, *Art Objects and Furnishings from the
William Randolph Hearst Collection*, New York, 1941, p. 281,
no. 39-25, ill. p. 33.

Vibert's playful sense of humor was never more
evident than in the text he provides in his *Comédie en
peinture* to accompany the reproduction of this work.
In place of his usual narrative, he reproduces two
handwritten letters in French. The first is signed by a
certain Maud Champson of 350 Fifth Avenue, New
York City, who claims to be a young woman of good
family with an insatiable curiosity to know the cause of
the levity among the brothers in the cloister. She offers
to pay any price to obtain the work, so that the artist
will divulge his secret. Instead of reproducing his
response, Vibert teases and amuses the reader by next
reproducing a letter from a Mr. J. F. W. Blackwhite,
who acknowledges that the young woman was the
invention of a friend of his with whom he bet that the
artist did not know the "nature of the scandal that stirs

all the figures in your painting." But the artist had
replied with a story to satisfy "her" curiosity. We will
never learn what it was, so, as with other of his works,
like *Le mystère*[1] and *La vue* (see no. 50), we must invent
a plot of our own.

What is clear yet again is Vibert's mastery of
watercolor technique. He brilliantly contrasts the look
of a faded Early Netherlandish fresco on the cloister
wall with the brilliant flowers.

1. See Atlanta, 1983, no. 65.

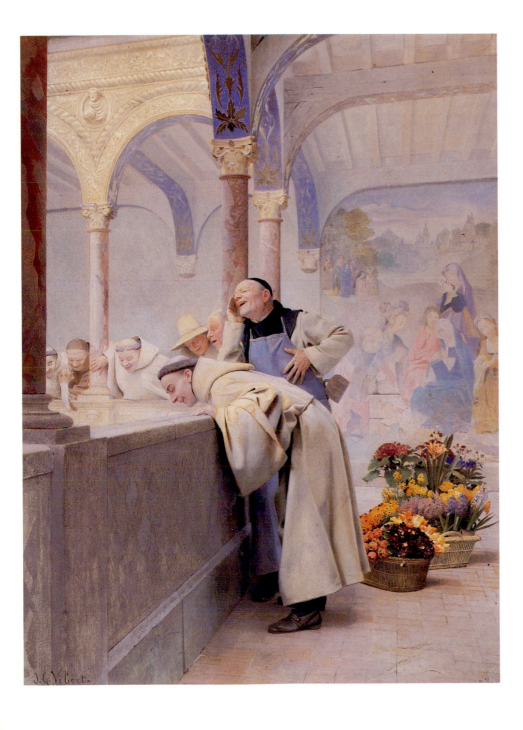

JEHAN-GEORGES VIBERT
1840-1902

50. *The Sense of Sight (La vue)*
 Oil on panel, 18 1/8 x 14 3/4 in. (46 x 37.5 cm)
 Signed lower left: *J.G. Vibert.*
 The Detroit Institute of Arts, gift of Mr. and
 Mrs. Merle V. Probst

Provenance: Sale, Plaza, New York, Oct. 31, 1946, no. 124;
Mr. and Mrs. Merle V. Probst, Detroit.

Literature: Vibert, 1902, II, p. 212, ill.

Vibert executed a series of works on the theme of
the five senses, but instead of presenting them as the
traditional allegorical embodiments, he chose to cast
them in the guise of modern clergymen. His
depictions of the sense of sight were particularly up-to-
date, showing in one case a cleric holding up a
photographic plate[1] and in this example an elegant pair
of binoculars. The motif of spying was one he used
frequently, as for example in the watercolor *Aures et
oculos habent (Ears and Eyes Have I)* that depicts two
clergymen peeking through and listening at a closed
door.[2] As is often the case in Vibert's work, this image
provokes us into speculating on the nature of the story.
Just as with *A Scandal* (see no. 49), we are curious to
know on what or whom this man is spying.

1. See Vibert, 1902, II, p. 212.
2. Shown by Vibert in the 1881 *Exposition de Société d'Aquarellistes
Français*, no. 3, ill. Also reproduced in Vibert, 1902, I, p. 15.

51. *Embarras du choix* or *The Sense of Smell*
 Oil on panel, 18 5/8 x 14 3/4 in. (47.3 x
 37.5 cm)
 Signed lower right: *J.G. Vibert.*
 The Brooklyn Museum, gift of Mrs. Carll H. De
 Silver in memory of her husband

Provenance: Mrs. Carll H. De Silver; gift to The Brooklyn
Museum, 1913.

Literature: Vibert, 1902, II, p. 216, ill.

This painting is also reproduced by Vibert among
his illustrations for the chapter "Les cinq sens" (The
Five Senses) in the *Comédie en peinture.* His text,
actually a debate among the senses as to which is
primary, has Maître Odorat (the sense of smell)
rapturize about the pleasure of perfume: "Le parfum!
. . . c'est le senteur des bois! C'est toutes les fleurs! . . .
c'est toute la femme!" (Perfume! It's the scent of the
woods, all the flowers, all women!) Since his
embodiments of the senses are all drawn from the
church, Vibert shows a cardinal inhaling the perfume
of a bouquet in a large vase in one of the exquisite
wood-paneled eighteenth-century salons often
employed for his settings. The unusually tender scene
conveys the pleasure derived from both the odor and
the visual beauty of the cut flowers, and this duality is
apparently the source of the title.

Vibert inherited his love for flowers from his
beloved grandfather, the famous botanist. He
delighted in painting vivid floral displays, as can be
seen in a number of other works in this exhibition (see
nos. 42, 49). The *Comédie en peinture* even has a
section titled "Le language des fleurs" (The Language
of Flowers), illustrated with a scene of a cardinal-
gardener consulting a large tome of the same title. In

the accompanying text, Vibert wrote: "Flowers,
evidently, speak to the human soul. The rose speaks of
love, the humble violet, hidden amidst the grass of
modesty. . . . In the language of flowers exists a
universal language that everyone understands."[1]

1. Vibert, 1902, I, p. 119. Flowers also appear as the centerpieces in *Le
bouquet de roses, Le bouquet de fête,* and *La fête du cardinal,* see I, pp.
186, 262, and II, p. 200.

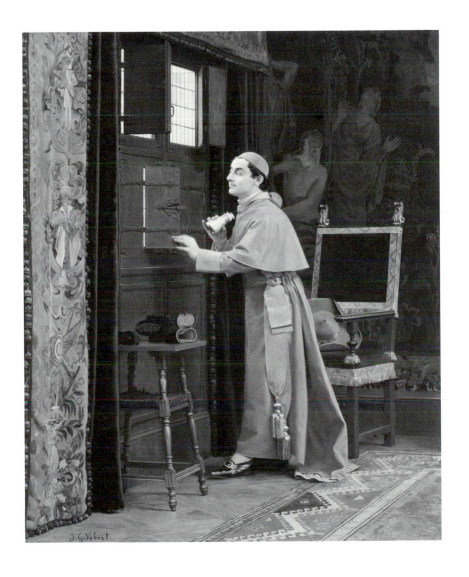

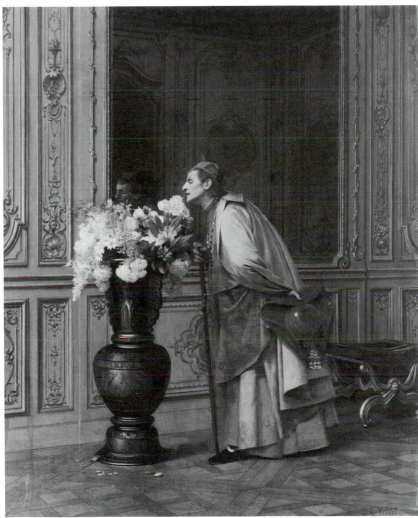

JEHAN-GEORGES VIBERT
1840-1902

52. *L'Amateur* or *A Missed Vocation*
 Oil on panel, 31 x 25 1/2 in. (78.7 x 64.8 cm)
 Signed lower right: *J.G. Vibert.*
 Sordoni family collection

Provenance: Sale, Parke-Bernet, New York, Oct. 18, 1945, no. 24.

Exhibition: Wilkes-Barre, 1975, no. 18.

Literature: Vibert, 1902, II, p. 94, ill.

This is one of Vibert's happiest cardinals. Others who dabble in cooking (see no. 45), sculpting (fig. 43), music making,[1] or even painting[2] seem to be mocked for their indulgence in other professions, but this amateur painter radiates true joy as he daubs away at the unseen canvas. His pleasure is nicely complemented by the glowing light emanating from behind the trees. In fact, in Vibert's text for "L'Amateur" in the *Comédie en peinture*, which includes this work (and another of a cardinal painting indoors),[3] there is a dialogue with the sun itself in which the heavenly sphere acknowledges he has not seen the landscape painter at work, for he is hidden from the sun's penetrating rays by his large parasol.

1. Vibert, 1902, II, pp. 84, 88, for *Le leçon de piano (The Piano Lesson).*
2. Ibid., p. 82, the vain painter in *Peint par lui-même (Painted by Himself).*
3. Ibid., p. 93.

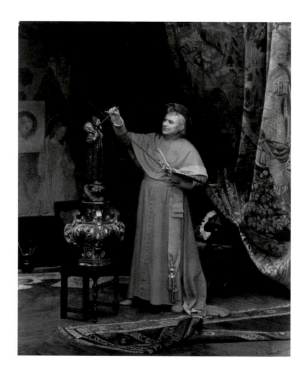

Fig. 43. *J.-G. Vibert,* A Great Artist, *private collection, courtesy Schweitzer Gallery.*

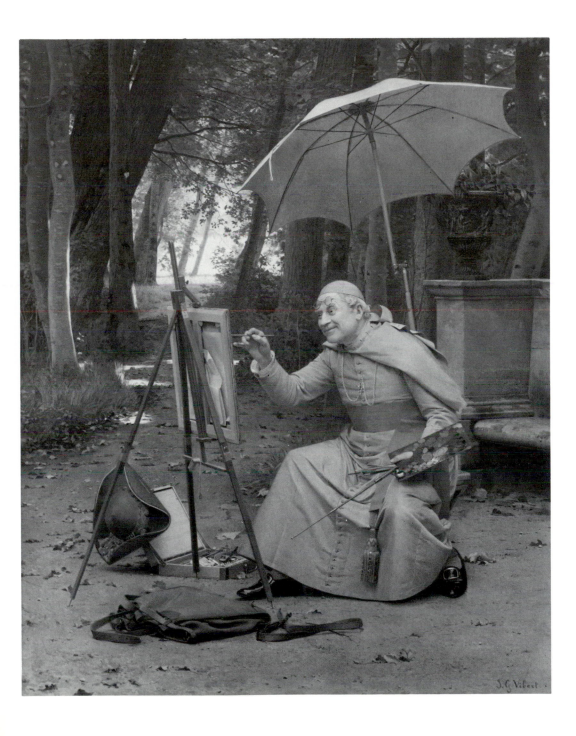

JEHAN-GEORGES VIBERT
1840-1902

53. *Le vilain gourmand (The Wicked Glutton)*
 Oil on panel, 31 3/4 x 26 in. (80.7 x 66 cm)
 Signed lower right: *J.G. Vibert.*
 J. E. Kampe, Washington, D.C.

Provenance: Sale, Christie's, New York, Oct. 24, 1990, no. 119.

Literature: Vibert, 1902, I, p. 168, ill.

Like *The Naturalists* (see no. 40), this image is placed by Vibert in his section "Les victimes de l'église" (Victims of the Church). It is near the end of Lent, and the bishop, seeing that it is a fine day, summons his faithful servant, a lowly priest named Bazilio.[1] He loads a silver tray with cakes, not for him, as Bazilio hopes, but to take to the pet ducks and swans. The bishop wears his non-ecclesiastical hat and shoes for this outing. Once arrived at the marble basin where they are to feed the birds, Bazilio cannot resist (*à la* Leporello) snatching one of the morsels; but, of course, he is caught in the act. The monseigneur disdainfully chastises him, "Oh, *le vilain gourmand* lucky for you that noon has passed and that Lent is over; give thanks to heaven. Five minutes sooner and you would have been eternally damned." If the moralizing is a bit thin, the painting is not. Vibert has marvelously captured the cool frosty atmosphere of a late winter's day. The red of the bishop's robe serves as a brilliant contrast to the whiteness of the marble and is reflected in the water of the duck pond. The setting is the circular colonnade at Versailles built by Mansart in 1685.

Vibert's concern for such coloristic effects in his specialized subject matter is recorded in his book *The Science of Painting*:

Let us follow a cardinal, dressed in red, whilst he walks in his gardens. At every instant the colour seems different, according to whether he receives the blinding rays of the sun, or the white reflection from a cloud, or shelters under the verdant shade of a leafy grove. Whether we see him on the intense green of the sunny lawns, under the dark green of the cypress, on the silvery surface of a lake, or under the azure of the sky, he still changes. He changes always, becoming pale before a bank of geraniums, and red before the marble of the statues; he gets dark in proportion as the daylight fades, until he becomes of a dark purple, and is dressed in black, like a simple priest, as he returns to his palace by the dusky shades of twilight.[2]

1. This same wily character appears in *Mystère*. See Atlanta, 1983, no. 65.
2. Vibert, 1892, p. 27.

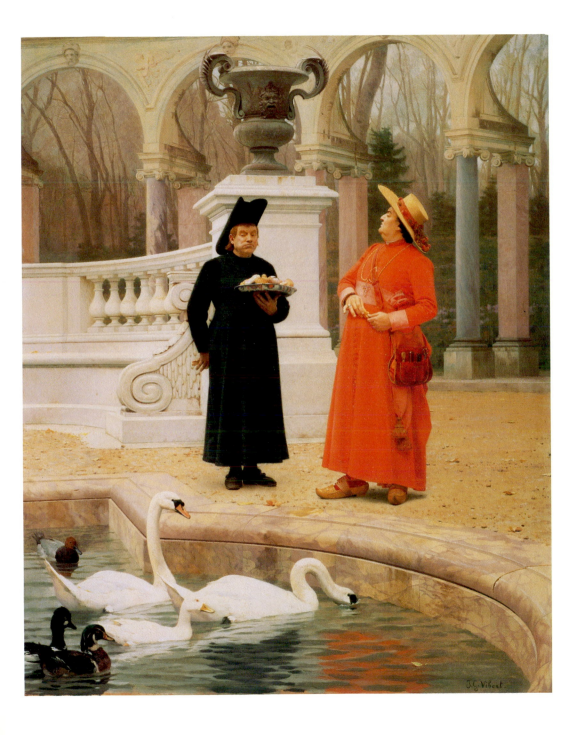

JEHAN-GEORGES VIBERT
1840-1902

54. *Les journaux (The Newspapers)*
 Oil on panel, 32 1/16 x 25 1/4 in. (81.4 x 64.1 cm)
 Signed lower right: *J.G. Vibert.*
 The Mr. and Mrs. James Wenneker collection

Provenance: Private collection, Kentucky, 1979.

Literature: Vibert, 1902, I, p. 44, ill.

Exhibition: Lexington, 1986, p. 66.

55. *The Wrath of the Bishop*
 Oil on panel, 16 1/8 x 13 in. (41 x 33 cm)
 Signed lower right: *J.G. Vibert.*
 Fred and Sherry Ross

Provenance: Sale, Lempertz, Cologne, June 12-14, 1980, no. 541.

Literature: Vibert, 1902, I, p. 46, ill.

In these two paintings, Vibert uses his ecclesiastical subjects to bring to task the power of the press. The text accompanying them in his *Comédie en peinture* is in the form of a rhetorical dialogue. Keeping the attack rather general, the first voice asks why the press should be above criticism when it now represents so many diverse points of view. It is in fact both a "public calamity and a blessing from heaven . . . can corrupt government but also . . . destroy abuses; . . . one fears it, one adores it, one makes offerings to it, one curses it. It is the idol of the day. And every society raises an idol in its own image." The blame for its vices is with "all of you who open newspapers, you are the

accomplices, it lives only by you and for you, so that some may writhe with laughter on seeing the faults of others." The debate concludes that "no one will touch the press so long as everyone uses it," but fortunately "there is no press in Paradise."

What the text rather laboriously relates is made instantly clear in both paintings. In the first, two churchmen are seen clearly wrangling over an article in the morning edition of *Le figaro*. It greatly delights the seated one, but his colleague, who seems to have just burst into the well-appointed chamber, is smitten with high dudgeon and disdainfully crumples the offending journal in his gloved hand. The contrast is one of types as much as of attitudes. The seated figure is shown full face, round and jolly; the standing one in profile is gaunt and drawn.

As always, Vibert represents the material pleasures of the environment, which also will not be found in Paradise. In addition to the usual parquet floors, oriental rugs, elegant wall hangings, and mirrored rococo mantle, a remarkable sculpture of the Good Shepherd stands on an ornate base. This same distinctive object appears in another painting titled *A Great Artist* (see fig. 43)[1] and, in fact, was in Vibert's home.[2]

The Wrath of the Bishop shows the further displeasure of the clergy with the press. The purple-clad bishop, livid with rage, is seated at his desk and crushes under his foot, like some heretical doctrine, a copy of *L'Intransigeant*, a paper known for its liberal views. Pen in hand he appears to await divine inspiration to compose his reply to the offensive article.

1. Vibert, 1902, II, p. 86, in which the cardinal is repairing the nose with a great flourish.
2. See the photograph of Vibert's grand salon that appeared in his estate sale, Paris, Nov. 25-26, 1902.

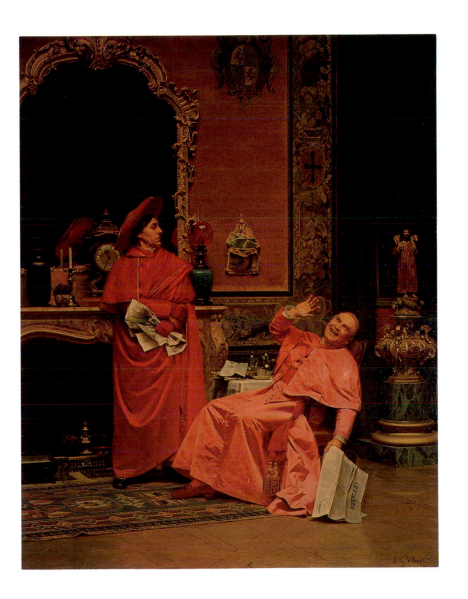

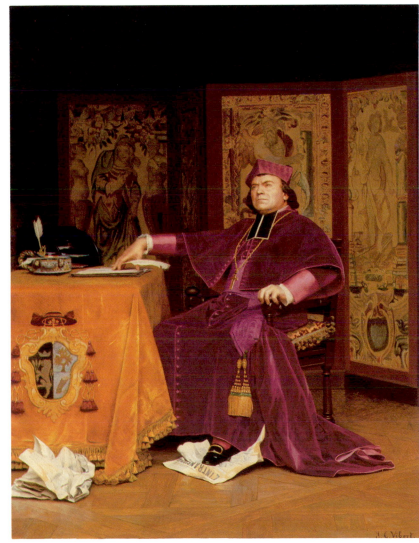

JEHAN-GEORGES VIBERT
1840-1902

56. *Tea for the Bishop*
 Oil on panel, 29 x 21 in. (73.7 x 53.3 cm)
 Signed lower right: *J.G. Vibert.*
 Fred and Sherry Ross

Provenance: Sale, Parke-Bernet, New York, Mar. 2, 1967, no. 114.

Literature: Vibert, 1902, II, p. 108, ill; Bénézit, 1976, X, p. 489.

The text of Vibert's chapter "L'Antichambre de L'évêché" (The Bishop's Antechamber) in the *Comédie en peinture* is not primarily about this painting, but is rather a conversation among the shoes of the bishop's various visitors of different rank to accompany a painting of that title of 1876 (fig. 44).[1] However, it does provide some insight into the subject presented here. The bishop's residence somewhere in the French provinces is a large palace built in the time of Louis XIV. The wing inhabited by the bishop had ill-fitting windows, and as a result he caught a cold and had his first attack of gout. Thus, at the insistence of the local marquise he moved his private chambers into the grander part of the palace, and she furnished it for him in the latest taste with all the comforts worthy of his rank. His housekeeper, who is also the goddaughter of the marquise, lavished attentive care on him and is here presenting the bishop with what is probably a cup of camomile tea. However, his condition has not improved, and he looks upon her with a sour expression, leading to some speculation that he may change housekeepers.

The essential humor of the scene is thus the contrast between the bishop's unhappy mood and the luxurious grandeur of his surroundings, where he rests with his gouty foot up on an elaborate *duchess-brisée.* The fashionable elements of his milieu include behind him a Japanese-style screen and in front a little inlaid Moroccan table.

1. See Vibert, 1902, II, ill., p. 110.

Fig. 44. *J.-G. Vibert,* **The Antechamber of the Bishop** *(after Vibert, 1902).*

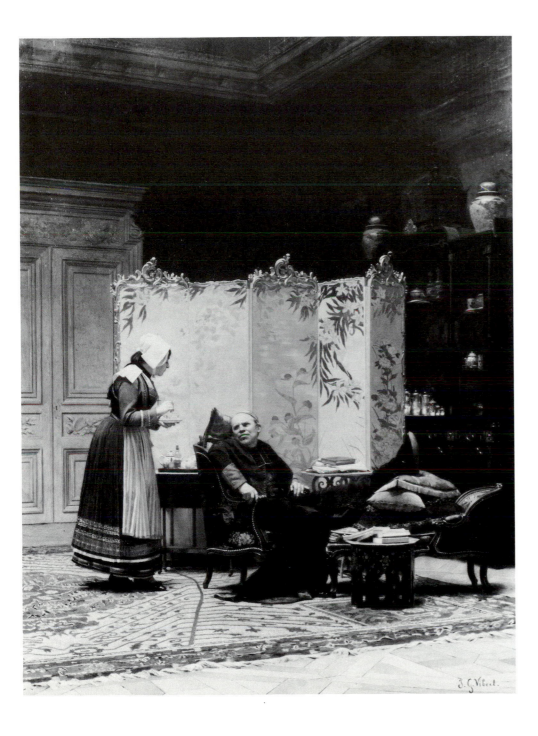

JEHAN-GEORGES VIBERT
1840-1902

57. *The Bibliophile*
 Watercolor and tempera on card, 5 1/2 x 7 1/2
 in. (14 x 19.1 cm)
 Signed lower right: *J.G. Vibert.*
 Edward Wilson, Fund for Fine Arts, Chevy
 Chase, Md.

Provenance: Christie's, London, May 29, 1987, no. 82.

Literature: Vibert, 1902, II, p. 195, ill.

Churchmen reading books, ranging from Rabelais[1]
to holy writ, were a frequent theme of Vibert. He
entitled one whole section of volume two of the
Comédie en peinture "Livres et oeuvres d'art" (Books
and Art Works). This small gem of artistry appears as a
historiated initial heading another chapter "Le
Bibliophile," which actually describes a different scene
of a cardinal having come upon a rare volume in the
home of his host. However, its evocation of the
passionate love that true bibliophiles have for old books
is equally well captured in this enigmatic bust-length
figure. There is an appropriate medieval sensibility
about the cardinal in profile who diligently studies the
illustrated text before him.

1. See the work sold at the American Art Association, New York, Apr.
14, 1916, and again at American Art Galleries, Feb. 24, 1927, no. 37.

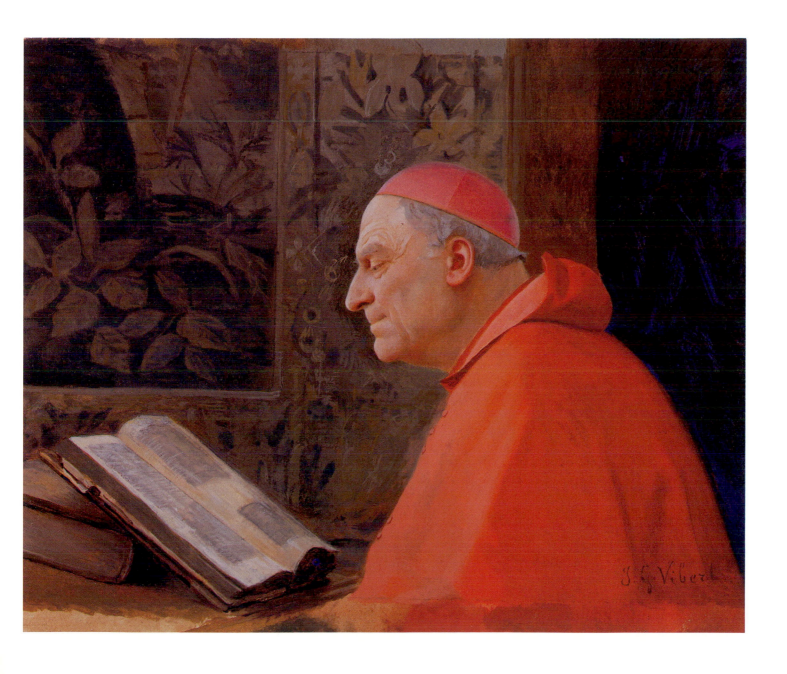

JEHAN-GEORGES VIBERT
1840-1902

58. *Coronation of the King of Rome*, ca. 1900
 Oil on canvas, 20 1/2 x 28 1/2 in. (52.1 x
 72.4 cm)
 Signed lower left: *J.G. Vibert.*
 The Saint Louis Art Museum, The John Fowler
 Memorial Collection, bequest of Cora Liggett
 Fowler, 1928

Shown only in Cincinnati

Provenance: John F. Fowler, St. Louis, by 1911.

Exhibition: *The Home Exhibition: A Collection of Paintings Owned in St. Louis and Lent to the Museum*, The City Art Museum, St. Louis, June-Oct. 1911, no. 81.

This and a larger version from the Martin collection now in the Joslyn Art Museum, Omaha,[1] depict the ceremony in which Napoléon I's son, born on March 20, 1811, was given the title King of Rome. Apparently, this is an imaginary scene, but Vibert presents a detailed historical panorama in which almost every character can be identified. Napoléon I is seated on a throne at the center with his son, Napoléon II, on his lap. To the right of them the crown and other symbols of power rest on a cushion. To their left one sees Prince Poniatowski, Marshal of France, and Cardinal Joseph Fesch, the uncle of Napoléon, in the left foreground looking out. Cardinal Ercole Consalvi, the Pope's diplomatic representative, pays homage before the throne, and standing in the right foreground Napoléon's brother-in-law Joachim Murat, with plumed hat, announces the guests. To the left of Murat seated well below the throne is the child's mother, the Empress Marie Louise, attended by another brilliantly clad cardinal.

Vibert, who wrote in his autobiographical sketch that he "loved only Napoléon and roses,"[2] painted a

small number of Napoleonic scenes (fig. 45).[3] For his paintings he chose private or ceremonial moments such as this rather than military subjects *à la* Meissonier or Detaille. There is certainly a recollection of Jacques-Louis David's *Sacre* or *Coronation of Napoléon* with the clergy paying homage to the emperor. Vibert, however, is no David, and his historical subjects lack the elements of humor and wit that enliven his best genre works. Nonetheless his sense of detail and decor are as sharp as ever, and as was suggested in the 1911 St. Louis catalogue:

> Though the sumptuous masses of red and purple attract the eye, one notes that the faces are portrayed with much delicacy and beautiful gradations of color, many of them as exquisite as though miniature upon ivory: and that some of the groups are especially fine in arrangement and composite effect; while passages of light contribute a charm that repays close inspection.

1. See *An Eye for Detail: French Academic Paintings from the Martin Collection*, Joslyn Art Museum, Omaha, 1990, ill., n.p. The Joslyn version was shown at the Exposition Universelle of 1900 and passed through the Alexander R. Peacock collection sold at the American Art Association, New York, Jan. 10, 1922.
2. Vibert, 1895-96, p. 79.
3. A painting of Napoléon playing chess with Cardinal Fesch formerly in the William Harold Sharp collection is now in the Haggin Museum, Stockton, Calif. See Sanders, 1991, pp. 156-57. This is most likely the painting Vibert exhibited at the Salon of 1899 under the title *L'Aigle et le renard (The Eagle and the Fox)*, no. 1956 (see fig. 45). One of Napoléon planning his coronation was in the J. P. Morgan collection according to Aline B. Saarinen, *The Proud Possessors*, New York, 1958, p. 63, and mentioned by Clement and Hutton, 1884, vol. II, p. 325; in the Vibert estate sale, Paris, Nov. 25-26, 1902, were included the painting *Napoléon Playing with the King of Rome* (sold again in the Hamilton collection, Parke-Bernet, New York, Jan. 28, 1953), and several Napoleonic sketches.

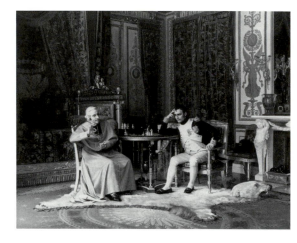

Fig. 45. *J.-G. Vibert,* The Eagle and the Fox *or* Check, *Haggin Collection, The Haggin Museum, Stockton, Calif.*

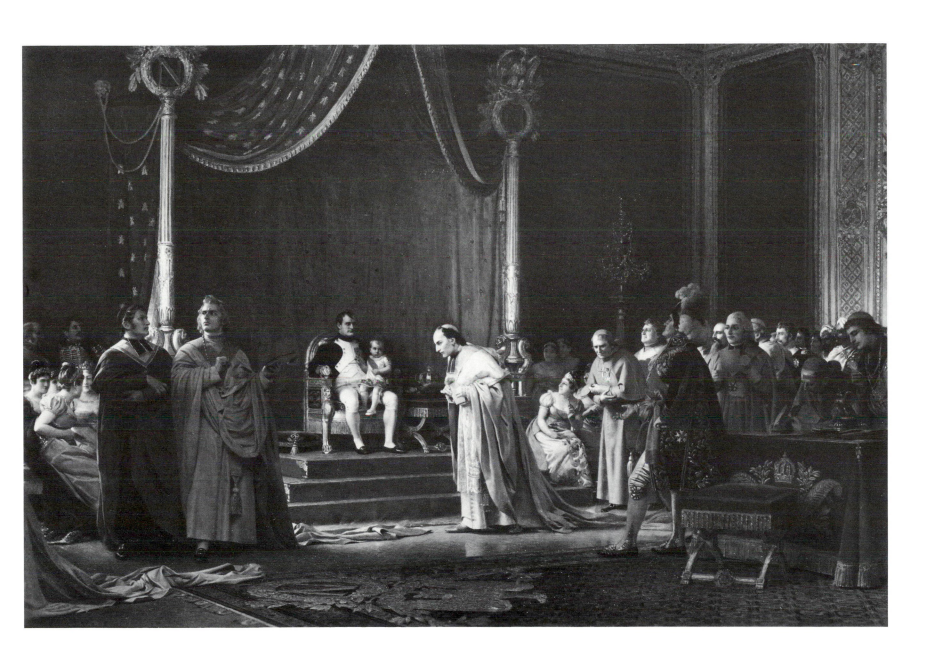

PAUL-ALPHONSE VIRY
NINETEENTH CENTURY

59. *The Falconer*, 1878
 Oil on panel, 22 x 16 3/4 in. (55.9 x 42.6 cm)
 Signed and dated lower left: *Paul Viry Paris 1878*
 Hugh V. Gittinger, Jr., Washington, D.C.

Provenance: Sale, Christie's, New York, Oct. 24, 1990,
no. 127.

Very little has been written about Viry, but the few
paintings that have appeared in sales and reproductions
indicate that he specialized in scenes of cavaliers and
elegant ladies. He was one of the Parisian artists visited
regularly by the American picture dealers Avery and
Lucas.[1] He seems to have had a particular fondness for
birds, dogs, and flowers. Cockatoos, cranes, and doves
are shown in other works.

The falcon, a suitable complement to the elegant,
chivalrous huntsman, appears not only here but also in
the painting *After the Hunt*. Another *Falconer* of nearly
the same size as the present example, but dated a year
earlier, was in the George Seney collection (sold in New
York, Mar. 31-Apr. 2, 1885, no. 55), and a smaller
Falconer was in the Walter Richmond collection,
Providence.[2] The 1899 sale catalogue for the latter
observed, "It is impossible to describe the microscopic
elaboration of every part of this picture. It reminds us
somewhat of the work of Bargue. Withal, the
ensemble is good, and the color is very agreeable in its
quiet tints." The same could equally well apply to the
present work, which is remarkable for the richness of
its combination of delicate textures, the feathery
smoothness of the dead game birds and the plush velvet
of the garment being the most notable.

1. See Avery, *Diaries*, 1979, pp. 174, 233, 271, 292.
2. Strahan, *Treasures*, III, 1880, p. 94. This work appeared in two
Richmond sales at Chickering Hall, New York, Feb. 17, 1893, and
Jan. 27, 1899, measured 14 3/4 x 11 3/4 in., and depicted the falconer
with three falcons.

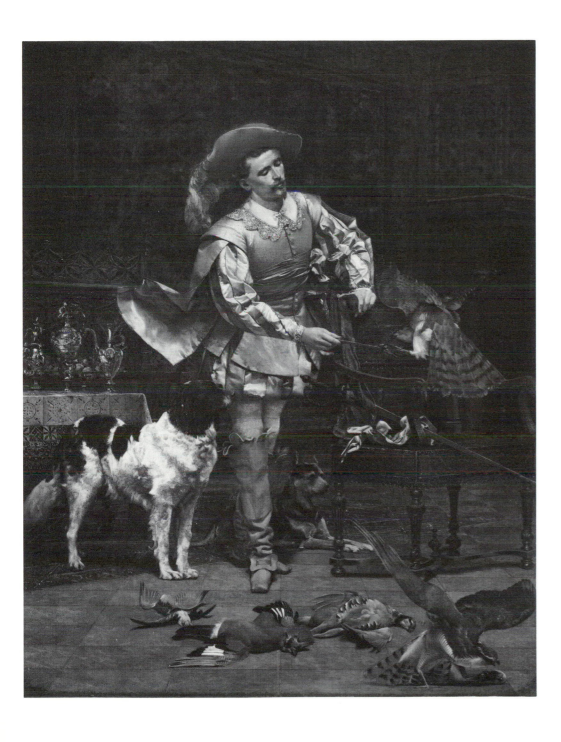

JULES WORMS
1832-1924

60. *The Spy* or *The Rival*
 Oil on panel, 11 5/8 x 10 in. (29.5 x 25.4 cm)
 Signed lower right: *J Worms*
 The Mr. and Mrs. James Wenneker collection

Provenance: Sordoni collection, Wilkes-Barre; Shepherd Gallery, New York, 1985.

Exhibition: Wilkes-Barre, 1977, no. 38.

According to Strahan, "Worms was born of a family of small Jewish shopkeepers. He entered, like a shop-boy, into the studio of a prosperous and overworked designer for periodicals."[1] Having thus learned the technique of lithography and worked as an illustrator, Worms was admitted to the Ecole des Beaux-Arts in 1849. He sent his first entry to the Salon in 1859 but really came into his own after visiting Spain in 1863. He made many sketches, which served him as the basis for scenes of Spanish life, particularly bullfighters and gypsies. He returned several times to Spain, including a six-week visit in 1871 to Granada accompanied by Marià Fortuny. So identified with Spanish subject matter was Worms that Montrosier could describe him as "*le plus espagnolisant des Espagnols*" (the most Spanish of the Spaniards).[2]

In 1868 he began with *La romance* (Paris, Palais de Sénat),[3] producing scenes of elegant society in the era of the Directorate. Inspired in part by Boilly, these realistic period pieces were distinguished from those of the Meissonier school by their more obvious sense of humor. At the Salon of 1876 Worms exhibited a *Spanish Dancer* and *Departure for the Révue*, which *L'Illustration* described as of an "execution which leaves nothing to be desired, except perhaps a more harmonious color." After this, the painter was made a Knight in the Legion of Honor.

The Spy is one of Worms's most inventive compositions with a narrative content more gripping than usual in his work. Set in a sun-drenched plaza, a *majo* wearing a vivid cape secretly observes, with clenched fist, as his rival talks to a *maja* on a balcony. This little drama is infused with sultry passion, and one can easily imagine a violent outcome. Worms employed the same locale of a Castillian *puerta del sol* with lion-topped pillar for two more simply descriptive paintings, *Un ecrivain publique (The Public Letter Writer)* (fig. 46), shown in the Salon of 1882,[4] and *Monsieur le curé*.[5] The theme of one *majo* spying on a rival also appears in the aptly titled *Rivalité*.[6]

1. Strahan, *Treasures*, II, 1880, p. 54.
2. Montrosier, 1881, I, p. 85.
3. See Paris, 1974, no. 236.
4. See *L'Exposition des beaux-arts, Salon de 1882*, Paris, 1882, p. 92.
5. See Worms, 1906, p. 131.
6. Ibid., p. 115.

Fig. 46. *J. Worms*, The Public Letter Writer *(after Goupil & Co.), photograph courtesy of Getty Archives.*

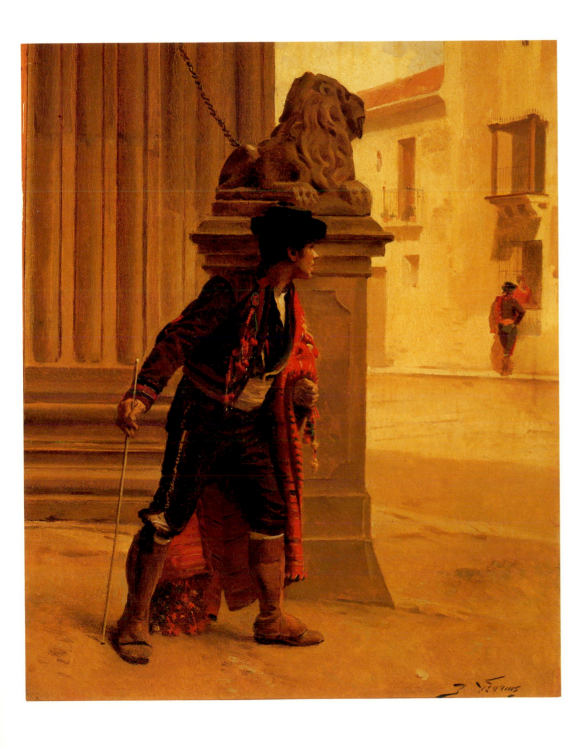

EDUARDO ZAMACOIS Y ZABALA
1842-1871

61. *Valetaille (The Flunkeys)* or *Music in the Antechamber*, 1866
Oil on panel, 12 13/16 x 9 7/16 in. (32.5 x 24 cm)
Signed and dated lower left: *Eo ZAMACOIS. 66.*
Sterling and Francine Clark Art Institute, Williamstown, Mass.

Provenance: T. W. Kennard; H. N. Smith; Darius O. Mills, New York and San Francisco; sale, American Art Association, New York, Feb. 14, 1934, no. 7; M. Knoedler and Co., New York; sold to Robert Sterling Clark, Feb. 28, 1934.

Exhibition: *Spain in Williamstown*, Sterling and Francine Clark Art Institute, 1988.

Literature: Strahan, *Treasures*, II, 1880, pp. 115-16; Sheldon, 1882, p. 117; *Clark*, 1972, p. 140, no. 901.

During his short career, Zamacoïs painted a number of small-scale works on panel in the manner of his master, Meissonier, but he always added an edge of humor or satire. Strahan describes this odd trio of figures somewhat freely as

> the valets of some Monsignori brought into an unfrequented ante-chamber, where the opinions of the Catholic world will not regard them; and under these circumstances he shows us what they will do . . . how technical is the bowing of the violinist! What critics his two companions are! Having been the figurantes of piety before the public, how sincerely they throw themselves into their true life of art, music, and aesthetics!

Strahan's memory of the painting he had seen in Mr. Mills's California collection was obviously faulty, for the overdressed lackey in a brilliant red outfit plays a flageolet, not a violin. Similarly attired comic figures can be seen in Zamacoïs's watercolor *Waiting at the Church Porch* in the Walters Art Gallery, which shows servants waiting for their masters to appear after a church service.[1] The Clark's little oil has a sparkle and brilliance evoking the quality of an old master, and certainly the underlying satire reveals Zamacoïs's knowledge of Goya. This aspect of Zamacoïs's imagery would be continued by later Spanish artists.[2]

1. See Gruelle, 1895, p. 176. This watercolor was sold in the J. T. Johnston collection, New York, Dec. 19-22, 1876, no. 323.
2. See José Gallegos y Arnosa's *Waiting for His Eminence* of 1902, sold at Christie's, New York, May 24, 1989, no. 142.

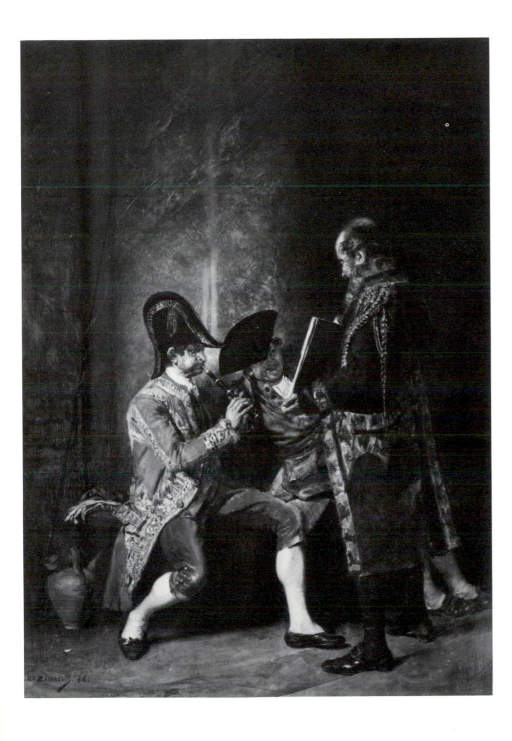

EDUARDO ZAMACOIS Y ZABALA
1842-1871

62. *The Toreador's Toilet*, 1866
Oil on panel, 9 7/8 x 7 3/4 in. (25.1 x 19.7 cm)
Signed and dated lower right: *Eo ZAMACOIS.1866.*
The John G. Johnson Collection at the Philadelphia
Museum of Art

Provenance: P. L. Everard, Paris; sale, Hôtel Drouot, Paris,
Mar. 31-Apr. 1, 1881, no. 182.

Literature: William R. Valentiner, *A Collection of Paintings and
Some Art Objects: Modern Paintings*, Philadelphia, 1914, III, p.
162, no. 1113; *John G. Johnson Collection: Catalogue of
Paintings*, Philadelphia, 1941, p. 67; Gaya Nuño, 1958, p. 334,
no. 2969.

Zamacoïs and Vibert collaborated on one
bullfighting scene (see fig. 41), and both produced a
number of independent works on the subject.
Théophile Gautier in his 1843 descriptions of Spain had
already indicated the fascination of this specifically
Spanish form of entertainment, writing, "a bull-fight is
one of the grandest sights that the imagination of man
can conceive." He also pointed out that in Spain the
word *toreador* is almost never used, but rather the correct
term is *torero*.[1]

The Toreador's Toilet is an intimate view of the torero
making his final adjustments before appearing in public.
He tightens his distinctive yellow sash. As if to help him
prepare for what lies ahead, a picture on the wall shows a
torero confronting a bull. Zamacoïs captures both the
sense of bravado and the lonely isolation necessary for
this dangerous but glamorous profession.

1. Gautier, 1853, p. 59.

EDUARDO ZAMACOIS Y ZABALA
1842-1871

63. *A Decorative Painter* or *Trop de Sang (Too Much Blood)*, 1868
Oil on canvas, 22 x 14 1/8 in. (55.9 x 35.9 cm)
Signed and dated lower right: *Eo ZAMACOIS.68.*
Philadelphia Museum of Art, the W. P. Wilstach collection

Provenance: W. P. Wilstach, Philadelphia, by 1872.

Literature: E.S., "Private Art Collections of Philadelphia, IV: The Wilstach Gallery," July 1872, p. 80; Strahan, *Treasures*, III, 1880, p. 32, ill. p. 28; Carol H. Beck, ed., *The W. P. Wilstach Collection*, Philadelphia, 1900, no. 334; *Catalogue of the W. P. Wilstach Collection*, Philadelphia, 1922, p. 139, no. 349; Gaya Nuño, 1958, p. 334, no. 2970.

Painted during the year he was in Italy, this work by Zamacoïs looks appropriately like a scene observed in a Roman cloister. As in many of the later works by Vibert, the holy fathers here act as art critics, whispering their complaints about the painter behind his back (much as the sacristan does in *Tosca*). In this case the complaint is "*trop de sang*," too much red or blood, on the curiously naive crucifixion. In 1872 this largest of three works by Zamacoïs in the Wilstach collection was described as representing, "a self-satisfied painter [who] daubs away at a hideous crimson Christ, while the monks surround him with satire and persiflage." Zamacoïs has taken great pains in rendering all the painter's paraphernalia.

EDUARDO ZAMACOIS Y ZABALA
1842-1871

64. *Court Jesters Playing Bowls*, 1868
 Oil on panel, 18 x 14 1/2 in. (45.7 x 36.8 cm)
 Signed and dated lower left: *Eo ZAMACOIS.68.*
 Mrs. Jesse Brownback

Provenance: Knoedler and Co., New York, 1879; T. R. Butler collection; sale, Mendelssohn Hall, New York, Jan. 7, 1910, no. 12; Mr. and Mrs. James A. Rafferty, Rye, N.Y.

The fascination with deformed jesters and dwarfs in French painting may stem from the popularity of Victor Hugo's play *Le roi s'amuse* of 1832, which was transformed by Verdi into the even more famous *Rigoletto* in 1851. At the Salon of 1866, the painter Ferdinand Roybet exhibited *Un fou sous Henri III (A Fool of the Period of Henri III)*, which achieved notoriety when purchased by Napoléon III's cousin Princess Mathilde. He continued to paint scenes of Renaissance jesters,[1] and other artists quickly followed his example, particularly Zamacoïs. Perhaps because of his Spanish origin, with memories of Velázquez and Ribera to inspire him, he, as was noted at the time, invested the theme with a darker character.[2] This may have added to his paintings' fascination for American collectors, and several other examples found their way to these shores.[3] The most famous was probably *The Favorite of the King* of 1867 (fig. 47), owned by William H. Vanderbilt.[4]

Eugene Benson's observations of 1869 are certainly applicable to the present work:

It was novel to see a group of hunchbacks and dwarfs in the antechamber of a king all clad in sheeny vesture, intense of hue like the plumage of tropical birds, in clear and glowing colors like carbuncles and emeralds and rubies. . . . The pictures of Zamacoïs had the attraction of the *bizarre* and the perfect. The picturesque, the grotesque, the elaborate all in one frame; this was more than the severe Gérôme gave in his

studied sensualities, more than the dry and prosaic Meissonier gave in his studies of costume and character.[5]

The dwarf buffoon, who is the centerpiece of the Vanderbilt painting, is in similar costume to the one standing here. He competes with two other lavishly dressed dwarfs as a cynical jester observes the action. The distinctive background panels of horsemen also appear in Zamacoïs's *Indirect Contribution* of 1866.[6]

1. Sale of the collection of Princess Mathilde, Galerie Georges Petit, Paris, May 17-21, 1904, no. 193; Omaha, 1990, p. 2.
2. Strahan, *Treasures*, I, 1879, p. 37, writes of "a certain Spanish brooding morbidness of temperament."
3. Other similar subjects by Zamacoïs in American collections included *Checkmated* of 1867 sold in the William H. Stewart collection, American Art Galleries, New York, Feb. 3-4, 1898, no. 101; *Court Jesters at Cards*, 1867, in the S. D. Warren sale, Mendelssohn Hall, New York, Jan. 8-9, 1903, no. 107; and *A Court Jester (Le fou du roi)*, in the Stebbins collection, sold, the American Art Galleries at Chickering Hall, New York, Feb. 12, 1889, no. 60. The most elaborate was *Court-Jesters in the Antechamber* of 1867 in the A. T. Stewart collection: see Strahan, *Treasures*, I, 1879, ill. p. 37.
4. See Strahan, *Treasures*, III, 1880, ill. p. 97.
5. Eugene Benson, in *The Art Journal*, 1869, quoted in Clement and Hutton, 1879, II, pp. 369-70.
6. Shown in the Salon of 1867 and in the collection of James H. Stebbins, New York; sold, the American Art Galleries at Chickering Hall, New York, Feb. 12, 1889, no. 65. See Strahan, *Treasures*, I, 1879, ill. p. 100.

Fig. 47. *E. Zamacoïs,* The Favorite of the King *(after Strahan, Vanderbilt, 1883).*

Ackerman, 1967
Gerald M. Ackerman, "Gérôme: The Academic Realist," *The Academy: Art News Annual*, XXXIII, pp. 100-107.

Ackerman, 1986
Gerald M. Ackerman, *The Life and Work of Jean-Léon Gérôme*, London and New York.

Ackerman, 1990
Gerald M. Ackerman, "The Néo-Grecs: A Chink in the Wall of Neoclassicism," *The French Academy*, Newark, Del.

Aldine, **1879**
"Paris Salon Pictures," *The Aldine*, IX, no. 12.

Arnot, **1936**
Permanent Collection of the Arnot Art Gallery, Elmira, N.Y.

Arnot, **1973**
Permanent Collection of the Arnot Art Gallery, Elmira, N.Y.

Arnot, 1989
Arnot Art Museum, Elmira, N.Y., *A Collector's Vision: The 1910 Bequest of Matthias H. Arnot*

Atlanta, 1983
High Museum of Art, *French Salon Paintings from Southern Collections*.

Avery, *Diaries*, 1979
The Diaries, 1871-1882, of Samuel P. Avery, Art Dealer, eds. Madeleine Fidell-Beaufort, Herbert L. Kleinfield, and Jeanne K. Welcher, New York.

Baltimore, 1970
Walters Art Gallery, *Fortuny and His Circle*.

Baltimore, 1977
Walters Art Gallery, *War à la mode at The Walters*.

Bellier and Auvry, 1882-87
Emile Bellier de la Chavignerie and Louis Auvry, *Dictionnaire générale des artistes de l'école française*, Paris, 3 vols.

Bénédite
Léonce Bénédite, *Meissonier*, Paris, n.d.

Bénézit, 1976
E. Bénézit, *Dictionnaire critique et documentaire des peintres . . .* , Paris, 10 vols.

Blanc, 1876
Charles Blanc, *Les artistes de mon temps*, Paris.

Blanc, 1878
Charles Blanc, *Les beaux-arts à l'Exposition Universelle de 1878*, Paris.

Boime, 1971
Albert Boime, "Jean-Léon Gérôme, Henri Rousseau's *Sleeping Gypsy* and the Academic Legacy," *Art Quarterly* (spring), pp. 3-30.

Bowron, 1990
Edgar Peters Bowron, *European Paintings before 1900 in the Fogg Art Museum*, Cambridge, Mass.

Brooklyn, 1988
The Brooklyn Museum, *Courbet Reconsidered*.

Brockwell, 1920
Maurice W. Brockwell, *A Catalogue of Paintings in the Collection of Mr. and Mrs. Charles P. Taft*, New York.

Brownell, 1901
W. C. Brownell, *French Art: Classic and Contemporary Painting and Sculpture*, New York.

Bryan, 1921
Michael Bryan, *Bryan's Dictionary of Painters and Engravers*, London, 5 vols.

Burty, 1866
Philippe Burty, "L'Oeuvre de M. Meissonier et les photographes de M. Bingham," *GBA*, I.

Burty, 1882
Philippe Burty, "Jean-Louis-Ernest Meissonier," *Illustrated Biographies of Modern Artists*, Paris.

Burty, 1892
Philippe Burty, *Croquis d'après nature*, Paris.

Calais, 1989
Musée des Beaux-Arts, *La peinture française du XIXe siècle: Collection Chester Beatty de la Galerie Nationale d'Irland*.

Castagnary, 1892
Jules A. Castagnary, *Salons (1857-1870)*, Paris, 2 vols.

Champlin and Perkins, 1888
J. D. Champlin, Jr., and C. C. Perkins, *Cyclopedia of Painters and Paintings*, 2 vols.

Chaumelin, 1887
Marius Chaumelin, *Portraits d'artistes: E. Meissonier, Jules Breton*, Paris.

Chesneau, 1864
Ernest Chesneau, *Peinture, sculpture: Les nations rivales dans l'art*, Paris.

Chesneau, 1868
Ernest Chesneau, *L'Art et les artistes modernes en France et en Angleterre*, Paris.

Claretie, 1876
Jules Claretie, *L'Art et les artistes français contemporains*, Paris.

Claretie, 1884
Jules Claretie, *Peintres et sculpteurs contemporains*, Paris, 2 vols.

Clark, **1972**
List of Paintings in the Sterling and Francine Clark Art Institute, Williamstown, Mass.

Clement and Hutton, 1879
Clara E. Clement and Lawrence Hutton, *Artists of the Nineteenth Century and Their Works*, Boston, 2 vols.

Constable, 1964
W. G. Constable, *Art Collecting in the United States of America*, London.

Cook, 1888
Clarence Cook, *Art and Artists of Our Time*, New York, 6 vols.

Dayton, 1972-73
Dayton Art Institute, *Jean-Léon Gérôme*.

Delteil
Loys Delteil, *Le Peintre-Graveur Illustré*, Paris.

Detroit, 1954
The Detroit Institute of Arts, *The Two Sides of the Medal: French Painting from Gérôme to Gauguin*.

Detroit, 1979
The Detroit Institute of Arts, *The Figure in Nineteenth-Century French Painting*.

Doucet, 1905
Gérôme Doucet, *Les peintres français*, Paris.

Durand-Gréville, 1887
E. Durand-Gréville, "La peinture aux Etats-Unis," *GBA*, XXXVI (July 1887), pp. 65-75, 251-55.

Fink, 1978
Lois Marie Fink, "French Art in the United States . . . ," *GBA*, XCII (Sept. 1978), pp. 87-100.

***Fortuny*, 1989**
Fortuny, 1838-1874, exh. cat. Fundació Caixa de Pensions, Barcelona.

Gautier, 1853
Théophile Gautier, *Wanderings in Spain*, London.

Gautier, 1856
Théophile Gautier, *Les beaux-arts en Europe*, 1855, Paris.

Gaya Nuño, 1958
Juan Antonio Gaya Nuño, *La pintura española fuera de España*, Madrid.

GBA
Gazette des beaux-arts, Paris.

Goncourt, 1956
Edmond and Jules de Goncourt, *Journal, mémoires de la vie litteraire*, Monaco, 12 vols.

Gonse, 1874
Louis Gonse, "Salon de 1874," *GBA*, X, pp. 31-49.

González and Martí, 1987
Carlos González and Montse Martí, *Pintores españoles en Roma, 1850-1900*, Barcelona.

González and Martí, 1989
Carlos González and Montse Martí, *Pintores españoles en Paris, 1850-1900*, Barcelona.

Gréard, 1897
Valery C. O. Gréard, *Meissonier*, New York.

Gruelle, 1895
R. B. Gruelle, *Notes: Critical and Biographical, Collection of W. T. Walters*, Baltimore.

Gueullette, 1863
Charles Gueullette, *Les peintres de genre au Salon de 1863*, Paris.

Guilloux, 1980
Philippe Guilloux, *Meissonier: Trois siècles d'histoire*, Paris.

Haskell, 1976
Francis Haskell, *Rediscoveries in Art*, Ithaca, N.Y.

Hering, 1892
F. F. Hering, *The Life and Works of Jean-Léon Gérôme*, New York.

Hoeber, 1900
Arthur Hoeber, *The Treasures of the Metropolitan Museum of Art*, New York.

Hook and Poltimore, 1986
Philip Hook and Mark Poltimore, *Popular Nineteenth-Century Painting*, Woodbridge, England.

Humbert, 1979
Jean Humbert, *Edouard Detaille: L'Héroïsme d'un siècle*, Paris.

Hungerford, 1979
Constance Cain Hungerford, "Meissonier's *Souvenir de guerre civile*," *The Art Bulletin* (June), pp. 277-88.

Hungerford, 1980
Constance Cain Hungerford, "Ernest Meissonier's First Military Paintings," *Arts Magazine* (Jan.), pp. 89-107.

Hungerford, 1989
Constance Cain Hungerford, "Meissonier and the Founding of the Société Nationale des Beaux-Arts," *Art Journal* (spring), pp. 71-77.

***Hyams*, 1964**
Isaac Delgado Museum of Art, *The Art Collection of Mr. and Mrs. Chapman H. Hyams*, New Orleans.

James, 1872
Anon. [Henry James], "Art," *Atlantic Monthly*, XXIX (Feb.), pp. 246-47.

James, 1958
Henry James, *Parisian Sketches: Letters to the "New York Tribune," 1875-1876*, London.

J. B. F. W., 1878
J. B. F. W., "J.-G. Vibert," *The Aldine*, IX, no. 6.

Johnston, 1982
William R. Johnston, *The Nineteenth-Century Paintings in The Walters Art Gallery*, Baltimore.

Keim, 1912
Albert Keim, *Gérôme*, New York.

Kraft and Schüman, 1969
Eva Maria Kraft and Carl-Wolfgang Schüman, *Katalog der Meister des 19. Jahrhunderts in der Hamburger Kunsthalle*, Hamburg.

Lagrange, 1861
Léon Lagrange, *La peinture et la sculpture au Salon de 1861*, Paris.

Lamb, 1892
M. J. R. N. Lamb, "The Walters Collection of Art Treasures . . . ," *Magazine of American History* (Apr.).

Larousse, 1865-90
P. Larousse, *Grand dictionnaire universel du XIXe siècle*, Paris, 17 vols.

Larroument, 1892
Gustave Larroument, *Le Salon de 1892*, Paris.

154

Larroument and Burty, 1893?
Gustave Larroument and Philippe Burty, *Meissonier*, Paris.

Lexington, 1973
University of Kentucky Art Museum, *Reality, Fantasy and Flesh: Tradition in Nineteenth-Century Art.*

Lexington, 1986
University of Kentucky Art Museum, *Nineteenth-Century French Art from the Wenneker Collection.*

Lexington, 1989
University of Kentucky Art Museum, *Bluegrass Collectors.*

Los Angeles, 1974
Los Angeles County Museum of Art and Gallery, University of California, Riverside, *The Impressionists and the Salon, 1874-1886.*

Lucas, *Diary*, 1979
The Diary of George A. Lucas, ed. Lilian M. C. Randall, Princeton, 2 vols.

Mainardi, 1987
Patricia Mainardi, *Art and Politics of the Second Empire: The Universal Expositions of 1855 and 1867*, New Haven and London.

Mantz, 1867
Paul Mantz, "Les beaux-arts a l'Exposition Universelle," *GBA* (Oct.), pp. 319-45.

Mantz, 1879
Paul Mantz, "La peinture française," *L'Art moderne à l'Exposition de 1878*, Paris.

Matthews, 1889
Alfred Matthews, "The Walters Art Collection at Baltimore," *Magazine of Western History* (May).

Ménard, 1873
René Ménard, "Collection Laurent Richard," *GBA* (Apr.), pp. 177-96.

Merveilles de . . . Salon de 1869
Les merveilles de l'art et de l'industrie, Salon de 1869, Paris.

Meyer, 1973
Ruth K. Meyer, "Jean-Léon Gérôme," *Arts Magazine* (Feb.), pp. 31-34.

Michel, 1884
André Michel, "Exposition des oeuvres de M. Meissonier," *GBA* (July), pp. 5-18.

Mollett, 1882
John W. Mollett, *Meissonier*, New York and London.

Montgomery, ed., 1889
American Art and American Art Collections, Boston.

Montrosier, 1881
Eugène Montrosier, *Les artistes modernes*, Paris, 4 vols.

Moreau-Vauthier, 1906
Charles Moreau-Vauthier, *Gérôme: Peintre et sculpteur*, Paris.

Morton, 1902
Frederick W. Morton, "An Appreciation of Jehan-Georges Vibert," *Brush and Pencil*, X, no. 6 (Sept.), pp. 321-28.

Murphy, 1979
Alexandra Murphy, "French Paintings in Boston, 1800-1900," *Corot to Braque: French Paintings from the Museum of Fine Arts, Boston*, pp. xvii-xlvi.

Muther, 1907
Richard Muther, *The History of Modern Painting*, New York.

Norton, 1984
Thomas E. Norton, *One Hundred Years of Collecting in America: The Story of Sotheby's Parke Bernet*, New York, 1984.

Omaha, 1990
Joslyn Art Museum, *An Eye for Detail, French Academic Paintings from The Martin Collection.*

Paris, 1884
Galerie Georges Petit, *Meissonier.*

Paris, 1893
Galerie Georges Petit, *Meissonier.*

Paris, 1974
Grand Palais, *Le Musée du Luxembourg en 1874.*

Patterson, 1989
Jerry E. Patterson, *The Vanderbilts*, New York.

Paturot, 1874
Nestor Paturot, *Le Salon de 1874*, Paris.

Philadelphia, 1978
Philadelphia Museum of Art, *The Second Empire: 1852-1870, Art in France under Napoléon III.*

Proust, 1981
Marcel Proust, *Remembrance of Things Past*, trans. C. K. Scott Moncrieff and Terence Kilmartin, New York.

Reizenstein, 1895
Milton Reizenstein, "The Walters Art Gallery," *New England Magazine* (July).

Robinson, 1887
L. Robinson, *Jean-Louis-Ernest Meissonier*, London.

Rosenblum and Janson, 1984
Robert Rosenblum and H. W. Janson *Nineteenth-Century Art*, New York.

Sanders, 1991
Patricia B. Sanders, *The Haggin Collection*, Stockton, Calif.

Sheldon, 1882
G. W. Sheldon, *Hours with Art and Artists*, New York.

Sloane, 1951
Joseph C. Sloane, *French Painting Between the Past and the Present*, Princeton.

Sterling and Salinger, 1966
Charles Sterling and Margaretta M. Salinger, *French Paintings: A Catalogue of the Collection of the Metropolitan Museum of Art*, II, New York.

Strahan, *Treasures*, 1879-80
Edward Strahan [Earl Shinn], *The Art Treasures of America*, Philadelphia, 3 vols.

Strahan, *Gérôme*, 1881-83
Edward Strahan [Earl Shinn], *Gérôme: A Collection of the Works in One-Hundred Photogravures*, New York.

Strahan, *Etudes*, 1882
Edward Strahan [Earl Shinn], *Etudes in Modern French Art*, New York.

Strahan, *Vanderbilt*, 1883
Edward Strahan [Earl Shinn], *Mr. Vanderbilt's House and Collection*, Boston, 4 vols.

Stranahan, 1897
Clara Harrison Stranahan, *A History of French Painting from Its Earliest to Its Latest Practice*, New York.

Tarbell, 1895
Ida M. Tarbell, *A Short Life of Napoléon Bonaparte*, New York.

Tausseret-Radel, 1892
A. Tausseret-Radel, "La peinture au Salon de Champs-Elysées," *L'Artiste*, Paris.

Ten Doesschate Chu, 1974
Petra ten Doesschate Chu, *French Realism and the Dutch Masters*, Utrecht.

Tomkins, 1970
Calvin Tomkins, *Merchants and Masterpieces: The Story of the Metropolitan Museum of Art*, New York.

Towner, 1970
Wesley Towner, *The Elegant Auctioneers*, New York.

Tulsa, 1989-92
The Philbrook Museum of Art, *With Exuberant Restraint: Nineteenth-Century French Salon Paintings from the Arnot Art Museum and the Philbrook Museum of Art*.

***Vanderbilt*, 1882**
Collection of W. H. Vanderbilt, 640 Fifth Avenue, New York.

***Vanderbilt*, 1884**
Collection of W. H. Vanderbilt, 640 Fifth Avenue, New York.

Van Dyck, 1896
John C. Van Dyck, *Modern French Masters*, New York.

Vapereau, 1893
G. Vapereau, *Dictionnaire universel des contemporains*, Paris.

Veron, 1876
P. Veron, *Les coulisses artistiques*, Paris.

Vesoul, 1981
Vesoul, France, *J. L. Gérôme . . . ses oeuvres conservées dans les collections françaises publiques et privées*.

Viardot, 1882
Louis Viardot, *The Masterpieces of French Art*, Philadelphia, 2 vols.

Vibert, 1892
Jehan-Georges Vibert, *The Science of Painting*, London.

Vibert, 1895-96
Jehan-Georges Vibert, "The Painter Vibert: An Autobiographical Sketch . . . ," *The Century Magazine* (Nov.-Apr.).

Vibert, 1902
Jehan-Georges Vibert, *La comédie en peinture*, Paris, 2 vols.

***Wallace*, 1968**
Wallace Collection Catalogues: Pictures and Drawings, London.

***Walters*, 1884**
The Art Collection of Mr. William T. Walters, Baltimore.

***Walters*, 1893**
Collection of W. T. Walters, 65 Mt. Vernon Place, Baltimore.

Walters, 1965
Walters Art Gallery, *A Selection of Nineteenth-Century Paintings*, Baltimore.

Weinberg, 1991
Barbara Weinberg, *The Lure of Paris*, New York.

Williamstown and Hartford, 1974
Sterling and Francine Clark Art Institute and Wadsworth Atheneum, *The Elegant Academics*.

Wilkes-Barre, 1975
Sordoni Art Gallery, Wilkes College, Wilkes-Barre, Pa., *Nineteenth-Century European Academic Paintings and Sculpture*.

Wilkes-Barre, 1977
Sordoni Art Gallery, Wilkes College, Wilkes-Barre, Pa., *The Sordoni Fine Art Exhibition*.

***Wolfe*, 1887?**
The Metropolitan Museum of Art, *The Catharine Lorillard Wolfe Collection in the New Western Galleries*, New York.

***Wolfe*, 1897**
The Metropolitan Museum of Art, *Hand-Book No. I: The Catharine Lorillard Wolfe Collection and Other Modern Paintings*, New York.

Wolff, 1886
Albert Wolff, "J. L. E. Meissonier," *Notes Upon Certain Masters of the XIX Century*, n.p. (trans. of *La capitale de l'art*, Paris).

Worms, 1906
Jules Worms, *Souvenirs d'Espagne, impressions de voyages et croquis*, Paris.

Young, 1960
Dorothy Weir Young, *The Life and Letters of J. Alden Weir*, New Haven.

Zakon, 1978
Ronnie L. Zakon, *The Artist and the Studio in the Eighteenth and Nineteenth Centuries*, The Cleveland Museum of Art.

Zamacoïs, 1948
Miguel Zamacoïs, *Pinceaux et stylos*, Paris.

Zola, 1959
Emile Zola, *Salons*, eds. F. W. J. Hemmings and R. J. Niess, Geneva and Paris.